SIN-A-RAMA

Sleaze Sex Paperbacks of the Sixties

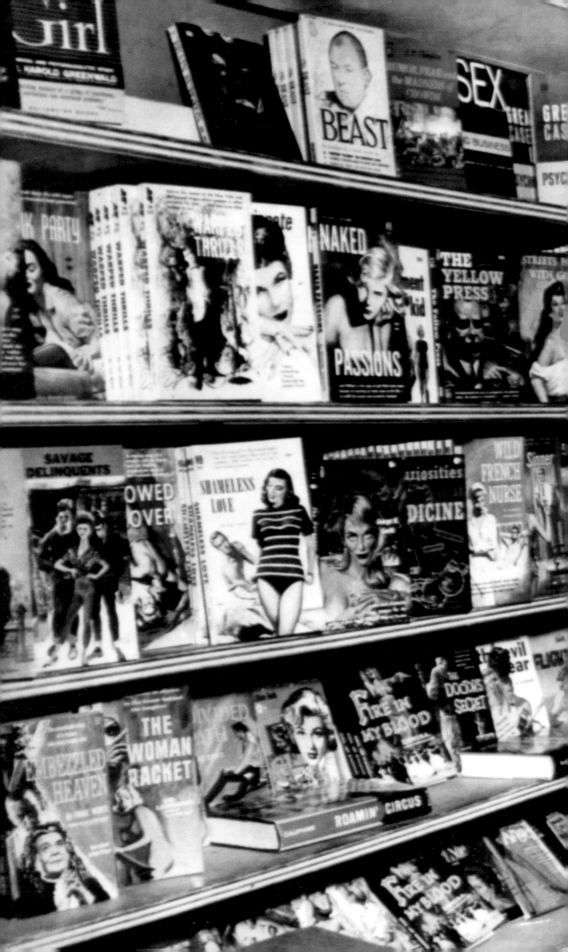

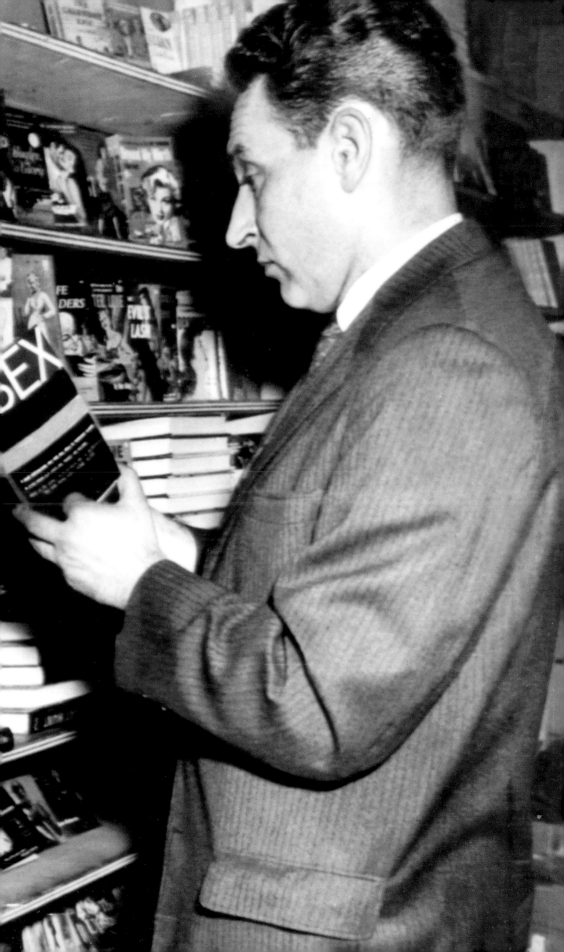

SIN-A-RAMA

Sleaze Sex Paperbacks of the Sixties

Edited by Brittany A. Daley
Hedi El Kholti
Earl Kemp
Miriam Linna
Adam Parfrey

Contributions by Stephen J. Gertz
Jay A. Gertzman
John Gilmore
Michael Hemmingson
Lydia Lunch
Lynn Munroe
Robert Silverberg

SIN·A·RAMA © 2005 Feral House

All Rights Reserved

ISBN: 1-932595-05-8

Feral House
PO Box 39910
Los Angeles, CA 90039

www.feralhouse.com

Design: Hedi El Kholti

10 9 8 7 6 5 4 3 2 1

The collections of Miriam Linna, Brittany Daley, Jeff Rich and Adam Parfrey were used as source material for the images within.

ACKNOWLEDGMENTS

The publisher wishes to express his gratitude to Brittany, Truman, Miriam, Steve Gertz, Earl Kemp, Jeff Rich, Lydia Lunch and Jay Gertzman for their enthusiasm and wisdom. Hedi El Kholti was again instrumental in improving this book with his right-on design choices. Last but not least to Jodi Wille for her very personal touches to the project.

Printed in China

CONTENTS

ADAM PARFREY

THE SMUT PEDDLERS

Softcore sleaze was, throughout the '60s, a jeopardous enterprise. Pseudonyms and fake addresses were the going concern on title and copyright pages. Though sex acts were described in winking euphemisms, sleaze publishers were often tried in court for transgressing Cold War-era suppression and paranoia. Some, like Greenleaf's Earl Kemp, and his boss William Hamling, went to prison.

Despite their comparative innocence as far as pornography goes, and vanguard court battles opening up freedoms we take for granted today, softcore (and hardcore) sleaze paperbacks are the forgotten black sheep of the publishing industry. The genre remains uncollected and unreferenced by the Library of Congress or any other known public or academic library. The "Sleaze Catalogue" appearing as an appendix at the end of this book is the first printed attempt to sort through the bewildering maze of smut publishers and fly-by-night operators. If it weren't for a small cadre of book collectors, sleaze of the '60s would be entirely forgotten.[1]

Erotic paperbacks sold in surprisingly large quantity[2] to white, male, middle-class patrons through mail-order catalogues, and in downtown "adult" stores, back-issue magazine parlors, and newsstand kiosks stocked by secondary magazine distributors (who also peddled nudist, girlie and men's adventure magazines).

The U.S. Government moved on sleaze with venom. Wearing an Aunt Bea hat in photo opportunities, congresswoman Kathryn Granahan ushered in the passage of the Granahan bill of 1958, which reinforced the Post Office's role as judge of moral righteousness, to "seize and detail the mail of anyone suspected of trafficking in obscenity."

In *The Smut Peddlers*, a 1960 paperback marketed as being "the most graphic account of the obscenity rackets," author James J. Kilpatrick[3] quotes Charles Keating—later convicted of bilking thousands in a savings and loan scandal—why sleaze must be put down:

> The [books] are not just amoral. They are openly and avowedly anti-Christian. It is not a question of depicting sin as virtue... Instead of the Christian concept of love and marriage, the magazines advocate a pagan, libertine life.

Author Kilpatrick phrases it this way:

> What is the narcotic in which these traders deal? It is raw sex, stripped of all beauty and poetry. Their purpose is to treat the sexual act as no more than the gratification of animal passions; their object is to stimulate a prurient desire for the sex without love that is lust. The marriage relationship, when it is treated at all, is a relationship to be violated; infidelity is fun, and adultery no more than a harmless pastime.
>
> It is a big business, a cynical business, a dirty business. And though pornography often is marketed in the form of "art nudes" or "pamphlets of medical instruction," or "realistic contemporary writing," the sordid intention of the distributors gives their ugly game away. Behind a flimsy mask of culture lies the leer of the sensualist.

The leer of '60s sleaze reveals the evolution of the decade. Sordid suburban alcoholism and "he man" gender types give way to the strawberry fields of sexual and ideological revolution. Even if horny readers failed to understand the confusing new scene, sleaze paperbacks offered them the opportunity to swap with psychedelic swingers and sin with hippie harlots.

Sin-A-Rama salutes the editors, authors and illustrators who refined their craft working sleaze, whether or not they publicly admit to doing so. (A list of authors and their pseudonyms appears as an Appendix.) We particularly wish to honor the artists and writers whose otherwise neglected careers glowed brightest in sleaze paperbacks. The compelling art of Robert Bonfils and Gene ("ENEG") Bilbrew are given consideration here, as well as the editing expertise of Earl Kemp, Don Gilmore and Brian Kirby, and the writing skills of Linda DuBreuil, William Knoles, and Jerry Murray. Within certain strictures, sleaze publishing allowed artistic freedom, albeit the writing and art would be largely ignored, and if not ignored, ridiculed.

No longer do pornographers evade recognition. Proudly they campaign for public office. The memoirs of porn actors are stacked on the front tables of family-sanctioned book chains. *Sin-A-Rama* explores the fascinating products of a transitional and revolutionary time, before erotica was reduced to the gynecological revelations of hardcore.

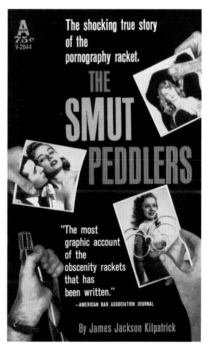

THE SMUT PEDDLERS (1960)
By James Jackson Kilpatrick
Avon Books

notes

1. Jay A. Gertzman, who in this book details the travails of East Coast and Midwest sleaze merchants, uncovers the fascinating career of Samuel Roth, whose court cases preceded and influenced the trials and tribulations of '60s sleaze erotica, in *Bookleggers and Smuthounds: The Trade in Erotica 1920–1940* (University of Pennsylvania Press, 1999). Gay and lesbian sleaze from the '60s have had several worthy book-length investigations, including *Queer Pulp: Perverted Passions from the Golden Age of the Paperback* by Susan Stryker (Chronicle Books, 2001), *Pulp Friction: Uncovering the Golden Age of Gay Male Pulps* by Michael Bronski (St. Martin's, 2003) and *Strange Sisters: The Art of Lesbian Pulp Fiction 1949–1969* by Jaye Zimet (Studio Books, 1999).

2. According to the notorious 1970 "Illustrated" Greenleaf Press edition of *The Presidential Report of the Commission On Obscenity and Pornography*, "the Commission estimates that 25 to 30 million 'adults only' paperback books were sold in 1969 [alone]."

3. Kilpatrick became the right-wing blowhard on *60 Minutes*' Point/Counterpoint segment in the mid- to late '70s.

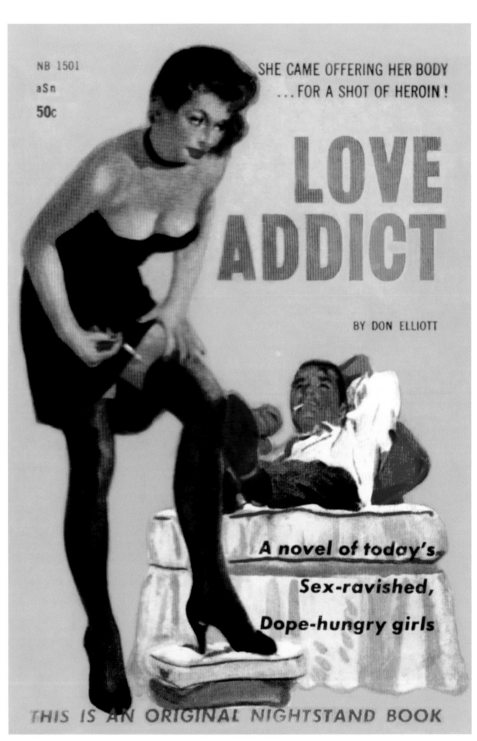

LOVE ADDICT (1959)
By Don Elliott (Robert Silverberg)
Nightstand Books
Cover Artist: Harold W. McCauley

ROBERT SILVERBERG

MY LIFE AS A PORNOGRAPHER

This is how I might write it if I were writing it today:

"Come on," she said, her green eyes wild with hunger for it. "Are you ready to fuck or aren't you?"

Her clothes dropped away and instantly, at the sight of her full, hard-nippled breasts and the dense, dark thatch of hair at the base of her belly, his cock sprang up into aching rigidity. She grinned and came toward him and knelt before him, slipping one hand under his balls and grasping his stiff shaft with the other.

"Go on," Holman said hoarsely. "Suck it! Oh, Jesus, suck it, babe!"

She tickled the tip of his dick with her tongue and rubbed it voluptuously for a moment or two between the heavy mounds of her tits, and then her lips slid over him and she took him into her mouth. Deep. Amazingly deep. And moved slowly back and forth, back and forth, wringing moans from him, driving him wild with sensation. Her mouth was as soft and as sweet as a velvet cunt. She squeezed his balls lightly as she sucked. He could feel the jism starting to pulse within him, on the verge of leaping forth into her throat. But then she pulled back and spread herself for him, and an instant later, to his amazement and delight, his hard cock was plunging into the hot, throbbing depths of her moist pussy, and—

The year was 1959, though, and the American government's ideas of what was permissible to print and sell through normal commercial channels was very different, so this is what I actually wrote:

She undid the garter-belt herself, and rolled down the stockings, and then she was nude, and he stood up, dropping his trousers, and she reached out and caught his arm and pulled him down again, and they rolled off the couch together, down onto the carpeted floor.

For what might have been an hour they lay there, side by side, lips glued, hands roaming up and down bodies, breath coming shorter and shorter. Holman opened his eyes and saw her staring at him, her eyes moist and the pupils that peculiar shade of green again. He smiled into her eyes and brought his fingers lightly down the small of her back, pausing at the dimples just above her firm, swelling buttocks.

It was like pulling a trigger. She began to gasp excitedly, and she dragged him over on top of her, her eyes going tight shut, her lips drooping open, moist and passionate.

"Now, darling! Take me now!"

She shuddered convulsively as the moment of union came. Her thighs tightened around him, and she began to writhe and moan—an animal moan, low and deep in her throat, coming from the same place that those deep, sad blues came from.

Holman clenched his teeth and gripped her shoulders tight, and she cried out three times, a whimper of excitement following, and then they were thundering away together on a tornado of passion, and she dug her fingernails into the skin of his back and gasped out breathlessly, "Oh oh oh *oh*," and Holman felt the explosion in his loins, and then they were lying quietly all of a sudden, limp and sweat-soaked, and he could feel the pounding of her heart when he touched her breasts, and the fireworks stopped.

It was over.

Hot stuff, yes? Well, actually it is, in its quaint fashion. No tits or cocks or cunts are mentioned, or any other nasty Anglo-Saxon words, no clits, no moist pussies, no vivid descriptions whatsoever of genital organs, erect or otherwise—not even of pubic hair; and an orgasm isn't a fountain of hot jism or anything else anatomically specific, it's a metaphorical "explosion in the loins." People don't fuck or screw, they experience "union." The tone is very antiseptic, almost prim, you would say. Even so, all the basic ingredients of the good old beast with two backs are there, the moans and groans, whimpers of excitement, and, yes, the explosion in the loins—everything you would want in a scene describing passionate sex, if you were living in 1959.

This was, in fact, the opening erotic passage in *Love Addict*, published by Nightstand Books of Chicago in October of that year—the first of about 150 novels of what we now would regard as very innocent softcore porn that I would write over the next five years for Nightstand under the pseudonym of "Don Elliott."

That's right. 150 full-length novels in five years. 30 a year, better than one every two weeks, month in and month out, between 1959 and 1964. Written on a manual typewriter, no less. (There were no computers then, not even IBM Selectric typewriters.) Other writers whose names would surprise you very much were turning the books out at almost the same sizzling pace. We were *fast* in those days. But of course we were very young.

I was 24 years old when I stumbled, much to my surprise, into a career of writing sex novels. I was then, as I am now, primarily known as a science-fiction writer. But in 1958, as a result of a behind-the-scenes convulsion in the magazine-distribution business, the whole s-f publishing world went belly up. A dozen or so magazines for which I had been writing regularly ceased publication overnight; and as for the tiny market for s-f novels (two paperback houses and one hardcover) it suddenly became so tight that unless you were one of the first-magnitude stars like Robert Heinlein or Isaac Asimov you were out of luck.

I had been earning a very nice living writing s-f since my graduation from college a few years earlier. I had a posh five-room apartment on Manhattan's exclusive West End Avenue ($150 a month rent—a fortune then!), I had fallen into the habit of spending my summer vacations in places like London and Paris, I ate at the best restaurants, I was learning something about fine wines. And suddenly two thirds of the magazines I wrote for were out of business, with a slew of older and better established writers competing for the few remaining slots.

But I was fast on my feet, and I had some good friends. One of them was Harlan Ellison, a science-fiction writer of my own age, who—seeing the handwriting on the wall in the s-f world—had left New York to accept a job in Chicago as editor of *Rogue*, an early men's magazine that was trying with some success to compete with its crosstown neighbor, *Playboy*. The publisher of *Rogue* was William L. Hamling, a clean-cut young Chicago suburbanite whose first great love, like Harlan's and mine, had been science fiction. Bill Hamling had published an s-f magazine called *Imagination*, which bought one of my first stories in 1954. From 1956 on, he had paid me $500 a month to churn out epics of the spaceways for him on a contract basis. Now, though, *Imagination* was gone, and Hamling's only remaining publishing endeavor was his bi-monthly girlie magazine.

Harlan, soon after going to work for him, convinced Bill that the future lay in paperback erotic novels. Hamling thought about it for about six minutes and agreed. And then Harlan called me.

"I have a deal for you, if you're interested," he said. "One sex novel a month, 50,000 words. $600 per book. We need the first one by the end of July." It was then the beginning of July. I didn't hesitate. $600 a month was big money in those days, especially when you were a young writer at your wits' end because all your regular markets had crashed and burned. One book would pay four months' rent. They were going to publish two paperbacks a month, and I was being offered a chance to write half the list myself. "You bet," I said. By the end of July Harlan had *Love Addict*—a searing novel of hopeless hungers, demanding bodies, girls trapped in a torment of their own making, et cetera, et cetera. (I'm quoting from the jacket copy.)

Bill Hamling loved *Love Addict*. By return mail came my six hundred bucks and a request for more books. I turned in *Gang Girl* in September. I did *The Love Goddess* in October. Later that month I wrote *Summertime Affair* also. Two novels the same month? Why not? I was fast, I was hungry, I was good.

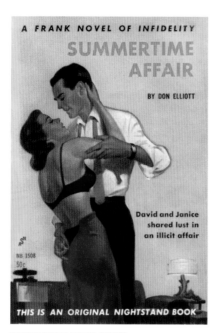

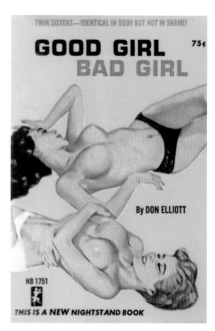

SUMMERTIME AFFAIR (1960)
By Don Elliott (Robert Silverberg)
Nightstand
Cover Artist: Harold W. McCauley

GOOD GIRL BAD GIRL (1965)
By Don Elliott (Robert Silverberg)
Nightstand Books

In October, also, the first two Nightstand Books went on sale—mine and something called *Lust Club*, by another young writer who also was making a quick adaptation to changes in his writing markets. His book, like mine, was really pretty tame stuff. What we were writing, basically, were straightforward novels of contemporary life, with very mild interludes of sexual activity every 20 or 30 pages. But the characters actually did go to bed with each other, and we did try to describe what they were doing and how they felt in as much detail as the government would allow.

At that time, fairly rigid censorship still prevailed in American publishing. It was illegal to publish or sell such classics of erotic literature as *Tropic of Cancer* or *Lady Chatterley's Lover*, and even the presence of words like "fuck" or "cunt" in a book could bring its publisher a call from the district attorney's office. To a reading public eager for vicarious sexual thrills, Bill Hamling's Nightstand Books, which were openly and widely distributed, offered a commodity that was in instant and enormous demand. Incredible quantities of the first two books were sold. It was impossible to reprint them fast enough.

Hamling sent me a bonus of $200 for each book I had written thus far, and raised my price to $800 from then on. And he decided

to publish four titles a month instead of two. "Can you possibly write two books a month for us?" he asked.

A Nightstand Book, you understand, was a 212-page double-spaced manuscript. I was setting myself up for an unthinkable amount of typing—not to mention the problem of inventing plots, characters, setting, all that stuff. But I didn't hesitate to say yes. I could type quickly and I could think quickly. And I had arrived at a perfect formula for these books. They were stories about ordinary people who were in the grip of powerful sexual obsessions that got them into trouble.

What I did was take a sympathetic character (male or female, it made no difference) who has normal, healthy sexual desires that are somehow being frustrated—the hard-working husband who suddenly feels a powerful need to have an affair, the woman who unexpectedly discovers that drinking too much makes her want to let go of her sexual inhibitions, with all the risk that that involves. Remove the frustration. But the fulfillment of the desires leads to complications and then more complications, which create tensions that can best be satisfied by more sex, and so on and on, in and out of bed and in and out of trouble, until in the end everything is resolved and the protagonist's life shows signs of becoming calmer.

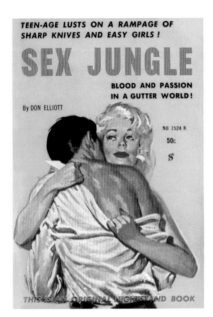

TEEN-AGE LUSTS ON A RAMPAGE OF
SHARP KNIVES AND EASY GIRLS !

SEX JUNGLE

BLOOD AND PASSION
IN A GUTTER WORLD!

By DON ELLIOTT

NB 1524 R
50c

THIS IS AN ORIGINAL NIGHTSTAND BOOK

SEX JUNGLE (1960)
By Don Elliott (Robert Silverberg)
Nightstand Books
Cover Artist: Harold W. McCauley

Any setting would do. I just had to pick my characters and set them in motion against a vivid background. I told tales of illicit goings-on at plush Caribbean resorts, of high school kids learning what to do with their bodies, of suburban swap clubs. Where I could make use of my own experiences, such as they had been at the age of 25 or so, I did. The rest I spun out of whole cloth, or out of my own teeming, steamy fantasies. (I had grown up in the repressed Fifties, and had plenty to fantasize about.)

I wrote *Pawn of Lust* and *Nudist Camp* in November, 1959. I wrote *Warped Lusts* and *Suburban Wife* in December. January produced only *Sin on Wheels*, but in February came *Sin Ranch* and *Trap of Desire*. And so on and so on, month after month. Each book took me exactly six days: one chapter of 16–18 pages before lunch, one of 16–18 pages after lunch, 12 chapters and 212 pages in all. No book came out short and none, of course, ran long: I became adept in moving my characters around in such a way that the climax of the plot always arrived on schedule in Chapter Twelve.

The books sold well and more retroactive bonuses were paid me for the early titles. Now I was getting $1200 a book for the new ones. That was an income of better than a thousand dollars a week at a time when dinner for two at the finest restaurant in New York cost about $40, including a bottle of first-rate French wine. My new career in pornography was rapidly making me rich.

I felt absolutely unabashed about what I was doing. Writing was my job, and I was working hard and telling crisp, exciting stories. What difference did it make, really, that they were stories about people caught in tense sexual situations instead of people exploring the slime-pits of Aldebaran IX? I experienced the joy—and there is one, believe me—of working hard and steadily, long hours sitting at a typing table under the summer sun, creating scenes of erotic tension as fast as my fingers could move. Of course, what I was writing was not "respectable," not even slightly, and so when people asked me what I did for a living I told them I was a science-fiction writer. (I was still writing some of that, too, as a sideline.) I could hardly tell my neighbors in my elegant suburban community that I was a professional pornographer.

But was I really writing pornography?

Not if the use of "obscene" words or graphic physiological description is your definition of pornography. As the sample I quoted above should show, the stuff was really laughably demure. Everything was done by euphemism and metaphor. No explicit anatomical descriptions were allowed, no naughty words. About as far as you could go was a phrase like "they were lying together, and he felt the urgent thrust of her body against him, and his aroused maleness was penetrating her, and he felt the warm soft moist clasping and the tightening..."

Unmistakably these people are Doing It. But his "maleness" is what's penetrating her, not his cock or his prick or his dick, and *something* is clasping and tightening, presumably a vagina, but we aren't told that in so many syllables. Characters didn't "come" —they reached "the moment of ecstasy." Men had neither cocks nor balls; they had "loins." Foreplay was a matter of cupping breasts and letting a hand "slip lower on her body." Anal sex? No such concept. Dildos and other sex toys? Forget it. Oral sex was indicated by saying, "He kissed her here and he kissed her there, and then he kissed her there." And so forth. None of it was much spicier than Peter Rabbit.

I limited myself to words that were in the dictionary because I had been warned at the outset that the publisher would not tolerate what he termed "vulgarisms" in the books. One reason for this was that he genuinely

didn't like them—he was basically a very earnest and straight type of guy, who would much rather have been publishing science fiction—but also he knew that might very well go to jail if he started printing them. *Jail*, yes—no matter what the First Amendment might say. (And eventually he did, many years later—not for publishing sexy novels, but for violating the postal code by sending an advertisement for an illustrated history of erotic art and literature through the mails!)

The list of what was a "vulgarism," though, kept changing in line with various court actions and rulings affecting Nightstand's competitors in the rapidly expanding erotic-book business. All across the nation, bluenosed civic authorities were trying to stamp out this new plague of smut. Whenever a liberal-minded judge threw out a censor's case, the word came down to us that we could take a few more risks in what we wrote, although our prose remained exceedingly pure by later publishing standards. And whenever some unfortunate publisher was hit by a fine, the word was passed to the little crew of Nightstand regulars that we had to try to be more proper.

One day the word "it" became a vulgarism. "*It*" as in "'*Do it*,' *she cried*," I mean. By this time Harlan Ellison had moved along to Hollywood, and my Nightstand editor in Chicago was Algis Budrys, another top science-fiction writer who had found it necessary after the s-f crash to switch from freelance writing to editing. Budrys phoned me to say that I must restrict my use of "it" from now on. I took a look at a recently published book of mine and saw that they had indeed changed all my "it"s to "that"s, creating stuff like: "*Do that*,' she cried. '*I want that! I want that!*'"

This sounded nuts to me, and I told Budrys I would refuse to abide by it. To prove it, I turned in a book in which "it" was just about every other word: "*Give it to me! I want it! It! It! I must have it!*" I was the star of the line, the first and most reliable and prolific writer they had, and I got my way. "It" was removed from the list of vulgarisms.

By this time—it was about 1962—I was turning out *three* Nightstand books a month. It was a fantastic amount of work to do, but I had no choice. Like many writers (Sir Walter Scott, for example, or Mark Twain) I had gone in for owning fancy real estate. I had bought myself an enormous mansion in the finest residential neighbor-hood of New York City, close to the Westchester County line, for the immense sum (then) of $80,000. The place had 20 rooms, all of which needed to be painted and furnished, and then too I had to think about the heating bill, property taxes, etc., etc. So I upped the output. The record for June, 1962, for example, shows *Unnatural*, *Illicit Joys,* and *The Flesh is Willing*—a typically productive month. That month the plumbing in the house broke down and I remember a team of five plumbers digging around in the back yard, simply trying to locate the water main, while I sat upstairs trying to turn out words fast enough to earn more than their combined hourly rate. And did.

One way I managed to keep up this amazing level of output was to assemble a sheaf of what I called "modules"—prefabricated sex scenes that I could simply plug into any book. Plots and characters had to change from book to book, of course, but under the highly restrictive rules we were forced to use there were only so many ways to describe what my people were up to in bed, and so I extracted relevant scenes from my books—a basic seduction scene, a copulation scene, a voyeurism scene, a rape scene, a Lesbian scene, and so on—and recycled them into the new manuscripts in the appropriate places, as needed. Nobody ever objected. (If computers had existed then, I could have done it all with a single keystroke. Instead I had to type it all out, over and over.)

The Nightstand line now was running to eight or ten books a month, maybe more, and as the list grew, a lot of other clever young men joined the roster of writers. (Entry to the list was by invitation only—the publisher didn't want to deal with amateurs, only with crafty young pros.) In an insecure career like freelance writing, those guaranteed monthly checks were very tempting. You would probably be astonished at how many eventually-famous writers were among my colleagues at Nightstand. We were like a bunch of future major-leaguers getting a chance to sharpen our skills in Triple-A minor-league baseball.

I won't name names, because it's not my place to do so. But I can tell you that two of today's most widely admired mystery novelists, now enormously popular and successful, were Nightstand regulars under the names of "Andrew Shaw" and "Alan Marshall." Their work for Nightstand usually had a broadly comic touch, which mine never did. (Sex was always Serious Stuff to me.) Another, who

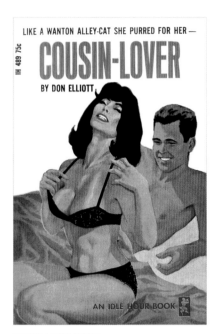

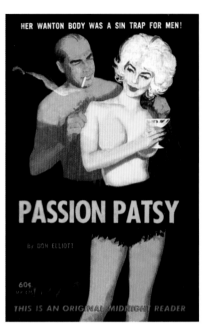

COUSIN LOVER (1966)
By Don Elliott (Robert Silverberg)
Idle Hour book
Cover Artist: Darrel Millsap

PASSION PATSY (1963)
By Don Elliott (Robert Silverberg)
Midnight Reader

wrote under the name of "J.X. Williams," became a major best-selling author of historical novels, specializing in American history, and I mean *major*. The author of the "Don Bellmore" books went on to a career as a Hollywood writer. "Clyde Allison" was the pseudonym used by a brilliant young mainstream novelist who died of alcoholism while still in his '30s. And, though I have no proof of this, I was told on good authority long ago that one of the Nightstand writers was a man who was *already* a best-selling author even then, and who was knocking out Nightstands on the side for the fun of it, without his wife's knowledge (or his regular publisher's) and having the payments sent to the mistress he was keeping.

We were all working hard, and having fun, and making plenty of money. (So was the publisher, who left Chicago for a Palm Springs estate.) Of course, all sorts of governmental units right up to the Federal level were trying to put us out of business, and there were indictments all over the place, and a nasty censorship trial in Houston. Since we writers worked under pseudonyms, and got our checks from a dummy corporation, we weren't involved in that.

But one day the FBI came to talk to me. It was all very silly. I received them in the paneled library of my imposing mansion.

We chatted about my writing—my *science fiction* writing. I showed them a few recent books on archaeology and science for young readers I had written—I was doing that too, in my spare time, and I just happened to have the books close at hand. The word "pornography" was never mentioned. They did ask me if I had ever done business with a company called Such-and-Such Enterprises. Evidently that was one of the dummy corporations that paid the writers for the Nightstand Lines; but it so happened that my checks came from This-and-That Enterprises instead, a *different* dummy corporation, and the nice FBI men had gotten things mixed up. "No," I said, absolutely truthfully. "I've never done business with Such-and-Such. I've never even heard of them." And that was that. The FBI men left, probably thinking there was some case of mistaken identity here, and no one ever bothered me again.

But I did stop writing for Nightstand a year or so later—not because I was afraid of more government harassment, but because after 150 erotic novels in five years I was getting pretty tired of marching my characters in and out of bedrooms. I wanted to get back to the intellectual challenge of science fiction, which was making a strong commercial recovery after its slump of the late '50s.

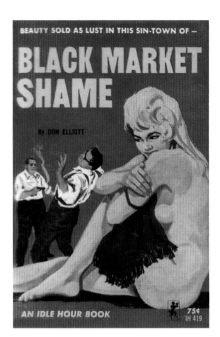

BLACK MARKET SHAME (1964)
By Don Elliott (Robert Silverberg)
Idle Hour
Cover Artist: Harold W. McCauley

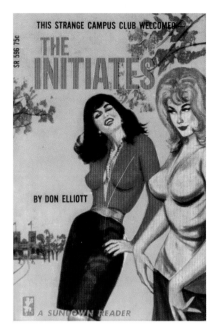

THE INITIATES (1966)
By Don Elliott (Robert Silverberg)
Sundown Readers
Cover Artist: Harold W. McCauley

And my non-fiction books on archaeology and science were very successful too; I wanted time to do more of those. So in a final flurry—*E for Eros*, *One Night Stand*, *Sin Kitten*—I went out of the business of writing erotic novels.

But I have no regrets about those five years in the sex-book factory—none. I don't think any of us who wrote Nightstands do. It isn't just that I earned enough by writing them to pay for that big house and my trips to Europe. I developed and honed important professional skills, too, while I was pounding out all those books.

Working at fantastic speeds (I once did a complete novel in three and one-half days, just to see if I could) we mastered the knack of improvising plots from scratch and making everything work out neatly at the required 50,000-word length: a wonderful exercise in structural discipline that has stood me in good stead ever since. There was no time to make mistakes: we had to get it right on the first draft, and we did, telling good stories in crisp, no-nonsense prose. And because we worked under pen names, we were free to let all inhibitions drop away and push our characters to their limits, without worrying about what anyone else—friends, relatives, book reviewers—might say or think about our work. We had

ourselves a ball, and got paid nicely while we were doing it.

And also we never forgot that we were doing the fundamental thing that writers are supposed to do: providing pleasure and entertainment for readers who genuinely loved our work. Huge numbers of the books were snapped up as fast as they came from the presses, which meant that they filled a need, that *somebody* appreciated them a whole lot. It meant something to me to know that my novels were brightening the lives of a vast host of people in those dim dark days of 30-plus years ago when puritanism was riding high and sex was in chains.

One hundred fifty novels! *Passion Patsy*! *Flesh Flames*! *Sin Hellion*! *The Orgy Boys*! Writing those books was a terrific experience and I look back fondly on it without shame, without apologies.

Robert Silverberg is the Hugo Award-winning science-fiction writer.

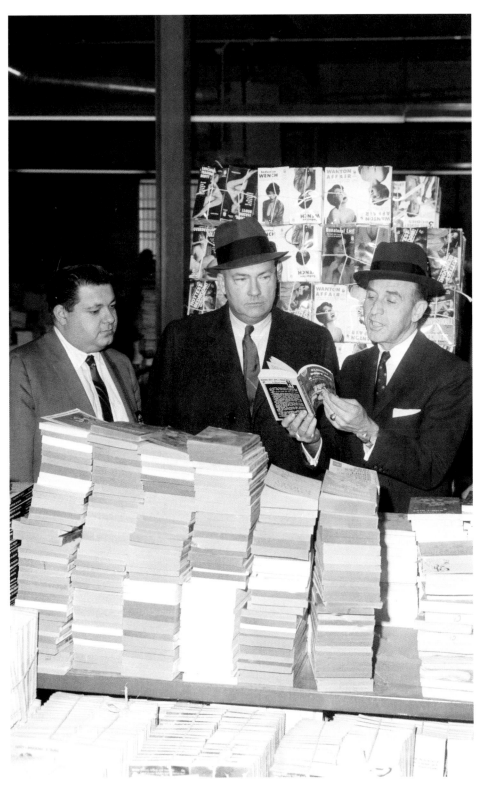

"The worst filth I've seen…" So said Police Commissioner Michael Murphy (center) after raids on distributors of allegedly obscene books in Queens following parental complaints. District Attorney Frank O'Connor (right) and aide Guy A. Vitacco, flank Murphy in one raided establishment at 35-27 31st Street.
Photographer: Bruce Hopkins © Bettmann/CORBIS

JAY GERTZMAN

SOFTCORE PUBLISHING: THE EAST COAST SCENE

Softcore sleaze paperbacks have an erotic promise that holds its own—the libidinous nudges of titles, blurbs and cover art, even the suggestions offered by the authors' names. In the earlier '60s, four-letter words were strictly taboo. Not only were "cock," "balls," and "pussy" inadvisable, but even the scientific designations for the sex organs were considered problematic. Unlike hardcore, the curtain rose in the first act, not the last: the sex scenes had to be in proportion to the bulk of the story, so setting and characterization were necessary.

As a sort of requiem for the genre, Olympia Press published, in 1971, *The Dirtiest Book in Town*, a fictional collection of softcore covers, blurbs, and text.[1] The storylines and euphemisms concocted were a satiric tribute to the verbal and narrative skills needed to write such books. There was, for example, the stream-of-consciousness gambit:

> Suddenly he was pumping and pounding and gasping and grunting and groaning and moaning and grinding and pushing and pulling and shoving and tearing.

The science fiction variation:

> They all had seven breasts, and not as we know them on Earth women—much larger, with nipples flaming red, and erect. The usual female opening was in the back, and in the front they all had oversized penes [sic]—three times larger than any known on Earth men... Then Philiotina, their chieftain, forced her huge erection into Bill's anus—way up to the base—while two others held his legs apart as she forced her hugeness in and out...

And the clinical report:

> Then he [vernacular for osculated] my [vernacular for mammalia (sic)]. I spun around and started to [vernacular for fellatio]. He [vernacular for digitalized] my [vernacular for genitalia]. Moments later we were [vernacular for copulating].

The softcore paperback sex pulp had a long span of popularity, a large readership, and a complex publishing history. It may have been a literary lightweight, but it took a lot of effort to get it to work correctly to bring in the money. And it certainly did do that. By 1969, according to the President's Commission on Obscenity and Pornography, in New York City alone, publishers issued per month, respectively, 20 titles with press runs of at least 75,000 copies (Midwood-Tower, with yearly sales of 7.2 to 9 million copies) and 12 titles with runs of about 25,000 (Bee-Line; about 3.1 million copies sold for the year).[2]

I.

Before we begin, we must be clear that popular paperback publishing after World War II was based on the procedures used to publish and distribute mass-market magazines. The antecedent of the adult bookstore was the urban newsstand. Successful booksellers and publishers understood what sold magazines, how their distributors operated, who bought them, and why the customers came back for more of the same. Paperback books, as well the digest-sized newsstand pulps that preceded them, were written and marketed as if they were magazines. Until 1957, the American News Company distributed both. Distributors were the most influential people in the business, for it was they who delivered, and placed in racks, the publications.[3]

There is a legal and cultural context for the ubiquitousness of the softcore sleaze paperback throughout the '60s. In 1959, Barney Rosset's Grove Press published an unexpurgated *Lady Chatterley's Lover* against the wishes of the author's estate as well as the Postmaster General's. Rosset could afford good lawyers, and he won his case against the Post Office by showing that he had prepared a scholarly edition of a literary classic.

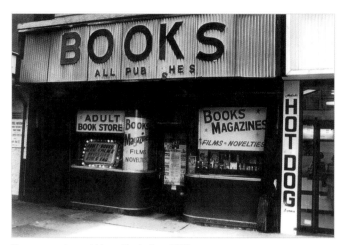

Sleaze emporium, mid-town Manhattan, 1963.

He then published *Tropic of Cancer*, and defended booksellers in over 60 jurisdictions who faced prosecution for carrying it. Liberating these two books from the obscenity laws almost bankrupted Rosset, but opened the way for other expressive work of literary, artistic, political, or scientific merit, and radically changed public taste as well. Rosset also published in cheap paperback under his Black Cat imprint well-written Victorian erotica, making this body of material available to a mass audience. There is a vast gap between Lawrence and Henry Miller's novels and the sleaze, but once the early '60s "de-censorship" decisions were made, publishers could plead that their books were not devoid of literary, artistic, political or social value. They often provided introductions by "experts" with Ph.Ds after their names. But more importantly, they could take advantage of the fact that, after *Lady Chatterley*, they were not offending contemporary social mores.[4] In 1963, the New York Supreme Court ruled that softcore magazines and books, while crude, afforded people without the education or taste to desire better a valid outlet for spending leisure time. Also that year, with *Tropic of Cancer* being openly sold, the Illinois high court stated that two softcore paperbacks, with the typical titles *Campus Mistress* and *Born To Be Made*, could not be censored, because they "do not go substantially beyond customary limits of candor" and were not "utterly without redeeming social importance."[5] In 1966, Illinois stated that seven paperbacks were not patently offensive and contained less sexual activity, sadism, oral sex and scatology than recently de-censored erotic classics. A bit later, the same court ruled *The Sex Addicts* was not obscene because "The acts of intercourse are not described in detail, so as to exceed the limits of contemporary candor in such matters, nor do we find repulsive and disgusting language of the kind given permission [by the *Chatterley* decision]."[6]

Softcore paperbacks were sold in newsstands, specialty stores of various kinds (cigar and candy stores, drug stores), bus and airport kiosks, and through the mail. The major point of sale was the bookstore, and the rise of the sex paperback coincided —at least on the East Coast—with the rise of the Adult Book Store. This major outlet was evolving by 1960 from what was usually called the Back Date Magazine and Book Store. The adult book shop shared ways of configuring space with its forerunner. Upon entering, one saw a center table, upright racks, and both library and pegboard shelving for paperbacks. Some of these, including the softcore novels, might be wrapped in cellophane (thus providing more prurient curiosity) and displayed on the center table, having had the cover price crossed out and raised.[7] The cash register was strategically placed, as it was in the back date magazine shop, often on a raised platform. Materials of special interest, more expensive than other items, might be behind the register, or proximate to the clerk and the register.[8] Non-fiction books on sexology, sexual anthropology, and prostitution, classic erotica of the past, and titillating bestsellers by Robbins, Wallace, and Susann were common in both back date magazine stores and the early '60s adult bookstores. Both shops had risqué novelties.

Back date magazine establishments carried girlie, adventure, and mystery pulps, but also all kinds of general-interest fare. In adult stores of the mid-'60s, one could find peep booths as well as a larger selection of sex toys and images, supplementing conventional steady sellers such as the greeting cards and erotic playing cards; photo and strip sets (a series of action photos which, when flipped through, gave the impression that the girls were moving); 8 mm films, records, and slides; and "art study" magazines of nudist and beefcake images. Many adult shops had windows that were blocked from the view of the passerby by signage or shades, accommodating citizens offended by the exclusively sexual goods. Blocked windows also created an atmosphere of prurience.

As sociologist Michael Stein put it, the "normalized" purchase of sexually explicit materials[9] required that both store owner and patron adopt a kind of "hiding strategy." Such was the ambiance in which softcore sleaze was purveyed.

Liberal court decisions of the 1960s by no means meant that police, clergy, and politicians became more tolerant of sexual expression in print or on film. The opposite was true. In New York, the Robert Wagner administration (1954–65) was a watershed. There were numerous confiscations of horror comic books and nude photographs which police officers, but certainly not lawyers, thought were obscene. A series of pornography raids followed the conviction of a photographer who wholesaled pictures of nude women. Instead of the decision being based on the presence of pubic hair, or the community's contemporary tolerances, the more general concept of "prurient interest" guided the decision.[10]

A Mayor's Citizens' Anti-Pornography Commission was created after Monsignor McCaffrey's 1963 call for action against "the disgrace that is Times Square" before World's Fair visitors arrived. Several months later, Operation Yorkville's Father Morton Hill went on a hunger strike until the Commission's four-point program was instituted. One goal was creation of a court dedicated to hearing obscenity cases.[11] Mayor Wagner "welcom[ed] his help and the help of other religious and civil leaders in rooting out this evil."[12] In 1966, the *Herald Tribune*, in an article headlined "The Problems of Times Square—Winos and Daffodils Take Over," described realtors' hopes that investors would purchase Times Square properties and turn the area into a "World's Fair industrial zone." The article's conclusion was that in the battle between "negatives and positives... the creeps and the investors will make it a struggle."[13]

All the despair over "the merchants of smut" making money by exploiting the prurience of a puritanical culture, the community action in the name of decency, and all the media coverage given screeds by politicians and clergy had the predictable effect. Times Square's sex businesses grew to include prostitution strolls and drug pushing. Middle-class citizens shied away from the increasing numbers of young Hispanic and African-American men visiting from Harlem and the Bronx.[14] In 1965, Broadway's premier general interest bookstore, The Concord, which had opened just north of the Paramount Theater marquee in 1933, closed. The owner cited street crime: marijuana sellers, pickpockets, drunks, flamboyant gays, and more generally the unruly after-dark atmosphere which had driven the playgoers away as soon as the curtain fell. "The street has turned into an unwalkable jungle," he said.[15] This was an exaggeration, but reflected an understandable public response to the environment in which one purchased softcore paperbacks, not only in New York but in Boston, Philadelphia, Baltimore, Washington, Pittsburgh, and other large eastern cities. No wonder some purchasers preferred cigar and candy stores, newsstands, and mail order outlets.

No wonder, also, that booksellers, distributors, and publishers of softcore sex novels had to face social stigma, harassment from police and community moralists, and legal fees. The largest New York City distributor of softcore paperbacks was G.I. Distributors. In the '60s, it handled both mass-market and secondary lines designed to appeal to the clientele of adult book stores. In April, 1963, police raided its Long Island City, Queens warehouse and confiscated many softcore paperbacks, bundled and ready to be trucked out to secondary retailers. G.I. was an established, well-financed company and defended itself vigorously. The owners sued the Police Commissioner and the Queens District Attorney for $325,000 in damages, and requested an injunction against further interference in the sale of their books, which they claimed were not legally obscene.[16] G.I.'s successful defense didn't stop police during the Wagner and Lindsay administrations from making periodic "sweeps" and "raids" during the rest of the decade.

There were two kinds of publishers, and two channels of wholesale distribution, for softcore '60s sleaze: mass-market and secondary. Mass-market firms such as Fawcett Gold Medal, which originated the paperback original (before the late '40s, paperbacks had been reprints of hardcover books), distributed to "department stores, drug stores, book stores, gift shops, specialty shops, in many places where you will see the softcover book on sale side-by-side with the hardcover books."[17] Fawcett acted as its own distributor, rather than relying on a separate middleman concern. Dell and MacFadden-Bartell did likewise, and all three firms distributed other publishers' books as well. Other mass-market firms with sexually-oriented material were Signet, Pocket, Berkley, and Grove (the aforementioned Black Cat Books). The 1970 Technical Report on Obscenity and Pornography (the Lockhart presidential Commission) reported Bee-Line, Tower and Lancer to be mass-market publishers, although these firms were of lesser stature than the ones previously mentioned.[18] Many publishers followed Barney Rosset and had their wares distributed by both mass-market and secondary outfits. His Black Cat paperbacks, including The Victorian Library, and the literary classics by Lawrence, Burroughs, and Miller, reached adult bookstores through the offices of G.I. Distributors.[19] Prurient interest paperbacks for the mass market may have reached points of sale not by national but by local, or independent, distributors. There were usually no more than one or two of these in any large city.[20]

The secondary market consisted of various specialty stores and newsstands, but focused in the '60s on adult outlets dedicated mostly or entirely to sexually explicit materials. Publishers, many of them functioning also as distributors, primarily handled imprints (and different "lines" specific to various fetishes) targeted exclusively for these sorts of readers. The Lockhart Commission explains that print runs for secondary books was between 10 and 30 thousand copies, while the mass market variety could often have been as high as 100,000.[21] This meant a higher unit cost for the secondary publisher. At the end of the decade, he typically would spend approximately $4,000 in production costs (author's fee, "make-ready," printing) and another $500 for shipping. On a print run of 30,000 copies, he would be spending 15 cents per book. Retail prices ranged from 95 cents to $1.95. If half the books printed were sold, and the publisher's return after dis-

tributor and retailer's fees amounted to half the cover price, he would do well, especially if he could publish ten or more volumes per month.[22]

The Commission listed some 15 eastern concerns: Olympia Press Inc., Overstock Book Company (Bob Brown), Interstate Book Distributors (formerly L-N), Cosmopolitan (formerly Eastern News), and Tuxedo in New York; Pendulum Books, Atlanta (Mike Thevis); Central Sales, LTD, Baltimore; Sovereign News Company, Cleveland (Reuben Sturman); Marble Distributors, Boston; Potomac News and Guild Press, Washington DC (Herman Womack); United Graphics, Delray Beach, Florida.[23] Other secondary publishers included Bedside, Fleur de Lis, Kozy, Casanova, and Tuxedo. Buffalo was the location of a publisher responsible for the following lines: Unique, Wee Hours, First Niter, After Hours.[24]

Thevis, Womack, and Sturman ran "empires of the obscene." For all three, the softcore pulp paperback, a significant cash cow, was one of several sexually-oriented products. Sturman, by the '70s, had created a multifaceted business: books (Eros Gold Stripe, Consolidated), sex emporia, peep booths, sex novelties (Doc Johnson's), and films. He had to deal with Mafia bosses on many levels, like them hiding his huge investments behind a shield of corporate names. Eventually his corporate shields were pierced and he was sent to federal prison, having become one of the century's media whipping boys for the kind of organized crime newspaper and TV "reporters" never attribute to tobacco, gas and oil, pharmaceutical, or military hardware industries and their corporate subsidiaries.[25] Womack, a man of physical and intellectual stature, established an enormous clearinghouse especially for gay literature. By 1970 he faced federal prosecution for distributing the latter (magazines, books, photographs), some of which featured underage boys.[26] Thevis, like Sturman, began with newsstand operations. By the early '60s his publishing and distributing operations were nationwide. His federal prosecutions for transporting obscene materials across state lines began in 1970. He became involved with murder, extortion, and arson charges, and died in prison.[27]

Mail order was an important method of selling softcore, as the ads in the back of many books show. Numerous catalogues crossed the country, especially reaching customers in towns and rural locations without bookstores. Of the many mail order concerns based in East Coast cities, Arnold Levy's World Wide Books was one of the largest. Levy, and many others, took advantage of the "drop-ship" method, of

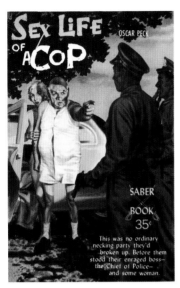

SEX LIFE OF A COP (1959) By Oscar Peck
Saber Books

which Womack was a leading practitioner. Womack would arrange to have his own name and address put on a mail order dealer's catalogue. When orders came in, Womack would make out an address label for each customer, and send it to the dealer with the order and one-half the remittance. The dealer, always grateful for additions to his mailing list, would send out the books.[28]

The Liberty Gift Shop, on Seventh Avenue just south of 42nd Street in Times Square, was a mini-center of secondary publishing and distributing in the mid-1960s. Chris Eckhoff, a vintage paperback bookseller, explains that Liberty's owner, Stanley Malkin, used the second floor of a topless bar he owned as an office for the editing of Unique, After Hours, Nitey Nite, and First Niter Books. Eckhoff thinks that Unique Books' Buffalo, New York address that might have been only a mail, or mail drop, address. It may be, conjectures C.J. Scheiner, bookseller and scholar of erotica, that there was a collaboration between Malkin and the owner of Gordon Books, located north of Niagara Falls near Hamilton in Canada, and thus close to Buffalo. The purpose of this collaboration would have been to distribute secondary market paperbacks in Canada. Malkin may have arranged with WWNC (World Wide News Company), AMD (American Magazine Distributors) or EMD (Eastern Magazine Distributors) to place his books in secondary markets, for these initials, Eckhoff points out, were on the spines of Unique, After Hours, First Niter, and Nitey Nite books.[29]

J.B. Rund, publisher of The Bélier Press, believes that Malkin might have distributed books in collaboration with Reuben Sturman. Sturman had realized by the mid-'60s how much more lucrative erotica was than any other kind of bookselling. He had already seen his warehouses raided in Detroit (1963) and Cleveland (1964). From the Cleveland location, the FBI confiscated 590 copies of Sex Life of a Cop, written and published by Sanford Aday (Saber Books, Fresno, CA).[30] Rund suggests that Malkin may have been Sturman's packager,[31] which means Malkin would have hired the writers and cover artists, had the press work done, and paid salaries. As packager, he would have received a flat rate, and possibly have been allowed to keep some copies to sell.

Malkin had the savvy to conduct successful sex book publishing and distributing operations. Earlier in his career, he ran an important distribution outfit called Satellite, in which Times Square's current smut king, Eddie Mishkin, was a partner.[32] An insider among New York's pariah entrepreneurs in erotica, he knew the popularity of fetish artists such as Bill Ward, Bill Alexander (later on the Hudson News staff),[33] Gene Bilbrew, and Eric Stanton. Bilbrew and Stanton had for years been doing artwork for Irving Klaw's Nutrix bondage booklets, which earned Klaw national infamy when the Kefauver Committee investigating the effect of obscenity on juvenile delinquency questioned him in 1955. These men created for Malkin's typewritten pulps dynamic cartoon-like images, in stark primary colors, which embodied the objects of the voyeur's lust: exaggerated breasts and buttocks, women lasciviously anticipating what the leering men in the pictures might do, women cavorting before male onlookers. Their work, which appeared on covers of various softcore novels, was imitated on adult bookstore posters in the hardcore period. It was an epitome, that is, of the Times Square bookstore and sex emporium, and perhaps of the secondary softcore market generally.

Another kind of softcore publisher was the "fly-by-night" variety. Such a person's books carry no indication of publisher or of publisher's imprint (or "line" or series), except in some cases for a phrase such as "An Original Arrow Reader." Chris Eckhoff has noticed that in some instances, except for the cover, the manufactured object had previously been on the market. The fly-by-night version was a kind of remainder. Its publisher had stripped the book of its original cover and a new one had been glued on, bearing a new title. In some cases a

new title page had been added, but in others there was none. Opening the book, one found the conventional half title (or "ad cart") leaf with a set of blurbs, then the first chapter, on the second leaf. On the final page or back cover is the "printed in USA" statement. The publisher had reissued the work unidentified, as a new line, hoping in this new sub-edition to get some additional return on it. Alternatively, the book may have been the product of someone who was undertaking a pirating gambit, having got his hands on a number of remainder copies of one or more books. A 1965 *New York Times* investigative article discussed yet another kind of "suitcase operator," who had paid to get books produced cheaply by offset in runs of 50 or 60 thousand and "[sold] their output to a distributor for about half the cover price." The suitcase "publisher" had a minimal investment, and probably operated alone, or with one or two accomplices. Their products were sold as single titles to a local secondary distributor. Only outlets like Times Square's adult stores carried them.[34]

Such a book was illegal. State laws required businesses to apply for permission to operate, and corporations to file certificates. Both in these papers and on the manufactured book itself, the publisher or distributor had to identify himself with a valid name and address for tax purposes. The people behind a fly-by-night operation, who dealt only in cash, did not dilute their profits by sharing them with anyone other than the distributor or bookseller. The former would have had a problem if his business records were audited. He would not have been able to identify the fly-by-night publisher by business name or address, and probably would have no invoices or receipts from him.

Many, but not all, secondary-market paperbacks carried the notice "Adult Reading" or "Adults Only" on their covers. They differed in content and production values from mass-market softcore sex paperbacks. Surveying the mass-market and secondary gay-lesbian paperbacks of the '60s, Laurence Miller finds little of the insightful delineation of tabooed sexual desire that made books by mass-market authors popular. Although secondary paperbacks sometimes featured a greater variety of gay and fetish lifestyles, they stressed the titillating and sensationally exotic. In contrast to the mass-market story, the secondary novel heavily favored female characters involved in the lesbian, high-heel, flagellation, and bondage scene who were two-dimensional randy perverts, not sympathetic troubled outsiders. There was little character develop-

ment or social observation. The same lower level of style and theme characterizes secondary sex pulps depicting heterosexual lifestyles. The secondaries were also more likely to have spelling errors, blurred or faint text, flimsy paper, weak bindings, and poorly composed title pages and covers.[35]

When the Lockhart Commission analyzed the secondary sex paperback industry in the late '60s, they found that the market was saturated, and that competition was cutthroat. Many titles were being dumped on discount shelves. There was also great hostility among distributors and publishers alike.[36] The Commission listed 15 secondary-market publishers in New York alone (there were three more in the Los Angeles area). Among these flourishing in 1968, or continuing to flourish then, were Bark Book Distributors, and Star Distributors Ltd. (both with organized crime connections); Overstock Book Company; G.I. Distributors; Interstate Magazine Distributors; and the Olympia and Ophelia Presses (both Maurice Girodias).[37]

III.

In 1965 Robert Redrup, a Times Square newsstand dealer, sold to an undercover policeman two softcore sex pulp paperbacks, *Lust Pool* and *Shame Agent*. In 1967, the ensuing case came before the Supreme Court, which was divided on criteria for obscenity. The Court adopted a policy of reversing without comment all obscenity convictions which reached it.[38] This decision was an open sesame for hardcore. By 1969, softcore sex pulps had been largely supplanted by "fuck books." But that is not quite the end of their story, thanks to a publisher with marketing genius, ideological conviction, and the courage needed to test the limits of public tolerance for sexual explicitness. This was Lyle Stuart, who successfully mainstreamed the adult bookstore softcore paperback. In 1969 Lyle Stuart published the hoax novel, *Naked Came the Stranger* by "Penelope Ashe." A *Newsday* journalist, Mike McGrady, had organized some two dozen colleagues to collaborate in writing a softcore erotic tale that he hoped would become as popular as Jacqueline Susann's breakthrough sexy potboilers. *Naked Came* was initially released in hardback and sold in general outlets.[39] The illusion of artistic and social value had to be present to give booksellers and customers the rationale they needed. The jacket had to be "tasteful," because otherwise the volume would appear to be what McGrady

admitted it really was. He liked the proposed cover art, with its downward-bearing phallic lipstick protruding from its casing. He suggested the addition of a nude woman, with her back to the viewer. Stuart took a chance on the jacket revision. The total effect was artistic enough to transform a pin-up nude into a study of classic beauty that hid salacious content behind a shield of sophistication for discriminating adults. The publisher learned from his bookstore contacts that it was the jacket that sold the book. Men took the book from its shelf, read it, walked away, and then, as they were leaving the store, bought it.[40] Notably, sociologists doing field studies during the late '60s were observing exactly this behavior pattern in patrons of adult bookstores.[41] *Naked* was on the fiction bestseller list in 1969.

Stuart followed the next year with *The Sensuous Woman*, pseudonymously authored by "J." He conceived the book, as he explained to the authoress, as a sex manual for women. Many softcore publishers had entries in this genre. Lyle Stuart Incorporated's would be revolutionary because it would make oral sex "respectable" for Americans.[42] It reached third place on the nonfiction list. Again, the cover art was key. Stuart originally planned to have an open-mouthed woman on the jacket, the colors of which were to be chartreuse and black. But his writer, an excellent publicist, had a better idea. She took Stuart to Bloomingdale's to show him how soap and perfume were displayed for discerning middle-class women. The colors and typeface on the revised, non-illustrated dust jacket suggested "sensuousness, not smut."[43]

Lyle Stuart claims to have "started the sex revolution in [trade] publishing," and tested

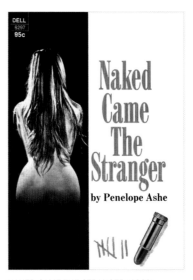

NAKED CAME THE STRANGER (1969)
By Penelope Ashe
Dell

the boundaries that separated entertainment from vice, bringing what had been disreputable 42nd Street stuff into the mainstream. To demonstrate the subtle but powerful effects of creative book packaging, and the weird contrast between the reality of text and the cosmetics of its exterior, one need only juxtapose the covers of *Naked Came the Stranger* and *The Sensuous Woman* with the softcore paperbacks illustrated in the book you now hold in your hands.

Jay A. Gertzman is the author of Bookleggers and Smuthounds: The Trade in Erotica, 1920–1940.

Notes

1. Terrance McKerrs and Fredric Dehn [editors], *The Dirtiest Book in Town: A Bedside Companion for the Sensuous Man and Woman* (NY: The Olympia Press, 1971). Some of Olympia staff writers mentioned in the Acknowledgments are Marilyn Meesky, Lou Caselli, and Michael Menzies. The subtitle is modeled after the bestsellers *The Sensuous Man* and *The Sensuous Woman*.

2. "Part II: Books and Magazines," President's Commission on Obscenity and Pornography, *Technical Report, Vol. III: The Marketplace: The Industry* (Washington, DC: GPO, [1970]), 86–87.

3. I am indebted to editor and writer Earl Kemp, email 17 Jan. 2004, for this insight and for many others regarding the paperback and magazine business, and also to Steve Gertz, email to the author, 21 March 2002.

4. Edward de Grazia, *Girls Lean Back Everywhere: The Law of Obscenity and the Assault on Genius* (NY: Vintage, 1993), 496–504; Kenneth C. Davis, *Two Bit Culture: The Paperbacking of America* (Boston: Houghton Mifflin, 1984), 241–45.

5. Paul I. Montgomery, "Pulp Sex Novels Thrive as Trade Comes Out into the Open," *New York Times*, 5 Sept. 1965, (hereafter abbreviated as NYT).," Felice Flanery Lewis, *Literature, Obscenity, and Law* (Carbondale: So. Illinois U.P., 1967), 192.

6. Lewis, *Literature, Obscenity, and Law*, 193–95.

7. Montgomery, "Pulp Sex Novels," 26.

8. *Peter Campbell Brown, Corporation Counsel of the City of New York, v Kingsley Books, Inc. et al*, Court of Appeals, State of NY, 1955, index number 41983, Supreme Court of the State of NY (clerk's office, 60 Centre St., New York City), pp. 32–35 (testimony of James Rushin, police department detective).

9. Michael Stein, *The Ethnography of an Adult Bookstore* (Lewiston, NY: Edwin Mellon Press, 1990), 73, 113.

10. Richard Kuh, *Foolish Figleaves? Pornography in-and out of-Court* (NY: Macmillan, 1967), 108–10; "21 Face Court in Smut Raid," *New York Post*, 19 Jan. 1961, 8; "Times Square Smut Raiders Nab 22," *New York Daily News*, 19 Jan. 1961, 5; "22 Arrested in Times Square Raid on Smut," *New York Herald Tribune*, 19 Jan. 1961, 18.

11. Ronald Collins and David Skover, *The Trials of Lenny Bruce: The Fall and Rise of an American Icon* (Naperville, IL: Sourcebooks, 2002), 240–41. See "Priest Denounces Smut in Times Square," *NYT*, 6 May 1963, 1; "City Opens Drive on Pornography," *NYT*, 29 Oct. 1963, 1; "Jesuit Begins Fast to Protest Pornography Sales to Children," *NYT*, 28 Oct. 1963, 24; "Mayor's Unit Seeks Pornography Curbs," *NYT*, 30 March 1965, 34.

12. "City Opens Drive on Pornography," *NYT*, 29 Oct. 1963, 1.

13. *New York Herald Tribune*, 6 March 1966, clipping preserved in H. Lynn Womack Papers, Box 2, Folder 11, Human Sexuality Archive, Kroch Library, Cornell U., Ithaca, NY.

14. William Kornblum et al., "West 42nd Street: 'The Bright Light Zone,'" Graduate School and University Center of the City University of New York, 1978, (typescript), 74–76.

15. Richard F. Shepard, "Times Square Home of Unbest Sellers Is Closing," *NYT* 26 Oct. 1965, 47.

16. "2 City Officials Sued in Seizure of Books," *NYT*, 10 May 1963, 17.

17. U.S. House of Representatives, Select Committee on Current Pornographic Materials, Hearings, 82nd Cong., 2nd Session, H.R. 596 (Washington, DC: GPO, 1953), 9–20. Testimony of Ralph Daigh, Vice President of Fawcett Publications.

18. President's Commission, III, 85–86.

19. Barney Rosset, personal interview, 23 Jan. 2001, New York City.

20. President's Commission, III, 76–78.

21. President's Commission, III, 94.

22. President's Commission, III, 94–98.

23. President's Commission, III, 89.

24. Laurence Miller, "Adult-Oriented Gay and Lesbian Paperbacks During the Golden Age," *Paperback Parade*, December 1997 [vol. 47], 42–58 (an excellent checklist).

25. Eric Schlosser, *Reefer Madness: Sex, Drugs, and Cheap Labor in the American Black Market*, (Boston: Houghton Mifflin, 2003), 116–18.

26. Peter Osnos, "Womack Arrested Again as Obscenity Publisher," *Washington Post*, 25 April 1970, Box 1, Folder 1, H. Lynn Womack Papers, Kroch Library, Cornell U., Ithaca, NY; James Griffin, "Dr. Womack and the Nudie Magazines," *The Washington Daily News*, 30 April 1970, Box 1, Folder 2, Womack Papers.

27. John Heidenry, *What Wild Ecstasy: The Rise and Fall of the Sexual Revolution* (NY: Simon and Schuster, 1997), 231–33; "Jury in Racket Case Will Not Be Limited," *NYT*, 21 Aug. 1979, 21.

28. Arnold Levy, personal interview, 23 April 1964.

29. For the information in the above paragraph I am grateful to the following: Chris Eckhoff, "After Hours Books," 25–27, and interview 14 July 2004; Clifford Scheiner, professor (Institute for Advanced Study of Human Sexuality) and erotica collector, interview 25 Feb. 2001; Stephen Gertz, bookseller and author, email 21 March 2002.

30. Schlosser, *Reefer Madness*, 116–18.

31. J.B. Rund, interview 15 July 2004, New York City. Rund's invaluable Bélier Press publications include those on the work of Bettie Page (*Private Peeks*), Eric Stanton (*Bizarre Comix*), and John Willie (*The Adventures of Sweet Gwendolyn*).

32. See Chris Eckhoff, "After Hours Books," *Paperback Parade*, April, 1996, 25–31. J.B. Rund told me (7 May 2003) that Malkin's bar was in the second building to the south of the bookstore; there was a small hotel in between. The Manhattan County Clerk's records show Liberty Gift Shop was opened and incorporated in 1952, and in 1964 changed its name to Forsythe Books. A Request for Business Name form in the New York City County Clerk's office lists Stanley Malkin, and Frank Adler, as owners of The Little Book Exchange, 228 W. 42nd Street, an address associated also with "smut king" Eddie Mishkin, distributor of at least one early edition of the typewritten flagellation booklets *Nights of Horror*, which he was enjoined from selling by New York police in 1955. In 1960, Mishkin's indictment for similar booklets eventually led to a prison sentence.

33. I am grateful to Chris Eckhoff for this information (interview Jan. 2004).

34. Montgomery, "Pulp Sex Novels," 26.

35. "Adult-Oriented Gay and Lesbian Paperbacks During the Golden Age," 26–42.

36. President's Commission, III, 90.

37. President's Commission, III, 89.

38. de Grazia, *Girls Lean Back Everywhere*, 512–18; Lewis, *Literature, Obscenity, and Law*, 196–97.

39. Mike McGrady, *Stranger Than Naked or How to Write Dirty books for Fun and Profit* (NY: Wyden, 1970), 2–3, 22–23.

40. McGrady, *Stranger than Naked*, 93–109.

41. David A. Karp, "Hiding in Pornographic Bookstores: A Reconsideration of the Nature of Urban Anonymity," *Urban Life and Culture* 1.4 (Jan. 1973), 427–51 (see esp. 442–43); William C. McKinstry, "The Pulp Voyeur: A Peek at Pornography in Public Places," in *Deviance: Field Studies and Self-Disclosures* (Palo Alto, CA: National Press Books, 1974), 30–40.

42. Lyle Stuart, "Breaking Through in Book Publishing," *Breaking Through in Book Publishing*, videotape, rec. 22 June 1972, Institute for the Advanced Study of Human Sexuality, San Francisco, CA (reel-to-reel tape).

43. Terry Garrity, *Story of "J": The Sensuous Woman* (NY: Morrow, 1984), 53–54.

STEPHEN J. GERTZ

WEST COAST BLUE

The 1960s began in 1957.

That was the year the United States Supreme Court upheld publisher Samuel Roth's conviction for manufacturing and selling obscene material. The Court rejected Roth's argument that obscenity was protected by the First Amendment.

But in Roth the Court developed a three-part formula for defining obscenity. The material had to appeal to the prurient interest of the average person, violate contemporary community standards, and be without redeeming social value. While ostensibly drawing a line in the sand, most obscenity cases since the 1930s ironically wound up obscuring that line.

In 1966, the Supreme Court was asked again to decide on obscenity. The case was Massachusetts vs. *Memoirs of a Woman of Pleasure* (AKA *Fanny Hill*), which had been wending its way through the appellate process since 1963, when the Massachusetts Supreme Court decided the book to be obscene. Now the U.S. Supreme Court decided that a work could not be proscribed unless it was, in the majority opinion of Justice Brennan, "utterly without redeeming social value. This is so even though the book is found to possess the requisite prurient appeal and to be patently offensive."

Suddenly, community standards regarding prurient interest were trumped by any value whatsoever. The publication of almost the entire corpus of explicit erotic literature became a reality. This was an epochal event, heralding nothing less than the democratization of reading in this country, for this kind of literature had prior been almost exclusively available to the wealthy or well-connected only, printed in small editions and generally cost-prohibitive for the average citizen.

With few exceptions, all porn book publishers of the era marketed and distributed books as they did their magazines: a 30-day shelf life with new titles to turn over every month. The publications looked like books but were actually magazines in book drag. Publishers played the numbers game, with profits based upon aggregate sales for the entire line. Newsstands, drug stores, liquor stores, cigar stores, any place that had space for a wire bookrack, were the primary point of sale.

The dawn of the paperback as a mass phenomenon came in 1939 when Pocket Books published 34 titles at 25 cents each. Together they sold more than a million and a half copies. By 1960, Americans were buying more than one million paperbacks a day. Their sales were, says E.R. Hutchison in *Tropic of Cancer on Trial*, a "godsend to the men who tend the newsstands in a period when magazine sales were sagging."

But "censors rose up like dragons when the first paperbacks were displayed in neighborhood stores," writes Hutchison. "Before the paperback revolution, censors had only some 1,500 bookstores scattered lightly across the country and slightly more than one percent of the adult population regularly patronizing those bookstores to worry about. This widening of book distribution channels to 95,000 outlets brought anguish to brooding censors who vividly imagined day-to-day corruption of children in their neighborhood haunts."

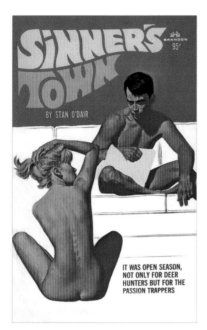

SINNER'S TOWN (1966)
By Stan O'Dair
Brandon House
Cover Artist: Fred Fixler

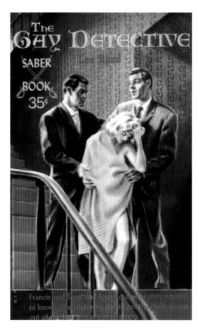

THE GAY DETECTIVE (1961)
By Lou Rand
Saber Books

Secondary periodicals distributors had always featured the marginal and risqué in their product lines, including comics, tabloids, "spicy" magazines, pulp romance, western, gossip, and movie fanzines. When, in the late-'50s to early '60s, distributors were pressured by local authorities to drop sexually-oriented titles from their rosters, many pornographers filled the void by establishing their own distribution infrastructures. And when counterculture publications began to experience difficulties with authorities, many found shelter with porn distributors who shared a common *epater le bourgeois* attitude. Art Kunkin's *Los Angeles Free Press*, for example, was distributed by pornographer Milton Luros' Parliament News.

RABBI PORN

"He's a diffident little guy with a slouch, a comfortable paunch hanging over baggy slacks and wearing a rumpled short-sleeved shirt … a constant bemused smile beneath his slightly crooked nose … continuously jingling keys and coins in his front pocket … [he] never speaks above a whisper, even when angry and more than anything loves reciting Talmudic parables and aphorisms for the benefit and enlightenment of his employees," a former employee recalls.

How did a nice Jewish guy, a *haimisher mensch*, wind up building the biggest, classiest porn operation on the planet?

Born in the Bronx, New York in 1911, Milton Luros began his career in the fine arts. For close to 20 years prior to entering the porn trade, he illustrated leading science-fiction magazines. When the sci-fi market declined during the mid-'50s, Milt began illustrating "spicy" men's magazines, selling work to, among others, Bentley Morris for *Adam* and *Knight* magazines. Morris recalls:

"Milt was a very charming guy, and an intellectual. The first time I meet him, he's sitting in the reception area of our office—this is the late '50s—and he's got his portfolio of art; he's there to sell us some artwork. He's really an artist, a very fine artist. He's got pastels, oils, charcoals; a very, very talented guy. He's like, 'you want erotica? Michelangelo? Whatever you want.' He was an art director in New York. Came out here [Los Angeles], needed work. The best part about it was we didn't have to pay him top dollar!"

This last remark by Morris is telling. Once a highly-paid illustrator, Luros was now hustling for money. In the can-do spirit of American

entrepreneurship, he set out on his own, contacting an L.A.-area periodicals distributor and receiving an advance for printing costs after selling the idea of publishing a high-quality girlie magazine at a time when all had poor production values.

Milt began building his empire. He named his publishing group "American Art Agency" (renamed "American Art Enterprises" in the late '60s). When his distributor ran for cover, Milt started his own secondary wholesale operation, and revolutionized nudist magazines by making them glossy, with attractive models. Then he turned nudism magazines into softcore publications, and made a fortune doing so. Soon Milt established his own printing operations, London Press and Oxford Bindery, and developed the slickest mail order of the industry. He was a corporate finance genius; the stock in his many corporations was held by a real estate holding company trust[1].

Though he played it safe, allowing others to fight the battles before he stepped in, Luros was, as Bentley Morris observes, "the master of the stretch," cautiously and incrementally pushing boundaries. But his caution didn't make much difference: because of his success, Milt Luros became a favorite target for prosecutors. Consultations with renowned 1st Amendment lawyer Stanley Fleishman became so frequent that Milt provided Fleishman with an office in the San Fernando Valley Luros porn compound.

Bentley Morris, who in addition to publishing *Knight* and *Adam* issued Holloway House and Avanti Art Editions, fine reprints of vintage erotica, says of Luros' Brandon House imprint for original erotica: "He did it well, superbly well—his books were fast, entertaining, good writing."

Barclay House was added by Luros for sexual nonfiction, and though many of these titles would stretch the definition of nonfiction to the breaking point, Milt had an in-house fact-checking department to vet every manuscript so that no matter how outlandish, the basic facts would be correct.

Brian Kirby, a young rare book dealer and jazz drummer from Detroit, migrated to L.A. in mid-1965. Soon after meeting Luros and supplying him with a copy of *Candy*[2] by Maxwell Kenton [Terry Southern and Mason Hoffenberg], Kirby joined his staff. Everybody loved Milton, and he paid the highest salaries in the business.

In the wake of the new Supreme Court decisions, Milt allowed Kirby to establish his own autonomous imprint, Brandon House

Library Editions, in 1966. This line reprinted vintage erotica, much of which had never been translated into English. Kirby designed the covers, wrote the cover blurbs, supervised his team of translators, and hired novelists and poets to write Introductions at a time when most industry Intros were written by bogus Ph.Ds to provide the legally required redeeming social value, no matter how tenuous.

Soon Brian pitched Milt on publishing original erotic novels by talented novelists and poets, no pseudonyms allowed. Milt agreed, and Brian Kirby became the Maurice Girodias of American publishing, issuing under the Essex House imprint a series of original American erotic novels. Before he departed the Luros organization, Kirby was in negotiations with The Doors' Jim Morrison for the singer-poet's first book, an erotic original. Alas, the book that got away.

The sales slump that plagued every publisher in the late '60s took its toll. Luros folded Essex House, and Brandon House Library Editions issued reprints of prior titles. With legal pressures secondary to the Miller decision and the business squeeze of shady competitors, Milton Luros sold his company to Paul Wisner, head of Parliament News in 1974; but the shadowy co-owner was Reuben "Ruby" Sturman, the Cleveland-based porn magnate and longtime friend of Wisner. Ruby succeeded in his quest to rationalize the crazy quilt of regional secondary distribution into a smooth-running national network.

DILLIES OF THE FIELD

During the mid-'50s, Fresno, an agricultural community in central California and "Raisin Capital Of The World," had a sociocultural *raison d'etre*: the books of Sanford E. Aday, a failed writer turned publisher and distributor, whose softcore imprints included Fabian, Vega, and Saber.

"Probably no one has given the FBI more trouble in the obscenity area than Sanford E. Aday. Certainly the Justice Department lawyers have had no tougher or more frequent customer on Interstate Transportation of Obscene Material (ITOM) than this man."[3]

The most infamous of his books was *The Sex Life Of A Cop* by Oscar Peck (pseud.), issued in 1959. By today's standards, it is innocuous stuff; by Cold War-era standards, it was evidence of Satan's influence upon American culture. Prosecuted by the Justice Department in 1963, Aday was indicted on

18 counts but convicted on five; of the eight books named in the indictment, *Sex Life Of A Cop* was the only one found obscene under the Roth legal formula. Aday and partner Wallace de Ortega Maxey were both sentenced to 25 years in prison, the stiffest in U.S. history for obscenity.[4]

Aday belonged to the early gay rights Mattachine Society with Ortega Maxey, a retired Catholic priest who became minister of the Universalist Church in Los Angeles (where the Matttachine Society held their meetings). Aday was among the first to openly publish gay and lesbian-themed books.

THE SOLITARY VICEROY OF SMUT

Nobody liked Marvin Miller. A reckless sociopath with a volcanic temper, Miller grew up in the slums of Chicago,[5] where he was first arrested for stealing a doughnut at an early age. Sent to a series of foster homes, it was discovered that he was a genius with numbers. While in high school, Marvin worked at a printing company, learning the mechanics of a business that would serve him later in life.

Barely out of high school, he went to work for Reynolds Aluminum. Within a year he'd made his first million, at the age of 17, by undercutting his employer. When Reynolds couldn't fulfill its contracts due to a strike, Marvin secretly traveled to Cuba, and made a deal with a consortium of Cuban manufacturers to supply them with aluminum. With a letter of credit from Chase Manhattan he made a deal with Hershey's Chocolate to buy their aluminum remnants, and went back to Cuba to sell the goods for a cool million profit, a million he soon lost when his partner looted their newly established household appliances business. Miller sucked it up and emigrated to California in the early '50s, where he embezzled more than $35,000 from his employers at a linen-supply house. After his release from prison, he became a master of insurance fraud, gaining the moniker, "Marvin the Torch." With his silver goatee, Miller was described by Carolyn See in *Blue Money* as looking like "a pleasant, blond Satan."

After his release from prison in 1961, Miller inched his way into publishing with novelty titles like *It's Fun To Be A Beatnik!* But when he came across Maurice Girodias' Olympia Press copyright-free catalog, he saw his opportunity, siring Collector's Publications.

"He prints the shoddiest books of all of us," Brian Kirby said[6] of Marvin, who used the lowest grade of paper available. Miller not only refused to pay his debts on principle, he kept operating expenses to a bare minimum, cutting manufacturing costs to the bone. He worked out of his house, waking every morning at four and editing manuscripts before dropping them off at the printer. Within 11 months, Miller issued 170 Collector's Publications titles.[7] Soon, he was a multi-millionaire.

Said Marvin: "I printed the dirtiest ones first. Apollonaire's *Autobiography of a Flea* [Apollonaire did not actually write the English classic], Pierre Louÿs' *She Devils* [*Trois Filles et Leur Mère*]. The government wasn't even on me yet. They hadn't even noticed. I kept putting the money I made back into the business. If I kept the millions I'd made in the first eight months, before the government got on me and I had to pay it all out in fines and lawyers, I'd be... I'd be a *millionaire*, that's what."[8]

Miller reveled in litigation and infamy. "Here, look at this," he told Peter Collier of *Ramparts* Magazine, holding out a mimeographed page listing a series of porn titles and their publishers. As Collier relates, "It is headed, 'Books On Which Complaints Should Be Filed,' and is handed out by Citizens For Decent Literature, the national censorship organization that is particularly strong in Southern California. With something akin to pride, Miller points to the fact that Collector's leads the list with 49 Books On Which Complaints Should Be Filed; his nearest competitor, Greenleaf, is a poor second with seven."[9]

In 1969, Miller was arrested and arraigned in seven Southern California jurisdictions for violating California obscenity statutes. Prosecutors dropped the charges in six of the communities offended, and ran with the case in Orange County, where Marvin had sent four of his explicit advertisements to a mother-and-son-owned restaurant. Marvin lost, appealed, and in its 1973 decision, the U.S. Supreme Court upheld his conviction on obscene solicitation, but tweaked the obscenity formula, devolving standards to the local level. At this time, disreputable Marvin Miller made U.S. legal history. He also earned a place in our social history with two pregnant footnotes: in mid-December, 1963, he published a quickie JFK assassination commemorative magazine, *Four Dark Days In History*, that contained the Mary Moorman photograph of the assassination with a view of the grassy knoll. When the Warren Commission began its investigation, they relied upon Marv's exploitation rag for evidence.

In the late '50s clandestine labs of Blake Pharmaceuticals medicated U.S. citizens on sleaze: the Chicago-based shell corporation was a mask for the manufacture of softcore porn fiction.

The operation was engineered by sci-fi superfans who became giants in that world: William L. Hamling as publisher, Earl Kemp as Hugo Award-winning editor. Hamling, founder and publisher of Phenix [sic] Publications, Ltd. AKA Greenleaf Publications, and Kemp, his V.P. and Editorial Director, would make First Amendment history on more than one occasion, becoming, as Kemp states with no little satisfaction, "national nuisances."

When the sci-fi market entered a black hole, Hamling established *Rogue* magazine, at the time the only serious competition for Hugh Hefner's *Playboy*. At the time *Rogue*, *Playboy*, and many other men's mag start-ups were limited to newsstand sales; deemed obscene, they were on the Post Office's Black List enjoined from offering subscriptions. Hamling offered subscriptions anyway. The Post Office seized every copy they could get their hands on, and Hamling sued the government for an injunction. Hefner also sued for an injunction in 1957, but Hamling's case wound up in the Supreme Court's docket ahead of *Playboy*'s suit, though Hefner filed earlier. Hamling theorizes that, "by that time *Playboy* had already made its image in the culture and the marketplace, the government undoubtedly presumed that they would have a better chance of victory attacking *Rogue*. So we went to court. We beat the government!" It was a landmark decision, second class mailing privileges were granted, and the magazine was declared not obscene"[10] under the Roth decision guidelines. But legal expenses had put a dent in the company's balance sheet.

Softcore paperbacks, an extension of Hamling's periodicals business, assumed a primary role to generate cash in 1959. His many imprints featured work by up-and-coming and established sci-fi, mystery and romance writers. Harlan Ellison, who wrote *Sex Gang* under the pseudonym Paul Merchant, worked as an editor for Hamling's imprints, not the least of which was Regency Books, a superior line devoted to non-sexual literature featuring titles by Robert Bloch, early Ellison, *Dragnet*'s Jack Webb, B. Traven, Philip José Farmer, Lester del Rey, and many others, including the first edition of Jim Thompson's *The Grifters*.

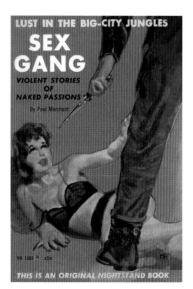

SEX GANG (1959)
By Paul Merchant (Harlan Ellison)
Nightstand Books
Cover Artist: Harold W. McCauley

Hamling distributed through Ray Kirk's Chicago-based All-States News Co., and with titles like *Born For Sin*, *Sin Girls*, *Sin Camp*, *Isle of Sin*, *Sin Cruise*, and *The Sinful Ones*, the books flew off the shelves. Kemp joined Hamling in 1961 as an apprentice editor, eventually inheriting Harlan Ellison's role of overseeing all editorial affairs. And Kemp began tapping "the grandfather of all porn mills ... the original science fiction mill operated by the Scott Meredith Literary Agency" which had switched to soft porn when the sci-fi market dried up. The Meredith soft porn operation began as a clandestine affair with a special mailing address and "black box" shipping cartons to deflect attention from the esteemed literary agency. Meredith collected $2000 per manuscript from Hamling/Kemp, theoretically $1000 to the writer plus a $1000 override for his agenting services, but was, in reality, paying his stable of writers only $500–$800 from the proceeds. "These prices, for 1961," recalls Kemp, "were in the neighborhood of grand larceny," an agent's wet dream.

But a nightmare began for Hamling when in 1961 Attorney General William M. Ferguson of Kansas brought an action against Nightstand, asking that 1,715 copies of 31 Nightstand titles be destroyed in accordance with Kansas law. Fighting it to the Kansas State Supreme Court, Hamling lost, but in 1964 won on appeal to the U.S. Supreme Court, thanks to the efforts of his attorney, Stanley Fleishman.[11]

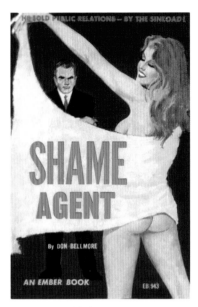

SHAME AGENT (1964) By Don Bellmore
Ember Library

By now, Hamling and Kemp were the number one publishers of softcore porn books in the nation. Forced to make routine payments to local police and public officials in Chicago and fed up with the parade of palms seeking grease, Hamling folded *Rogue* in Chicago in 1965, and moved to San Diego where he reorganized his firm as Phenix Publishers, Ltd., setting up Reed Enterprises, Inc, his own distribution arm.

In contrast to the Chicago years, when Hamling and Kemp routinely used all manner of subterfuge to camouflage their activities, they decided to become as in-your-face as possible after the 1966 Supreme Court obscenity decisions cleared the way for the sexually explicit. But the government hadn't forgotten them.

"At times there were as many as half a dozen competing agencies bugging the lines," Kemp recalls. "At times we could get nothing but police radio calls on our phones. I remember going out to a payphone and calling the cops and demanding that they release at least one phone line for business purposes." The post office routinely seized incoming and outgoing mail, opening it, copying it, diverting it, analyzing it, and, on occasion, delivering it—late. A post office inspector has the right to suppress material simply by notifying the "offender" that what he is mailing is illegal.

And who judges what's illegal? Why, the post office, of course. "It was necessary for us to travel as far as 100 miles to mail routine business mail and even then we could only

use the same post office a couple of times," Kemp remembers.

Though Kemp and Hamling published their share of copyright-free Olympia Press titles, they also printed hundreds of original works. At its height, Greenleaf and allied imprints issued close to 500 books a year.

From July 11 through September 4, 1966, Hamling was tried in Houston, Texas on a 25-count indictment, though he escaped conviction. Stanley Fleishman routinely assigned a local legal ace as defense counsel when clients were in trouble elsewhere. Here, Fleishman hired the flamboyant Texas attorney Percy Foreman, famous for gaining acquittals for clients with gossamer-thin possibilities. Kemp, amazingly, was not part of the indictment; he was, in fact, subpoenaed by the prosecution as a potential witness. "The FBI tried a couple of times to rehearse me in a script they had prepared for my testimony," Kemp recalls. "I asked Percy how to handle it. He said, 'Don't give the FBI cocksuckers the time of day!' And Percy really meant it. They never called on me to testify." The jury hung, a mistrial was declared, and when it was all over the judge told the prosecutor, "Don't you ever bring a case like this before this court again!"

That the jury couldn't make up its mind was testament to the confusing, subjective nature of federal obscenity statutes. The trial cost Hamling $300,000 in legal fees. Partners in Fleishman's office absconded with a sign from the Los Angeles Superior Court's Public Defender's office, which they proudly hung on a wall in their suite, blocking out the "L" in Public.[12]

A year after the trial, Hamling shelled out another $100,000 for legal services. As publisher of *Lust Pool* and *Shame Agent*, he assumed responsibility for Robert Redrup's legal woes in New York State through the U.S. Supreme Court. Legal scholars considered this decision to be the virtual end of book censorship in America.

"Hamling was ecstatic. As he saw it, the courtroom battle that had begun more than 30 years before in the case of United States v. One Book Called *Ulysses*, resulting in a victory for the literary elite, had now ended in 1967 with a triumph for the man in the street."[13]

The business had been sweet for Hamling. A millionaire several times over, he had homes in Palm Springs and La Jolla. He occupied the penthouse suite in Reed/Phenix/Greenleaf's offices. As Brian Kirby reported for the *L.A. Free Press*, "to call it lavish would do it an injustice. His desk is as large as my office. A painting that looks like a Miro hangs behind Hamling."[14]

In the sleepy village of Ajijic, Jalisco, Mexico, Kemp bought a house, turning Ajijic into a South-of-the-border porn Yaddo. Gallons of tequila, good Mexican pot, and lines of coke fueled the festivities. Many of Kemp's writer friends purchased homes there. Twenty-five miles away, Donald H. Gilmore, Ph.D (diploma-mill), AKA "Douglas H. Gamlin" and probably "Dale Gordon," and his wife Betty, established their own porn mill in Guadalajara, moving their work through Greenleaf.

Back in the States, sci-fi writer Mike Resnick, who claims to have written porn under 150 pseudonyms, became a subcontractor, collecting $1000 from Greenleaf, paying his stable of writers $500, hiring an assistant to edit each manuscript at $50 apiece, and another assistant the same fee to type the edited manuscript. When Kemp cut fees to $600 Resnick shifted to producing illustrated photo-porn, buying 100 stills at $400, and novelizing them for $250 more. He even cut typist fees to $25 each. Kemp ponied up $1200 per photo-illustrated manuscript.[15]

Porn publishers, more so than sex researchers, psychologists and psychiatrists, understood the human sexual psyche with singular perspicacity. By the early '70s, Greenleaf, according to Kemp, became number five in number of titles released annually, right behind mainstream paperback publisher Bantam Books.

There was, to be sure, other porn activity in San Diego during the Phenix/Greenleaf era. Don Partrick, a smooth-talking salesman for Reed Enterprises, went out on his own with Publisher's Export Company. PEC was also fed by the San Diego and Mexico porn mills and had an extensive line including Rapture Novels, PEC Giants, Girls Together, Colorful Novels (featuring African-Americans), a male-oriented (gay) imprint, a Narcissus Series amongst many others, not the least of which was Pompeii Press, an imprint devoted exclusively to sado-masochist themes.

The end came for Greenleaf in 1971 when Hamling and Kemp published an explicitly-illustrated edition of the U.S. government's *Report of the President's Commission on Obscenity and Pornography*. Soon after the Greenleaf illustrated edition came to market, the Feds went after Hamling, Kemp, Corporate Secretary Shirley Wright, and corporate controller David Thomas. While a mistrial was declared regarding the publication's obscenity, the four were convicted of pandering through the mails, and Kemp and Hamling endured humiliating and embittering jail sentences. Greenleaf, once known for story with sex, now followed the industry pattern: sex with as little story as possible.

BIRTH OF A PORNSTER

In August, 1965, Hugh A. Jones, a twenty-something living in Boulder, Colorado, picks up a writer's magazine and spots an ad: publisher of adult books seeks new ideas. He responds, and the publisher, Dave Zentner, likes his ideas.

Spanking: Sex or Sadism is the first of 49 sexual pseudo-documentaries Hugh A. Jones writes for Zentner, a bi-coastal character known primarily for his imprints Bee-Line and Century, and many West Coast imprints yet to be untangled. Aside from Bentley Morris, distributor of Zentner's imprints through his All-American Distribution Company (AADC), who asserts that Dave Zentner was "a great raconteur," few have kind words for him. Hugh A. Jones, who wrote for Zentner under the pseudonyms "Harvey T. Leathem, M.D." and "Dr. Sadie Cousins, Ph.D," says Dave Zentner was "a nasty SOB."

According to Jones, Zentner "nursed me through my first four books—meaning he hollered, mostly about deadlines." For the first few years of their association, writer and publisher never met; all dealings were conducted over the phone. Hugh pitched ideas to Dave; if Dave liked them, he gave Hugh the green light. Sometimes Dave published them himself but as often as not laid them off to other porn publishers at a profit.

Soon, Jones began writing for Dick Sherwin, owner of RNS Publishing, distributed through Ed Scheff's Columbia News, a mid-size secondary periodicals distributor in L.A.'s San Fernando Valley. Sherwin published girlie mags and packaged the porn imprints, Venice Books and Private Editions, as well as issuing his own imprints. His operation was "a classy place with photographers, editors, a very professional organization," Jones reports.

Just prior to getting out of the business in 1971, Hugh says he "was bored and went on the Joe Pyne TV show to publicize my writing." Pyne was among the first TV talk show insult-interviewers. On this episode, he provides an example of the cultural hypocrisy intrinsic to erotica: during a commercial break, after unmercifully slicing and dicing Hugh for the last 15 minutes, Pyne jots a quick note. "Here," he tells Hugh, "get in touch with this guy; he pays better."

Sample rant from Sanford Aday's Saber Books' backpages.

CAST THY BOAT UPON THE WATERS FOR THE BREAD

Milton Van Sickle, an editor-writer for Luros, Bentley Morris, and Pendulum Books, heard about an overseas editing job offered by an American in Monte Carlo, Monaco.

Monte Carlo? What's an American porn publisher doing in Monte Carlo?

The short answer is the promise of glamour. After all, Monte Carlo is the city that Somerset Maugham called "a sunny place for shady people,"

The publisher was Jim Stevens, Harvard graduate and high roller. But Stevens knew little about publishing, so he hired as his editor-in-chief Jim Cardwell—a respected writer of mysteries, horror fiction, and ribald short stories, and, ironically, a former teacher of police science. Cardwell was the modern Mephistopheles whose efforts would make Liverpool Library Press the best-selling imprint in the business.

"From 1969 to 1972 I perpetrated some 25 novels for Liverpool Library Press—ten or so solo efforts, the rest collaborations with Jeff Wallmann."

Witness testimony from a latter-day hearing of the House Un-American Activities Committee?

No, the confession of six-time Mystery Writers of America (MWA) Edgar Award nominee Bill Pronzini, who declares that Stevens was involved in a scheme to evade U.S. tax law. Either due to Liverpool Library's profits or those of one of his, as Bill puts it, "quasi-legit ventures," Stevens fled the U.S. in late '69, escaping the IRS's tentacles after establishing, in 1967, the Liverpool Library imprint in Sausalito.

Stevens insisted that his writers move to Europe; their checks were drawn on European banks and had to be cashed there. Stevens paid his writers $1200 per manuscript and often their European rent as well.

When most porn paperbacks were selling an average 32K-40K per title, the books Cardwell produced for Stevens often sold 80,000 copies apiece due to his excellent European distribution. "A great many of the sales were to English-speaking readers in Scandinavia and other parts of the world. Stevens' distribution network was at least as good and maybe better in foreign countries than it was here," Pronzini recalls. Additionally, Stevens was a master of branding: all LLP books had a standardized wrapper design featuring softcore line drawings. Luros and Thevis would copycat LLP with their Bristol Library Press and Little Library Press, respectively.

"We were assigned a 'theme'—incest, mother-son variety," for instance, Bill recalls, "and given strict guidelines: eight to ten chapters, each of at least 20 manuscript pages, each to contain an extended and lavishly detailed sex scene involving one of the obvious variations and two, three, four, or more participants, the last couple of chapters to be an orgy in which everybody takes part. We were also given a two-page style sheet consisting of columns of words and phrases headed 'Turn-Ons' (i.e., to be used often) and 'Turn-Offs' (not to be used at all). These were allegedly the result of a survey of LLP readers but I suspect they came from Stevens' febrile imagination. We were encouraged to use 'fuck,' especially in dialogue; other vulgarisms such as 'cocksucker' were a no-no. Go figure.

"My own favorite 'turn-ons' were the elaborate euphemisms with which we larded our LLPs: 'the hot, throbbing core of her being' and 'his mighty quivering penile member.' Two other things we were required to do: write a scene in which the heroine is briefly ashamed of her sudden plunge into sexual excesses; and write an introduction lauding the 'social relevance' of the novel and containing psychobabble about changing mores and 'neoteric concepts for succor in interper-

sonal relationships' (Wallman's great non-sense phrase). This and every other LLP we wrote, collaboratively or individually, contains a post-coital shower scene and some variation of 'Oh God, oh God, her tortured mind screamed, what have I done! How can I ever hope to overcome this terrible debasement!'"

REQUIESCAT EN PACE

By 1970, the open publication and ready availability of explicit sexual-themed books had lost its novelty: the sales slump of the late '60s; the wholesale move to adult book-shops after local communities legislated pulp porn out of neighborhood retailers;[16] the reduction of strong story elements to a mere skeleton; the acceptance and publication of erotic novels of exceptional literary strength by mainstream publishers; the move away from print media to visual; and the hijacking of the business by organized crime. This unlucky combination tolled the death knell for the golden age of American erotica. Yet there was another nail in the coffin: the edict issued throughout the industry that the serious was now supreme, all humor in pulp porn was now verboten. Throughout the decade, pulp porn writers often reveled in the comic aspects of human sexual behavior. As plummeting print runs indicated, the audience for

A GREENLEAF CLASSIC GP555 ADULT READING $12.50

THE ILLUSTRATED PRESIDENTIAL REPORT OF THE COMMISSION ON OBSCENITY AND PORNOGRAPHY

Introduction By The American Civil Liberties Union.
Dr. Eason Monroe/Executive Director for Southern California

THE COMPLETE TEXT

This 1970 Greenleaf Classics production, with hard-core photos illustrating The Presidential Commission on Pornography helped land editor Earl Kemp and publisher William Hamling in the brig.

pulp porn had dwindled considerably to those interested simply in masturbatory inspiration. The audience had changed and it was no laughing matter.

Stephen J. Gertz is a noted historian and bibliographer of rare erotica, and an antiquarian bookdealer in Los Angeles.

notes

1. Buried in legally mandated circulation notices in his magazines is the fact that Title Insurance and Trust, a Los Angeles real estate concern of long standing, holds the Luros stock in trust.

2. *Candy* had been originally published in Paris by Maurice Girodias' Olympia Press. Because of the Manufacturing Clause in contemporary U.S. copyright law, any book printed outside of the United States did not receive automatic copyright protection. A foreign publisher could, however, receive ad interim protection for five years if the publisher simply filled out a form and paid a small fee. Girodias never availed himself of this protection and as a result virtually every book in his catalogue—with the possible exception of Nabokov's *Lolita*, Burroughs' *Naked Lunch*, and Donleavy's *Ginger Man*—was without copyright protection of any kind whatsoever in the U.S.

3. Roberts, Edwin A., *The Smut Rakers*, Silver Spring, MD, *Newsbook—The National Observer*, 1966, p. 81.

4. Aday and Ortega Maxey did not, fortunately, have to serve their full terms.

5. I am deeply indebted Carolyn See for permission to liberally use early biographical material on Miller from her 1973 book, *Blue Money* (NY: David McKay, 1973).

6. Collier, Peter. *Pirates of Pornography*, Ramparts, Aug. 10, 1968.

7. Collier, *ibid.*

8. See, C., *ibid.*, p. 24.

9. Collier, *ibid.*

10. *Los Angeles Free Press*, June 21, 1971.

11. A Quantity of Copies of Books v. Kansas, 84 Sup. Ct. 1723 (1964).

12. I am indebted to Stephen Rohde, Esq., who was an associate in Fleishman's office, for this golden nugget.

13. Talese, G., *Thy Neighbor's Wife* (Garden City: Doubleday), 1980, p. 400.

14. *Los Angeles Free Press*, June 21, 1971.

15. Resnick, Mike. "How I Single-Handedly Destroyed The Sex Book Field For Five Years And Never Even Got A Thank You Note From The Legion of Decency," Mimosa #26 e-zine, 2001, pp. 19–20.

16. Secondary to the Supreme Court's 1969 Stanley v. Georgia, which legalized the private possession of obscene material but gave license to locals to get the stuff out of the sight of children.

Earl Kemp (no shirt), Gary Sohler (yellow shirt), and Jerry Murray (black shirt) on location in Mexico with a group of models photographing stills for their photo novel *Hang-Up Canyon*. Circa 1968.

MICHAEL HEMMINGSON

AN INTERVIEW WITH EARL KEMP OF GREENLEAF CLASSICS

Earl Kemp edited smut and went to prison for it. For many years he was mum about his days with William Hamling, Nightstand Books, Greenleaf Classics, et al.—from Evanston, Illinois to San Diego, California— but now he has a lot to say. "In 1964, William Hamling discovered California," Kemp recalls in the online memoirs he's been keeping the past few years. "What he found was ... an elite hideout for the elite, a fantasy in anyone's imagination. Here, everywhere he looked, he saw someone he recognized, someone rich and famous and admired ... the more he became addicted to California living, the less we saw of him around the Porno Factory in Evanston.

"Hamling picked out and rented suitable office space for the companies in an industrial complex at 5839 Mission Gorge Road. In 1964, Mission Valley was a bit out of the way, rustic and very agrarian.

"Our sleazy little fly-by-night business, at prime time, was housed in the four-story Mission Square office building in the heart of Mission Valley, directly across I-8 from San Diego Jack Murphy Stadium. We owned the building. We occupied three of the four floors and all extra space was rented out to ordinary respectable commercial tenants.

"In addition we owned a block-square warehouse and shipping facility also located in San Diego. We owned and operated a number of building maintenance-related businesses. We were landlords. We had office space and consultants in a number of major cities in the United States and elsewhere. We owned a healthy mail order company in San Diego. We owned a robust mail order company in Copenhagen. We owned a literary agency in La Jolla. We were partners in general-release motion picture ventures. We owned completely unrelated businesses like Perry Penguin, ten-pound bags of ice cubes in freezers for convenience stores. Bookland, an upscale bookstore front for Hamling in Palm Springs. Numerous upscale residential properties, bought furnished. A yacht. The usual..."

Earl Kemp protesting the Vietnam War while two-handed fishing on the Colorado River.
Photo by Harold Butler circa 1966.

Michael Hemmingson: *The infamous background of Greenleaf Classics—aside from having started off as a SF pulp magazine publisher—is that J. Edgar Hoover set his sights and G-men after the company...*

Earl Kemp: We didn't even have time enough to get completely set up good in our new offices before they started increasing their pressure on us, illegal pressure being used in an attempt at prior restraint of trade, of telling us what we could publish. Hoover was so pissed-off at us that he began a serious crush effort. There was a telephone pole outside my office window less than 100 feet away from my desk. For months, hidden inside a small little tent atop that pole, an alleged "repair man" was working on some really serious problem... for six months or longer. The surveillance became so intense that in order to have a private business conversation, every party to that conversation would gather around the conference table in the editorial office. Our fingers did the talking. One of us would type some important part of the discussion onto a paper and begin passing the typewriter around. After the typed conversation was finished, every sheet of paper was burned and the ashes flushed down the toilet. The typewriter ribbon was disposed of away from the office.

Earl Kemp and Stan Sohler, Baja, Mexico, 1966

Did you have formulas for your writers? What was the average word-length per book?

Most of this came out of serious research conducted by Donald Gilmore in the early 1960s. He undertook the task of finding out how porno affected the reader and then structuring all else to accommodate that. Sales was, after all, the only objective. They were pegged at 50,000 words, on average. There was only one formula for each category of fiction (nonfiction was not included in this but handled separately): hetero, homo, lez, etc.—and it varied slightly for each. It was also a constantly changing formula with those changes being dictated by marketplace reaction and legal edicts. A significant sex scene in every chapter was required, but using the Gilmore psychological activators, it was possible to insert eroticism between the sex scenes. The object was to never let the erection subside.

Was it all work-for-hire or were royalties paid? Did the writers who do well get pay increases on their next books?

Some writers got contracts and royalties, but they were the exception and were worth the extra bookkeeping. Generally, they were not worth that. When we started out, in 1959, we were paying $1,000 for the manuscript and $200 per reprinting. This did not include extortion overrides. We paid as high as $2,000—the rates haven't kept pace with inflation, I notice. As the business boomed, we were inundated with viable manuscripts, so we began a steady process of cutting the price we would pay accordingly. When I resigned from Greenleaf, we had reached an all-time high (or low if you prefer) of $300 per manuscript and we were still rejecting usable ones by the score, weekly, because we simply

couldn't publish any more than we were already doing.

Explain the editorial process for each book— so the manuscripts come in, how involved was the editing? Did you send books back for rewrites? I ask this because if you were doing around 40–50 books a month, where do you, as an editor, find time to deal with that many titles on a day-to-day basis?

The first reader reads everything that comes in, rejects capriciously and out of hand, sorts the remainder into possible good, possible usable, and passes it along to first editor. If they like it, it gets passed on to Editor-in-Chief who usually just rubberstamps the purchase. Almost without exception we never sent anything back for rewrite. At the peak we were doing 50 titles a month. There were somewhere in the neighborhood of 20 senior editors and half that many interns. There were 20 proofreaders. I didn't read them all except for the ones I actually edited, and I edited a lot of them.

How much were the Mafia involved with the sleaze business?

It is almost impossible to tell where the Federal Agent ends and the Mafia takes over. The Mafia had total control of paperback porno by 1973. You couldn't sell a single book that they didn't profit from in some manner. They owned 99% of all the distribution and the retail outlets at the same time.

How much time did you do, and where?

Three months and one day, all at Terminal Island in Long Beach. This was at the time the federal legal bad boy minimum. As things were constructed then, perhaps still, convicted criminals were the personal possession of the judge who sentenced them for three months and one day. At three months and two days, they become property of the Justice Department so the judge has only that much time, that one day, to salvage that criminal from the Justice Department grist mill.

Tell me about it...

Bill Hamling and I were allowed to empty our pockets and give the contents to our wives, waiting forlornly to say goodbye to us for an unknown length of time. Then we were ushered through the back door and down a back

Earl Kemp served as Robert Bonfils' model for the *Dr. Death* series. Corinth Publications, 1966.

hallway and placed into a holding cell. There were as many as a dozen people clustered tightly inside that little cell trying our damnedest not to notice any one of the others. We were there for a long time. Not one of us in that cell could sit down on any one of the benches, nor could we stand anywhere near the walls, or get our shoes on the floor near where the benches were. All of them, the benches, the floor beneath them, the walls behind them, and the ceiling overhead … damn near every inch of space … were liberally decorated with human excrement. Where did it all come from, and when? Better yet, why? Bill and I were shackled together, finally, and removed from the shithouse in lockstep chain shuffle. We had been singled out, from all of the convicts inside that cell, for the obligatory Perp Walk. The television cameras and news people were waiting for yet another look at the convicted pornographers as they slink off to prison.

Tell me about the other inmates.

Terminal Island was a co-educational prison at the time and this was completely unexpected. Everywhere I turned there were females of all types from the gorgeous to the ridiculous, and many of them were active, working hookers. They had pimps, just like on the outside. The whole place, in those days, was awash in drugs of all kinds. It was commonplace to smell pot smoke almost all the time coming from one direction or another. It was also commonplace to use cocaine to help pass the time. The prison was one of the biggest drug and sex parties I had ever been invited to; it

was difficult to tell what was more prevalent, doing drugs or having sex. Various administration officials and guards would bring the drugs in to their special pet convicts who would sell them and give the cash back to their handlers … every day … and they would leave the place with their pockets bulging with $100 bills. And, it's also important to keep in mind that not one of us criminals was allowed to have any cash at any time.

Any famous inmates?

There were many fellow prisoners that I found intriguing, personally, for different reasons. One of them was Sandra Good, one of Charlie Manson's groupies, a spoiled rotten rich kid from San Diego. It was perhaps that background, of San Diego, that made the connection, plus my enormous curiosity about a man like Manson. And, there was another attraction as well: Sandra was one hell of a good looker, and I responded to her positively and wanted to know more. Only she wasn't having any of anything … Manson had so controlled her that she couldn't see any other man but him. Another of my special friends was Sarah Jane Moore, known as Sally in the joint. She was the one who, being controlled by the FBI, tried to kill Gerald Ford. I constantly chastised Sally for being too late and missing an appropriate target—"The Evil One." Only Sally wasn't much for humor.

Michael Hemmingson lives in San Diego and has written novels like The Comfort of Women, House of Dreams, 66 Chapters about 33 Women *and* Wild Turkey. *He recently co-edited* Expelled from Eden: A William T. Vollmann Reader.

DONALD E. WESTLAKE

In those wonderfully sinful early days of sleaze, Donald E. Westlake was one of the original prime movers, courtesy of the Black Box Happy Pornographers. Some of the Black Boxers were occasional staffers of Scott Meredith Literary Agency, and others were new-hires, signed on with great expectations as Future Great Writers To Be. Hal Dresner was one of the gang, and so were David Case, Evan Hunter, John Jakes, Arthur Plotnik, Milo Perichitch, Lawrence Block, Dave Foley, William Coons, and William Knoles.

I was one of Westlake's editors at Nightstand Books in Evanston, Illinois, in the early '60s. He has been quoted as saying he wrote 28 sleaze novels as "Alan Marshall" (or his twin, "Alan Marsh") during those years. All efforts toward identifying those 28 books have proven to be futile; Westlake professes to have forgotten everything he knew about any of it. Donald Westlake should be proud of every one of the sleaze books he wrote, and help reclaim them.

I asked Westlake to share his anecdotes. Instead of information, he gave me permission to quote the compulsive things he had to say on the subject in *Adios, Scheherezade* (Simon and Schuster, 1970):

> What the heck am I doing? I put the paper in the typewriter, I typed the number 1 midway down the left margin. I quadruple-spaced, I indented five, and then I was supposed to write the first sentence of this month's dirty book. So what do I think I'm doing? I'm sitting here typing nonsense, I'm supposed to be typing sex.

> He explained what I was supposed to do. There was a formula and a system. There was practically a blueprint. It was the closest thing to carpentry you can imagine. As a matter of fact, I don't see at all why I couldn't write up the formula and sell it to *Popular Mechanics*.

> This typewriter uses the smaller size type, elite type, and five thousand words in elite type runs fifteen pages. My manuscripts are exactly one hundred fifty pages long, my chapters exactly fifteen pages long. I do one chapter a day for ten consecutive days, and there's another book. I was a pretty fast typist before I started doing these books, and I'm a faster typist now, and after the first few books the formula made things very easy for me, so I work an average of four hours a day when I'm doing a book, for a total of forty hours. My pay is nine hundred dollars, and that's twenty-two dollars and fifty cents an hour.

> ... I'm sort of a pornographic Kukla, activated by the hand of the masturbating high school boy, piping rotund obscenities into his waxy ear.

> Nobody can do this shit forever.

> You look at the typewriter one day, and you say to yourself, I don't *want* to write about people fucking. I don't want to write about people going down on each other, I don't want to write about people fingering themselves and each other, I don't want to write about all those deadly dull preliminary conversations ("I just arrived in New York today," she said, laughing self-consciously). I don't want to write pointless stories about pointless people who live in a gray limbo of baroque sex and paper-thin characterization, I don't want to *do* this shit any more.

LAWRENCE BLOCK

Lawrence Block was 19 years old when he began his career writing pornography (as Andrew Shaw) for Henry Morrison inside one of Scott Meredith's notorious Black Boxes.

In "If Memory Serves...", Lawrence Block's Introduction to his short story collection *One Night Stands*, he wrote,

> For God's sake, when I wrote [this] my type-writer still had training wheels on it.
>
> I was writing books, "sex novels" was what we called them, though they'd now get labeled "soft-core porn." I wrote one to order the summer before I returned to Antioch, and the publisher wanted more. So that's what I did instead of class work. And I also went on writing crime stories. At the end of that academic year, in the summer of 1959, I dropped out again, and this time it took. I started writing a book a month for one sex novel publisher [Nightstand Books], and other books for other publishers, and from that point the crime short stories were few and far between.

Early in 1961, when I began my tenure at The Porno Factory, one of my first tasks was checking the proofreader's marks against the revised book pages for *$20 Lust*, by Andrew Shaw (NB1546, 1961; cover painting by Harold W. McCauley). It was my first encounter with that famous writer of yesteryear but far from my last. At the time, I didn't even know that Shaw was only a pseudonym hiding Lawrence Block from his soon-to-be-waiting fans. That was a secret Scott Meredith wanted to hold on to as long as possible, a misguided effort to protect his Black Box pornography writers from the world at large, and to hide his personal shame at being involved with that market himself.

I recognized right away that Shaw's were noticeably better than those coming from his contemporaries who had coalesced into a social club they called "The Happy Pornographers."

$20 LUST (1961)
By Andrew Shaw (Lawrence Block)
Nightstand Books
Cover Artist: Harold McCauley

CINDERELLA SIMS (1973)
By Andrew Shaw (Lawrence Block)
Nightstand Books
Cover Artist: Robert Bonfils

Lawrence Block's famous Wanted Poster photos.

Lawrence Block used a better grade of typing paper than most of the other writers; his manuscripts were very easy to spot because of it. He had nice wide margins all around each page with lots of room for the editor's eyes to read the words and his pencil to write in whatever was needed. He was a pretty good typist too, and made relatively few strikeovers. And he took the time to correct some of his typos. The only negative I can recall is that occasionally Block would stretch his typewriter ribbons beyond endurance.

Working a Block manuscript, for an editor, was relatively easy. The big stack of reasonably typed pages seemed to dwindle before the editor's very eyes. Hundreds upon hundreds of same-formula sleaze books passed through my hands and, always, Shaw's were among the very best written and frequently the best selling ones, too.

Block grew too good for that field and moved on to bigger and better novels and publishers. And to very wide recognition and acclaim.

Lawrence Block makes me swell with pride every time I see something new, better, damn near best originating from him. Larry isn't alone in that special spot, of course. His company includes Ed Westlake and Hal Dresner for sure, and Bill Coons, and everyone who ever had a hand at trying to be Andrew Shaw. Sort of like having a whole bunch of neglected children who have managed somehow to not only survive on their own but to soar to relative greatness among their contemporaries.

Now, for your reading pleasure, here is Andrew Shaw writing a vicarious sex scene

snipped from *Cinderella Sims* (RN3034; cover painting by Robert Bonfils):

It was time.

And then it began.

I've already said it was good, and that's about all I can say. It was the beginning and the end of the world. It was a pair of bodies drawn to one another like magnets, clutching and clinging, working rapidly and relentlessly, making moves and seeing stars and breaking records.

"Ted, I love it. Ted, I love it I love you I love everything!"

I loved everything, too.

And it got better and better and better, and it got faster and faster and faster, until it had to stop or it would almost certainly have killed us both.

Then the explosion came. The earth began to tremble and shake, and guns went off and rockets shot up and satellites went into orbit.

And so did we.

DONALD A. GILMORE

Donald A. Gilmore, Ph.D. was the Godfather of Sleaze Paperbacks. While there were some questions as to the legality of his doctorate, there were never any doubts as to his accomplishments. Responsible for more people becoming sleaze hack writers than anyone else, Don was the Johnny Pornseed of beatoff book professionals.

In glorious yesterday Guadalajara, Don and Betty Gilmore set up a pornography empire. He accomplished impossible things in no time at all and had the world's very best connections to anything he could ever think of needing. I often thought there was some deep, dark secret actually lurking behind the façade of the man who had become my best friend. There were too many little oddities like being on the last plane out of Havana, under gunfire, when Castro kicked the bums out.

It was Don Gilmore who not only insisted that I needed a house in the Guadalajara area but he located the right one for me, walked me through the lease to acquire it, and supervised the renovating construction crew in my absence. It was heaven just waiting for me to move into Camelot for several seasons of glorious sin.

When I was with him in Mexico, abruptly, without any forewarning, Don rushed off for a month-long tour of Argentine automobile assembly plants and returned to Mexico in love with German efficiency. And then there was the oddest thing of all, Gilmore's sudden return to the States after becoming a very successful businessman and entrepreneur in Guadalajara.

Gilmore wasn't a partying type like most of the writers; he was compulsively driven to be a workaholic and innovator. He spent most all his time hobnobbing with Guadalajara's native elite, his "best friend," the U.S. Counsel to Guadalajara, and prominent businessmen.

For the better half of the 1960s, Gilmore held forth as one of the largest pornography providers in the business from the biggest, most pretentious house he could lease in Guadalajara. His creative writing school produced such sterling professional writers as Leslie Gladson, Vivien Kern, and Lee Florin, among others.

In his spare time, he turned out travel guides like *Mexico on $5 a Day* and huge coffee-table picture books on needlepoint and fashion. He had quite a personal collection of antique pornography and wanted to display it to his best financial advantage. For Greenleaf, Gilmore produced a series of large, heavily illustrated, semi-technical fact books that were tremendous sellers. He focused on a four-volume set of eight-page comic books ("the kind men like") and a couple of related spin-off volumes. He wrote Ph.D. introductions—under numerous doctor pseudonyms—to a large number of books, and, from his Guadalajara porno mill, regularly furnished fiction manuscripts to most of the publishers working within the genre in New York as well as on the West Coast.

When things like this were seemingly impossible, a huge Mexican moving van and crew appeared at the Gilmore residence in Guadalajara. They carefully packed everything in the house, loaded it into the van, and drove that van straight across the international border without pausing and on to San Diego, where the Gilmores had acquired a new residence (big, elaborate, and pretentious).

Even the CIA couldn't pull off a stunt like that, and I tried my best to find out why and how it had happened, but Don wouldn't tell me. He said, "I had to return to San Diego so I could give you the biggest damned going-to-prison party there ever was. I mean it literally; invite everyone you know."

And he did, and I did. For the first time ever, all my friends gathered up together into the Gilmore's impressive mansion near downtown San Diego. There were writers, editors, artists, photographers, and models. There were auto mechanics and delivery persons and professors and most of the office staff and their partners and lovers. There were lawyers and hookers and an undercover cop or two.

I lost contact with the Gilmores in the mid-'80s somewhere in suburban Chicago and have spent much time and effort trying to relocate them, unsuccessfully. Wherever they are I would like to make sure they know that I know that they changed my life permanently and much for the better.

Don, Betty ... forever in my heart...

Alan Marshall

Seaport Stud

ROBERT BONFILS

Robert Bonfils was the world's greatest paperback cover artist, only no one noticed. Decades later, with all his accumulated work at hand, the fact is undeniable.

He grew up in Kansas City and went to the Kansas City Art Institute, where he was taught by Thomas Hart Benton. His classmates were people like Bill and Jim Teason, Ken Riley, Jackson Pollock, and Harry Feldman. He did a stint in the Army then moved to Chicago and continued his studies at the Art Institute of Chicago.

He finally landed a job at the prestigious art agency of Stevens, Hall, Biondi, and his real education began. The staff of artists there were about the best in town, some the best in the country. They undertook the hands-on task of completing Bonfils' education and turning him into first a professional commercial artist and second the world's greatest paperback cover artist to be.

Here he did covers and illustrations for children's books, covers for Mercury record albums, and ads for Miller High Life beer.

Eventually Stanley Schrag of Playtime Books and the brothers Sorren of Merit Books all discovered Bonfils, and he began painting his first paperback covers for them.

When Harold W. McCauley retired from Nightstand Books and moved to Florida, William Hamling hired Robert Bonfils to replace him, with a big difference. He was to move to San Diego and help set up an entirely new publishing operation. Bonfils was the Art Director and I was the Editor-in-Chief of what was to become Greenleaf Classics.

Since both of us were moved from Chicago to San Diego at the same time, we were thrown together quite a bit, although we had never known each other while we lived in Chicago. We became best friends instead of coworkers and began spending almost all of our free time together; after all, we didn't know anyone locally. We partied together,

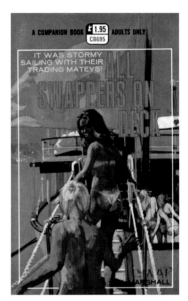

ALL SWAPPERS ON DECK (1970)
By Alan Marshall
Companion Books
Cover Artist: Robert Bonfils

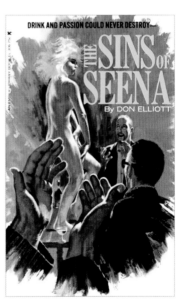

THE SINS OF SEENA (1965)
By Don Elliott (Robert Silverberg)
Ember Library
Cover Artist: Robert Bonfils

SEAPORT STUD (1967)
By Alan Marshall
Candid Reader
Cover Artist: Robert Bonfils

Robert Bonfils on his sailboat anchored in Ensenada, Mexico, harbor.
Photo by Earl Kemp, November 1967.

dinnered together, vacationed together, the-atered together. We bar-hopped all over Tijuana together ... we were soulmates, if not twins.

Bob was adventurous in those days, and had lots of things to catch up with that he had earlier repressed, like camping in gorgeous, remote locations. He had all kinds of maps showing locations of former Indian villages and we would prowl them, harvesting arrow-heads, beads, and pottery shards, all over San Diego County and way into Mexico as well.

Bob bought a huge parcel of land in East County San Diego that became a wonderful hideaway. There were huge rock boulders to play on and ancient trees providing abun-dant shade. The pride of the area was a huge private pond, the new home of skinny-dipping. Wild animals and birds galore, fra-grant blossoms from native wildflowers ... the perfect reflecting place.

Another of Bob's requirements was a big sailboat, a really big sailboat. Its record log said that it had sailed on numerous occa-sions to exotic ports in Hawaii and Tahiti, in its lifetime ... everything that Bob secretly wanted to do himself.

We had some delightful times on board that ship, far out to sea, knowing not what we were doing. There were half a dozen of us pretending to take on the task of sailing, while drinking, smoking Indica, and pretend-ing to fish. We would dock in Ensenada Harbor and go to town for liquor.

The boat was stocked with empty booze bottles. On each trip to Mexico, we would fill all of them with the same type of liquor the bottles once held, then sail back to the U.S. with one of the best-stocked bars in town, at a fraction of the local cost. On one occasion,

the U.S. Coast Guard approached us well into Mexican waters. As they were climbing onto the boat, some of us were dumping weighted-down pot overboard on the opposite side.

Once, on vacation in Ensenada, we couldn't get a hotel room anywhere in town because of some convention. We spent hours looking for a place to stay and even began offering bribes for rooms. Finally, a kind desk clerk told us that we could probably rent a room at a bordel-lo. It turned out to be a huge old hotel just at the edge of town in a residential neighbor-hood. It had once been a thing of great grandeur and delight, but was falling to debris by the time we reached it. Bob and I spent time examining the structure, most of it board-ed up and off-limits, lusting for the stained glass windows, the wallpaper, the crystal chan-deliers, and the hardwood floors in several grand ballrooms. The girls of the establish-ment kept busy all night long running up and down the hotel corridors and giggling.

Busy with what we were doing at the office, we never noticed just how superb an artist Bonfils was. At our peak, we were producing 50 paperback novels every month and one skin magazine every day. It is hard to imagine that today: producing 50 novels a month, painting 50 cover paintings a month, and all the while living and playing and enjoying life.

Posing for some of Bonfils' better covers was a pleasure and just one fringe benefit of being the boss.

Robert Bonfils is retired now, but he still paints in his studio every day. He concentrates on fine art and commissioned portraits and on recreating, to order, his staggeringly beau-tiful original cover paintings from the past.

LINDA DuBREUIL

Linda DuBreuil was the reigning queen of pornography in the 1960s. Under numerous pseudonyms, she provided several book-length manuscripts for numbers of publishers every month. It has been estimated that she wrote more than 300 novels during those years. Linda did all of this on her own, without an agent, eventually becoming the star producer for a number of publishing concerns. She bore her crown nobly, telling everyone that if they want to be writers they have to do more writing and less partying.

Female erotica writers were decidedly in the minority. In the pre-pulp days, in France, Iris Owen made quite a name for herself writing Traveller's Companion books as Harriet Daimler. Scott Meredith's Black Box pornographers didn't include a single woman writer, but Marilyn Goldin ghosted eight "Alan Marshall" books for Donald E. Westlake. Contemporary female writers like Marion Zimmer Bradley (AKA "Miriam Gardner," "Marlene Longman," "Morgan Ives," "Dee Chapman," "Brian Morley," "Dee O'Brien," etc.), Diana Butts, Norma Erickson, Vivien Kern, Rosemary Whiteside, Peggy Winter, etc. also toiled regularly for the sleaze gristmill, but Linda DuBreuil outpaced them all.

For a few short but glorious years, Linda and I were neighbors in suburban Guadalajara, Mexico. She was such a delightful person we instantly abandoned the book writer and book buyer relationship and got down to the basics of friendship, and the real Meaning Of It All.

I liked her the moment I saw her; before an hour had passed, I was hopelessly in love with her. She was a fireball of energy and nonstop fun. She was the life of every party she ever went to and the hostess with the mostest whenever it was her turn to shine. She had perfected a talent that kept most people she encountered in awe: Linda could roll absolutely perfect joints using only one hand, and was frequently called upon to demonstrate her talents.

But she had another talent besides writing that I liked much better, and grew to anticipate and to lust after with a mighty hunger. Linda also was the world's best pie maker.

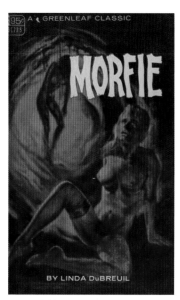

MORFIE (1967)
By Linda DuBreuil
Greenleaf Classics
Cover Artist: Robert Bonfils

SEX ON ST. JAMES STREET (1968)
By D. Barry Linder (Linda DuBreuil)
Greenleaf Classics
Cover Artist: Harry Bremner

Linda DuBreuil and her son John Eric
Poling, who wrote under the name of
Eric Jay. Albuquerque, NM, May 1979.

Jerry Murray on a camping trip in Mexico
circa 1966. Photo by Earl Kemp.

She would take over the entire kitchen, and make pies to die for. They were so good, I finally asked her to give me lessons.

I always felt very privileged to be in the kitchen with Linda, hers or mine, with her face smeared with flour and fruit-pie filling, idly passing the time of day.

Because of Linda's appearance and vagueness of age, she found ways to use both to her advantage. One of her favorite routines, and one she loved to tell at length to an appreciative audience, is the one about hassling porno store operators. Linda would burst into adult bookstores condemning everything like Carrie Nation, berating the proprietor and clerks unmercifully. Then she would break into peals of laughter and confess to putting them on. She would point out her own books with real pride, and autograph them for the clerks and customers. They would take her to lunch and figuratively carry her around on their shoulders—the Queen of Pornography at the top of her form.

Over the years that I knew her, Linda wrote under many pseudonyms. The one I am most proud of, though, is the name D. Barry Linder.

I created that pseudonym, a simple play upon her real name, which helped perpetuate the myth that Linda was a male named D. Barry Linder who wrote occasionally under the female pseudonym of Linda DuBreuil. Of her writing, I have heard said more than once, "She has to be a man, no woman can write like that."

Linda's son, John Eric Poling, also lived in Jalisco and wrote sleaze books under the pseudonym of Eric Jay. In his own right, Johnny was very special. He was conducting some experi-

ments in peyote and other native substances that were delightful to participate in.

Together, Linda and Johnny gave a monumental party at their palatial estate just outside Guadalajara. It was a lawn party, spilling out of an elegant landscaping dominated by a huge hole. A pit, actually, containing the remains of a long and eventful fire and a gloriously roasted pig.

Linda's books were always great sellers for us and we went out of our way to promote them. Harry Bremner would do a fantastic design or Robert Bonfils would paint one of his masterful covers for each of them.

My personal favorite was Morfie (Greenleaf Classics GC225, 1967, cover painting by Robert Bonfils). I felt proud to publish it, and was pleased, to discover that Linda also favored it. In her autobiography, The Girl Who Writes Dirty Books (Leisure Books LB2250K, 1975), Linda described how thrilled she was when I bought the manuscript from her.

Writing about herself, Linda said, "I can't live without writing and it must have been difficult indeed to live with a woman who gave the impression that the typewriter was more important than the company of a husband..."

Writing about me, Linda said, "I have enjoyed a beautiful friendship with this man over a span of several years."

Linda my dear. I love you, too.

It was a sad day for me when the DuBreuils decided to move back to the States and reluctantly began disbanding their household. Linda, Frank, and Carolyn moved back to French Lick, Indiana, a town whose name has always given me much secret joy even though I've never been there.

JEROME MURRAY

For decades, Jerry Murray, one of the least-known best-selling writers, plowed the fields of professional hackdom, turning out books on cue for all takers. He used many pseudonyms over those years and almost every one of them was chosen with humor in mind.

It's hard to think of Jerry (Jerome, formally) without humor. He's the one who tosses it into every situation and every anecdote.

I can't recall when or how we met, only that he was a producing writer and I needed him in a bad way, but not as much as I would have ever suspected.

Jerry and I often prowled the four-wheel-drive backwoods of San Diego County and Mexico, drinking tequila and passing joints and telling lies.

Jerry has a special place in my book; he is one of the people I talked into making the fateful migration to Mexico. One of my first neighbors in Ajijic, Jalisco, Mexico, Jerry and I kicked back with endless weed and cut-rate booze and pennies-a-day help and the prettiest skies anywhere, all spread out along the shoreline of an incredible lake. We had the time of our lives together, doing Guadalajara and being done by it in return.

In the middle of nowhere, every day, regardless of how much tequila and mota had been consumed, Jerry would excuse himself, climb into the back of his VW van, grab his manual typewriter, and go to work. Religiously, routinely, so many pages every day. Nothing else was ever allowed to interfere with the writing, with the livelihood, with the steady checks pouring in response to his fantastic discipline.

Jerry was one of the great pornographers; you could always depend upon him to deliver the exact manuscript you were expecting and on time. If you didn't watch closely, you could even find yourself walking through his novels as a character—a bad character, of course, but recorded forever within Jerry's sleaze-book repertoire.

He was at his very best, and blossomed into spontaneous exuberance once I teamed

LAURA'S TRAINING CAMP (1972)
By Ray Majors (Jerome Murray)
Nitime Swapbooks

him up with Gary Sohler (a second-generation pornographer, son of Stan Sohler, who packaged skin magazines for Milton Luros). Gary was a well-known Los Angeles nudie photographer. The two of them became electric and rushed off into a series of photo novels that sold like hotcakes at a church bazaar.

Jerry would work out a rough script and turn that over to Gary, who would hire models, pick locations, etc. If they worked it right, they could get as many as two books out of one day's photography. And that included driving models to the locations, some of them way into Mexico. The finished book would be half text and half pictures with the close-up still photography keyed into the text action.

Within erotica, Jerry was equally at home writing straight or gay novels, from any viewpoint and involving any reasonable number of players. Still a San Diego resident, Jerry has retired and is now writing his memoir.

WILLIAM KNOLES

William Knoles in Puerto Rico circa 1968.
Courtesy Lynn Munroe Collection.

Under the pseudonym Clyde Allison, William Knoles created Trevor Anderson, 0008. He was the best writer I ever worked with.

Knoles is best known for the sleaze satires of James Bond, the 20 eagerly sought-after *Man from Sadisto* paperbacks published by Greenleaf Classics. Sporting hand-lettered titles by Harry Bremmer and stunning covers by Robert Bonfils, the 0008 series is the sparkling crown of the entire sleaze paperback period, from all producers combined. The last complete set to sell at auction went for $5,000.

William Knoles was a science fiction fan, novelist, and satirist. He was a Scott Meredith/Richard Curtis staffer and client, a big-time partier, heavy drinker, recluse, and bi-polar extrovert/introvert. He killed himself to escape his half-evil twin self.

It was my good fortune to be Bill Knoles' friend, confidant, and dare-I-say mentor during those turbulent '60s and '70s. He was the first of many "secret" Black Box Happy Pornographers overseen by Scott Meredith whom I knew and worked with.

He was a spectacular standout as a writer, and he quickly came to the attention of every editor in the Greenleaf organization. Everyone wanted to be Clyde Allison's editor. The need became a real problem around the office and we had to transfer Clyde from desk to desk to make sure everyone had an equal amount of time fondling each manuscript and working their way lovingly through the pages. Now and then, manuscript pages waving in the air, one of the editors would rush out of their room and loudly announce, "You've just gotta hear this..." and proceed to read Knoles excerpts aloud in fits of giggles, gasps, and delight.

Bill and I communicated regularly when he was living in a remote location in Massachusetts that was reached by telephone. I admit using him shamelessly for my personal benefit. Every time I was feeling depressed, all I had to do was to grab the phone and call Bill. The sound of his

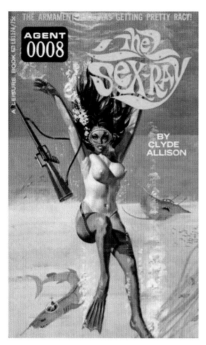

THE SEX RAY (1966)
By Clyde Allison (William Knoles)
Leisure Books
Cover Artist: Robert Bonfils

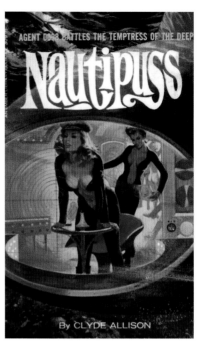

NAUTIPUSS (1965)
By Clyde Allison (William Knoles)
Ember Library
Cover Artist: Robert Bonfils

voice, the feel of his intellect, the presence of his humor was all it took. In two seconds flat I was laughing my ass off.

I have to admit that I was not aware of Bill's bipolar disorder; he hid it from me so effectively. There were times when he wasn't as funny as usual, or I couldn't reach him for a while, but didn't think anything unusual was going on. I thought he was one of the happiest, best-adjusted people I knew. Appearances and actions often hide the direst personal plagues.

Knoles and I worked out the general plan for the 0008 series together. Initially, we thought of him as 069 to further complement James Bond, but we tossed the idea aside as soon as it became unhandy. Finally, we settled for "triple ought eight."

Eventually every editor in the firm made additions to the mythology and suggested characters, plots, or satire titles. We did much of this via the telephone but also through correspondence. I've always had the feeling that those documents, should they ever surface, would make one hell of a good editor/writer treatise.

Bill's bipolar disorder peaked just before Christmas 1972, and he took the shortest route to freedom. Lynn Munroe described Knoles' departure this way:

"Bill Knoles, who loved parties and people, was alone. Bill Knoles, who hated the cold, was alone on Cape Cod, freezing in December. Perhaps he realized that we are all of us terribly alone in this world. We surround ourselves with family and friends, but at the end, in the dark cold times, the long December nights, we are so alone. Sometime on December 20, William Henley Knoles put his pocket money and Social Security card on a table. He took a warm bath. In the bathtub he slashed his throat open with a razor blade. Somehow he found the strength to do it again, since the coroner's report tells us he had 'deep neck lacerations.' Plural. The cause of death is 'exsanguination.' In layman's terms, he bled to death."

Then, to make matters worse, his sister got so pissed off at him that she deliberately went through all his possessions, making sure she burned every scrap of every letter in every file, every manuscript page, finished or not… everything on paper belonging to Bill, his creations, and his past.

ED WOOD

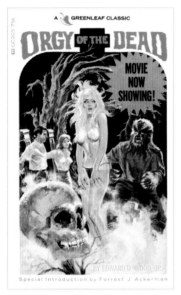

ORGY OF THE DEAD (1966)
By Edward D. Wood Jr.
Greenleaf Classics
Cover Artist: Robert Bonfils

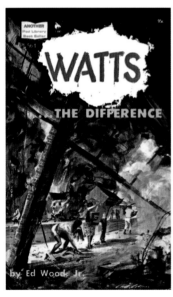

WATTS...THE DIFFERENCE (1967)
By Ed Wood Jr.
Pad Library

Everyone knows about the man who made those awful movies years ago, but not too many people know Edward D. Wood, Jr., the famous sleaze book writer.

Ed Wood phoned sometime in the 1960s and told me that he was going to be in San Diego and wanted to get together. Vaguely amused at the prospect, I invited him to come for lunch.

When the scheduled time arrived, so did Ed Wood, along with his friend Criswell. They erupted into the office reception area in a flutter of flapping wings and billowing, twirling capesmanship that was enough to rival an entire ballet troupe.

Criswell was ablaze in heavy layers of theatrical make-up that made him look like a circus clown. His clothes were almost threadbare, but were meticulously maintained as if they were the remnants of a once-great wardrobe. Criswell had a remarkable voice, almost mesmerizing in its intensity. He could use it with real force and easily project it across an entire restaurant, causing every head to turn and admire the professional at work. Then, just as quickly, he would lapse into an almost childish glee, once he knew he had them in his hands.

Ed Wood was similarly attired in well-worn clothing, only he wasn't nearly as flashy as Criswell. If he didn't talk or show his panties, he could pass for an almost normal person with no trouble. But he didn't look nearly as good as Johnny Depp.

Now that they were inside my office, I realized that I had a new problem on my hands. In those days I was still a bit square and reserved, easily embarrassed. Wood and Criswell were doing a heavy trip on me. I didn't dare take them to a restaurant I routinely frequented. Part of my duties was to take visiting dignitaries to lunch, and I could not easily convince myself that the two clowns performing in front of me were visiting dignitaries.

In hindsight, I would have treated Ed Wood and Criswell like dear friends and had taken them to the restaurant where I entertained *real* visiting dignitaries. They deserved it then and they deserve my acknowledgment of that now. Only that was then, and I

hunted down a restaurant where I wouldn't be seen as they went into one of their attention-garnering routines.

They were fantastic together, moving like a well-oiled machine, empathically communicating and finishing the other's sentences. I didn't know whether to be scared or amused. Fortunately, amused won out, and I didn't miss out on one of life's rare moments … sharing in fleeting touches of greatness.

Ed Wood was noted for wearing female garments, especially things that feel fantastic against the skin, like silk panties and cashmere sweaters. Every time I saw him, without fail, even though I wasn't interested, he would tell me what female garments he was wearing at the moment, in case they weren't visible (like nylons). He would also offer to show me that he was really wearing them, especially the panties; he always wanted to show off the panties. I managed to avoid the exhibition somehow.

Both Wood and Criswell (I never saw Wood without Criswell) made a special trip to see me just to pick up his check every time it was possible, and to have lunch with an audience. When I handed Ed Wood his first Greenleaf check, time froze. He looked at it in disbelief, then broke into a big grin, doing a quick two-step dance in excitement. I guessed that the $500 check represented the largest amount of money Ed Wood had seen at once in a long time. (1966 dollars went a long way.)

Wood wrote the text portion of *Orgy of the Dead* (Greenleaf Classics GC205, 1966, world-class cover painting by Robert Bonfils), and it only did so-so in the marketplace. But a copy of that book would bring a pretty penny at eBay auction these days. Too bad I didn't have psychic power enough to get Ed Wood to autograph a hundred copies or so for my retirement.

We published three of Ed Wood's books that year. Besides *Orgy of the Dead*, there was *Parisian Passions* (SR611, 1966, by J.X. Williams; cover painting by Darrel Millsap) and *Side-Show Siren* (SR618, 1966, by Edward D. Wood, Jr.). Wood was insistent that I use his real name. He loved to see it anywhere, everywhere.

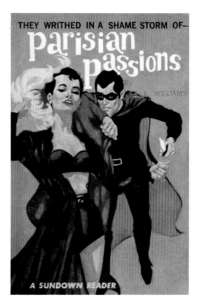

PARISIAN PASSION (1966)
By J.X Williams (Edward D. Wood Jr.)
Sundown Readers
Cover Artist: Darrel Millsap

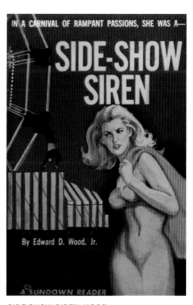

SIDE-SHOW SIREN (1966)
By Edward D. Wood Jr.
Sundown Readers

JOHN GILMORE

MY SLEAZE ADVISOR, ED WOOD

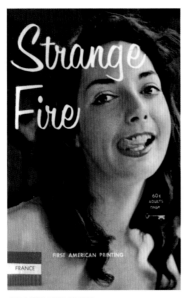

STRANGE FIRE (1963)
By Neil Egri (John Gilmore)
France

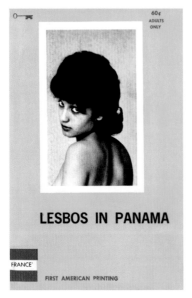

LESBOS IN PANAMA (1963)
By Neil Egri (John Gilmore)
France

When I met Ed Wood, Jr., he was wearing a bright Hawaiian shirt with a pair of bilious neon-yellow pants that sort of shimmered under the fluorescent tubes in Lou Kimzey's office at International Publications. The tub in one of the bathrooms was used as a storage dump for the books they published under the "France" imprint: "Your guarantee of exciting and entertaining reading."

Lou Kimzey's operation wasn't giving Ed the edge he needed—meaning money paid on the barrelhead. Their excuse was always that the book was still at the lawyer's, still in "editing," still being read, and so on. Ed Wood couldn't wait through the run of Kimzey's excuses as to why he hadn't coughed up the hard-earned dough when due, so eventually he went to another publisher, then another, writing book after book at a pace like dribbling a basketball.

Gena's [wife of John Gilmore] father was also writing for "France," and warned me, "You have to go in there and yell. You have to scream and pound on the desk before he'll pay you. If you call on the phone, you'll never get paid. They're all thieves. Rotten fucking thieves. Go in threatening that you won't leave until he pays you. They're scared of the law, so they won't call the cops to haul you off. He'll pay you something—part of it, all of it—something to get your ass out of there."

Ed wasn't screaming or pounding the furniture. He told me, "I know the fucker and I'm afraid of him, because I'll fucking work myself sick and have to fight like a son of a bitch to get the money." For a man who had written and directed movies for a grand a crack, he was looking at easy cash with Kimzey. Collecting it was the trick. Kimzey would hit someone low for maybe three-fifty a book. Kimzey would get the hungry ones. For the others he'd slug out half a grand to seven hundred. A few months later, he was paying close to a grand a book—which Ed had made elsewhere.

The law was hard and fast: no dirty words, no "cock" or "cunt," you couldn't directly

mention the sexual organs, and even pubic hair was taboo. Sex scenes had to result from relationship—couldn't be promiscuous or they would be considered pornography. The books had to have a moral. Good had to shine through in the end. They couldn't even *smell* dirty.

I wrote *Brutal Baby* in nine days and followed it with *Dark Obsession*, another nine-day novel. Then came *Strange Fire*, inspired by a black chick I knew in Greenwich Village, and a bunch of bikers. *Lesbos in Panama* was next, another midnight express.

"I've read *Brutal Baby*," Ed told me. "Maybe there's a picture in it. Don't let Kimzey have any rights except first North American. No one's ever asked him for that, so he'll think you're a hot shot."

We sat on the grass in front of a theater on Laurel Canyon and shared a bottle of vino. I didn't like drinking before sundown. For Ed, it didn't make any difference where the sun was. He drained the bottle and smacked his lips, said he was still thirsty and managed to pull himself up.

A bullet-nosed Studebaker stopped by the curb and Criswell stuck his head out of the window. "Ed! Ed!" he called. "There's a dead guy on the streetcar tracks off Gardner. A dog was just pissing on him. You ought to get some shots before the cops haul the stiff away. You'll use it in your next movie, Ed…"

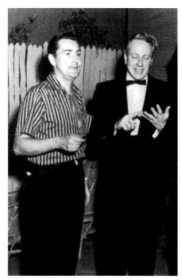

Ed Wood with Criswell

--

John Gilmore, actor, director, and writer (Severed; Live Fast, Die Young; The Garbage People; The Tucson Murders; Fetish Blonde) *wrote a half-dozen sleaze porn novels under the pseudonym Neil Egri. The Ed Wood memory is adapted from his 1997 memoir,* Laid Bare: A Memoir of Wrecked Lives and the Hollywood Death Trip, *published by Amok Books.*

John Gilmore

RON HAYDOCK
AKA VIN SAXON

Ron Haydock and the Boppers, Chicago 1958. (Ron center). Photo courtesy Norton Records.

SEX-A-REENOS (1966)
By Vin Saxon (Ron Haydock)
P.E.C.
Cover Artist: Doug Weaver

Ron Haydock is not particularly well-known as an author, or as a musician, a screenwriter, an actor, a poet, or much of anything else. His bones moulder in a suburban Chi-town grave-yard, where they were planted deep 26 years ago without fanfare. As a teenager, he cut a handful of crudely spectacular rock 'n' roll records for a tiny independent Chicago label: "99 Chicks," "Baby Say Bye Bye," "Rat Fink." Film fans hold his performances in Ray Dennis Steckler's *The Thrill Killers* and *Rat Pfink and Boo Boo* in high regard. And paper-back mavens set their Haydock collections apart from the pack.

Ron's books draw heavily from personal experience, providing a peephole into the life and imagination of a young cat who declared in an early novel: "The story of my life? Easy. I'm out for kicks in life, doing whatever I want whenever I want, on the move like there's no tomorrow, and living like there's only today!"

21 and just married, Ron Haydock arrived in Hollywood with young bride Jean at the end of 1960, set on carving out a career in the movies. Jean worked as a secretary while Ron pounded the pavement, hanging out with sci-fi fanzine buddies and visiting Forrest J. Ackerman, high priest collector/publisher/his-torian of all things film and fantasy. Through Forry, Ron met writer Jim Harmon, a film and radio show enthusiast and historian who was working on an adult novel, *Vixen Hollow,* for Art Enterprises—one of the burgeoning Southern California sleaze magazine publishers who had branched into paperbacks via their Epic and Pagan lines. Jim encouraged Ron to try his hand at writing adult material, and they worked together on several titles. *Vixen Hollow* (Epic 104) was followed by *The Man Who Made Maniacs* (Epic 107), *Sudden Lust* (Pagan 102) and *The Celluloid Scandal* (Epic 109). Ron's collaborative efforts went uncred-ited until 1962, when Jim and Ron began operating under the handle Judson Grey for *Wanton Witch* (Epic 119) and *Twilight Girls* (Epic 135). *Twist Session* was issued by International Publications on its France imprint during this same period. IP was operat-ed by publishing mastermind Lou Kimzey, founder of *Hop Up*, which he sold to Peterson Publications, and *Dig*, the teenage magazine, which he sold to Deidre Publications in late 1959. *Twist Session*, a fast-paced sleazer about deviant disc jockeys and record collectors, no doubt hit home with Kimzey. Ron was brought in

APE RAPE (1964)
By Vin Saxon (Ron Haydock)
Rapture Books

PERVERTED LUST (1964)
By Vin Saxon (Ron Haydock)
Rapture Books

PAGAN URGE (1963)
By Vin Saxon (Ron Haydock)
Rapture Books

to work on *Famous Monsters*, Forry's legendary magazine, and soon afterward, Ron was offered the editorship of a brand new magazine, the short-lived *Fantastic Monsters*.

Ron landed at the newly formed Pike Books via his friend, Bob Pike, who had learned the business at Golden State Distribution. Bob accepted two manuscripts from Ron that he issued under the pseudonym "Don Sheppard" (name of a hep character in *Twist Session*). *Flesh Peddlers* (Pike 212) and *Scarlet Virgin* (Pike 215) appeared in 1962, with a second printing (with different cover art) of *Peddlers* following in '63. By then, Ron had become "Vin Saxon," a name that he would use for the rest of his adult fiction career. Out of the San Diego (via Culver City)-based Rapture Books came the bizarrely sentimental jungle love titles, *Pagan Urge*, reissued within months with a new cover as *God of Lust* (Rapture 103), and *Ape Rape* (Rapture 202). He wrote the transvestite tome *Lust for Lace* as "Jeff King" (Rapture 102), the fetishistic *Perverted Lust* as "Rita Wilde" (Rapture 201), and *Six for Sex* (Rapture 403). *I Want to Sin* (NT 3002), another 1964 "Vin Saxon" title, appeared bearing a Nite-Time prefix, a Golden State GSN brand and a Fitz Publications imprint. *Erotic Executives* (NT 117) clocked in that year as well, showing Nite-Time as a PEC (Publishers Export Company) imprint.

Through *Fantastic Monsters*, Ron befriended independent filmmaker Ray Dennis Steckler, who promptly tapped Ron for work as a screenwriter and actor. *FanMo* folded after only seven issues, and Ron's marriage broke up, sending him into a tailspin. Still, the novels continued. *Unnatural Desires* (PEC 113), issued in '65, and *Whisper of Silk* (PEC French Line FL5), issued in '66, brought the transvestite theme back out of the closet for "Vin Saxon." The best was to come in 1966, when PEC issued three fabulous "Vin Saxon" titles, *Pagan Lesbians* (N 137) and *Lesbian Stripper* (G-1108), *Sex-A-Reenos* (N 135) and *Flip-Side Lover* (N-130) under the name "Jay Horn," the latter being a redo of the sole France title. *Sex-A-Reenos* is the definitive rock 'n' roll sleaze paperback, which packs detail upon detail of Ron's life as a Bopper back in Chicago. *Caged Lust*, a reissue of *Ape Rape* (Rapture 201) appeared early in 1967, signaling the end to Ron's career as an adult fiction scribe. He continued working with Steckler, moved back to Chicago for a while, wandered to New York City where he stayed several months with living legend Bhob Stewart, writing reams of stories and novelettes, only to destroy them in the end. In the '70s, he found work editing one-shot movie star magazines and *Monsters of the Movies*.

Ron was last seen alive on August 12, 1977. He met that day with Steckler, who had relocated his film operations to Las Vegas. Ray recalls Ron being obnoxious and out-of-control. When he drove him to the airport, he assumed Ron would fly back to Hollywood. Instead, disoriented and wobbling, he began hitchhiking home. He was struck in the wee hours by a semi truck, and was killed instantly.

*Miriam Linna collects paperbacks and publishes two collectors fanzines—*Bad Seed *and* Smut Peddler. *She is currently compiling a book about post-War juvenile delinquency entitled* The Bad Seed Bible. *Miriam operates Norton Records and Kicks Magazine out of Brooklyn with her husband Billy Miller. Ron Haydock's music is available from www.nortonrecords.com.*

A NEW MARCH HASTINGS NOVEL

F271

HER PRIVATE HELL

LESBIAN LOVE: Can a hunger so strong be so wrong?

LYNN MUNROE

MIDWOOD BOOKS AND ISAAC PAUL RADER

Harry Shorten came from the Midwood section of Brooklyn, New York. With his partner, artist Al Fagaly, Shorten made his fortune with a comic strip called *There Oughta Be A Law*. Shorten thought up the ideas and Fagaly would do the drawings.

Looking around for somewhere to invest all his cartoon money, Shorten decided to become a paperback book publisher. He looked at the success of Beacon Books, a series of slick, cheap throwaway melodramas and sexy romances with flashy girlie art covers marketed to men and published by Universal Distributing. Shorten figured he could do the same, and at 505 8th Avenue in Manhattan, in 1957, he started a paperback book line named for his old neighborhood. The first batch of Midwood Books were either *There Oughta Be A Law* paperbacks or unnumbered experimental forays in the Beacon style.

By Midwood 7 in 1958, the authors and artists we recognize as Midwood Books were in place. Shorten was getting his early manuscripts from the Scott Meredith Literary Agency, where Meredith's band of employees and clients were soon churning out a book a month for William Hamling's Nightstand Books, too. And he was getting his cover paintings from the Balcourt Art Service, the same agency that supplied many of the covers for Beacon.

Although nobody at Midwood knew it then, most of the books were by the same writers turning out the Nightstands. For example, Loren Beauchamp (Robert Silverberg) would become Don Elliott a year later at Nightstand, Sheldon Lord (Lawrence Block) would become Andrew Shaw. Some of the writers, like Alan Marshall and Clyde Allison and Al James, used the same name for both.

All of Midwood's early books dealt only with aspects of human sexuality. Shorten's

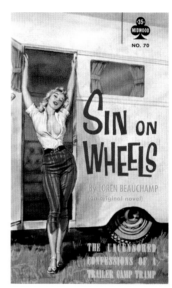

SIN ON WHEELS (1961)
By Loren Beauchamp
Midwood
Cover Artist: Paul Rader

WILD HONEY (1963)
By Don Karl
Midwood
Cover Artist: Paul Rader

HER PRIVATE HELL (1963)
By March Hastings
Midwood
Cover Artist: Paul Rader

Paul Rader

only interest was a profitable product. His first editor was a brilliant, doomed writer named Elaine Williams, who wrote as Sloane Britain. His right-hand man, art director, and later editor was Marshall Dugger. Shorten didn't know much about books, but he was savvy enough to bring in people who did.

Just five men (Beauchamp, Lord, Marshall, Orrie Hitt and Don Holliday) wrote almost all of the first 40 numbered Midwoods. This hard-working group carried and established Midwood until Shorten was able to build his own stable of regulars—names like March Hastings, Dallas Mayo, Kimberly Kemp, Joan Ellis, Jason Hytes and Sloane Britain.

Midwood titles are bright, colorful, flashy and above all, eye-catching, which is why cover artists like Rudy Nappi, Paul Rader and Robert Maguire were so important to their success. On many occasions, the cover is more interesting than the book inside. PG-rated sex scenes popped up every few pages full of innuendo and veiled references to "throbbing manhood" and "dark triangles." Though romance books and soap opera were usually the province of women fans, Midwoods and Beacons were marketed to men.

Even their lesbian titles, while obviously enjoyed by many female readers then and to this day, were often written by men using female pen names like Barbara Brooks, Jill Emerson and Kimberly Kemp. At the time they were edited by men and marketed to men.

The man who painted 300 covers for Midwood, Isaac Paul Rader (who signed his art as Paul Rader) started his paperback career after changing agents, and going with Balcourt Art Service in 1957. After 1958 Rader illustrations suddenly appear in men's magazines like *Swank* and *Bachelor*, and paperback covers for Gold Medal, Ace, Pyramid, Berkley and Midwood.

From his 30 years doing painting portraits, and later doing advertising and illustration, Rader tried to make his paperback covers fashionable. But Midwood did not want their covers to be fashionable, just eye-catching and beautiful. Balcourt described the kinds of covers he supplied by genre, like "westerns" or "science fiction" or "sexy." Rader quickly became one of the greatest "sexy cover" artists of the era. His realistic take on such fantasy subjects as dreamy blondes and sultry redheads distinguishes him from the pack. Rader continued to turn out Midwood covers throughout the '60s, elevating the paperback cover to classic pin-up status.

After being diagnosed with a stomach tumor in 1967, Rader did a few last covers for Midwood, and recycled some of his Midwood covers for Bee-Line. He retired from paperback illustration in 1970, painting portraits and teaching Adult Education classes. Paul Rader spent his last two years in Ocala, Florida, where he died in 1986 at the age of 79.

Lynn Munroe sells vintage paperbacks at http://lynnmunroebooks.tripod.com/.

BRITTANY A. DALEY

ERIC STANTON

The artist known primarily for dominant women and a high output of '60s sleaze paperback covers was born Ernest A. Stanten on September 29, 1926, in Brooklyn, New York. When he was 12 years old, his sister caught scarlet fever, and the young Eric Stanton was quarantined for a month. During this time, he started to draw out of boredom. Immersing himself in comic books, he learned how to draw the sexy women that would later be integral to his style.

At 17, Stanton joined the Navy and began serving out of Maine, where he began drawing sexy girls on other sailors' handkerchiefs. After his discharge, and two years of waiting tables at his stepfather's restaurant, he quit to work with a man named Boody Rogers on comic strips called *Babe Darlin' of the Hills* and *Sparky Watts*. Stanton's job was to do the lettering, and coloring after they came back from the printer.

While working for Rogers, he bought a girlie magazine and happened upon an Irving Klaw ad selling bondage art, so he wrote Klaw. After seeing Stanton's work, Klaw challenged him to come up with something better. Stanton met the challenge, and Klaw bought his work. Stanton began drawing wrestling women full-time. Stanton took Klaw's suggestion that he attend The Cartoonist and Illustrators School. While there, he studied under Jerry Robinson, an artist for Batman comics. Stanton also became friends with fellow student and fetish artist, Gene Bilbrew, who began working for Klaw as well.

Stanton quit working for Klaw in 1956 and soon after began working for Lenny Burtman. During his stint with Burtman, Stanton produced one of his more famous works, *Sweeter Gwen*, a take-off of John Willie's *Gwendoline*. At this time, Stanton shared a studio with Steve Ditko, famed for his *Spider-Man* work. Stanton and Ditko were good friends and helped each other with ideas, inking, and storyboarding.

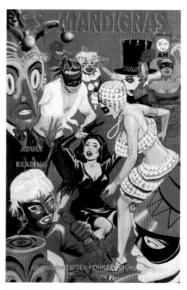

S.S. MARDIGRAS (1966)
By Yvette Delon
After Hours
Cover Artist: Eric Stanton

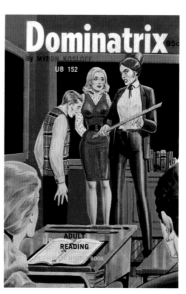

DOMINATRIX (1968)
By Myron Kosloff
Unique Books
Cover Artist: Eric Stanton

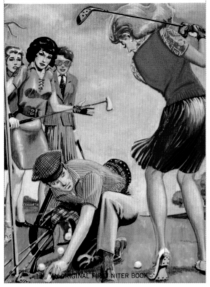

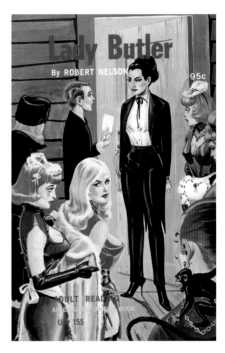

HOLE IN ONE (1965)
By Peter Willow
First Niter
Cover Artist: Eric Stanton

LADY BUTLER (1968)
By Robert Nelson
Unique Books
Cover Artist: Eric Stanton

After an antagonistic relationship with Burtman, Stanton briefly worked for Max Stone, whom he quit working for after being cheated on his pay. Stanton's next gig was working for Satellite Publications' Stanley Malkin and Eddy Mishkin. For Satellite, Stanton painted beautiful watercolor and tempera sleaze paperback cover illustrations featuring gorgeous, domineering women. Between 1963 and 1968, Stanton painted over 100 sleaze paperback covers for the imprints After Hours, First Niter, Wee Hours, and Unique Books.

After Satellite Publications went out of business in the late '60s, Stanley Malkin gave Stanton the company's mailing list. Using this list as a customer base, Stanton began self-publishing a series of small, bound books known as Stantoons. After a while, Stanton developed personal relationships with customers in the mail order business.

Stanton continued working until he passed away from complications from a series of strokes on March 17, 1999, leaving behind his second wife, Britt, their son and daughter, and two sons from a previous marriage.

Stanton will be remembered for his fighting femmes, and wild, whip-wielding dark-haired dominatrixes. Stanton drew women with high doses of sexuality exuding through their tall frames and mile-long legs. Dark-haired Stanton vixens were nearly always seen grinning with delight as they hovered over innocent, frightened blondes and effeminate men, writhing in fear. Victims are seen kneeling on the ground or cowering into submission while facing unbearable torment.

Brittany A. Daley is a prelaw student at Minnesota State University, Moorhead, and a rare book dealer when she's not researching and collecting 1960s sleaze paperbacks.

BRITTANY A. DALEY

GENE BILBREW

One of the most prolific sleaze paperback cover artists was Gene Bilbrew, an African-American who also used the pseudonym "ENEG" (his first name spelled backwards). Bilbrew's unusual style was characterized by strong, sturdy men and women who were anything but delicate.

Gene Bilbrew was born in Los Angeles in 1923. In his twenties, he worked at Will Eisner's Manhattan studio, assisting him on *The Spirit*. He then attended The Cartoonist and Illustrators School in New York City and studied under Burne Hogarth, creator of the famous *Tarzan* comic strip. Bilbrew befriended fetish artist Eric Stanton at the school, and it was Stanton who suggested that Bilbrew work for Irving Klaw (perhaps best known today for his work with Bettie Page), who published books and comics on the once-taboo topics of bondage and other fetishes. Bilbrew dove headlong into the fetish genre in 1951, producing many bondage comic strips for Klaw. By the mid-'50s Bilbrew added Lenny Burtman's *Exotique* magazine to his repertoire, along with other fetish publications such as *Fantasia* and *Ultra*.

In the early '60s, Bilbrew began illustrating the covers of sleaze paperbacks put out by Stanley Malkin and Eddy Mishkin's Satellite Publications. Satellite Publications was headquartered at a New York City bookstore called Liberty Gift Shop, and the editing of Satellite books was reputed to have been done at a Times Square strip club Malkin owned. Bilbrew worked at Satellite from 1963 until about 1967, producing approximately 50 covers for the imprints After Hours, First Niter, Nitey Nite, Unique Books, and Wee Hours. Bilbrew's work for Satellite ceased when they went out of business.

Bilbrew also illustrated sleaze paperback covers for Joe Sturman's Connoisseur Publications, over 80 of them for the CP imprints Chevron, Corsair, Crescent, Exotik, Mercury, Phantom, Wizard, Vanguard, including every cover for Satan Press. Joe Sturman, anxious to get out of the sex industry at the end of the '60s, handed over his assets to his

PASSION PSYCHO (1965)
By Jack Kahler
Satan Press
Cover Artist: Gene Bilbrew

THE EXPERIMENTERS (1965)
By Juliette Rowell
Satan Press
Cover Artist: Gene Bilbrew

SPANKING NOVEL (1966)
By Edward Landon
Unique Books
Cover Artist: Gene Bilbrew

DISCIPLINE DIGEST (1966)
By Anthony Wilkins
Unique Books
Cover Artist: Gene Bilbrew

brother Reuben. Following this transfer of power, the imprints Bilbrew illustrated for were discontinued, and his work for Connoisseur came to an end.

Bilbrew continued illustrating paperback covers into the porn era, working for such imprints as Euro Classics, Tortura Press, Spade Classics, and Dr. Lamb Library.

Though little is known about Bilbrew's personal life, he is reputed to have had an insatiable appetite for drugs and alcohol, and a penchant for white women. His buddy Eric Stanton has been quoted as saying that Bilbrew wanted to be white. What eventually brought about Bilbrew's downfall, though, was not his racial conflicts but his drug addiction. By 1974, Bilbrew was so destitute that he was living in the back room of one of Eddy Mishkin's porn stores. He was still doing artwork but by that time the quality of his work had begun to suffer. Bilbrew died of a drug overdose in a Mishkin store at the age of 51.

Bilbrew stands out among the sleaze-era artists, primarily due to his distinct way of depicting women. Bilbrew women were of the R. Crumb and Amazon variety, with large frames and fuller figures which certainly wouldn't correspond with beauty ideals today. A robust Bilbrew woman typically had firm, muscular thighs and buttocks, ultra-

wide hips, and enormous, egg-shaped breasts. These babes could flex their muscles with any man and even their faces had a mannish look, with square jaw-lines and hardened expressions. Bilbrew's women boldly displayed sexuality and often seemed to be the manipulators rather than helpless victims. Though faces and jaws often seemed manly, Bilbrew's women had extra-curvy full figures, their breasts frequently spilling out of their outfits, often with a nipple showing through thin clothing. Irving Klaw often asked Eric Stanton to cover Bilbrew's nude tops and bottoms and what he perceived to be phallic symbols in Bilbrew's work.

Bilbrew drew a greater variety of races compared to other sleaze artists, including Asians, Latinos, and African-Americans. Some have speculated that Bilbrew drew himself on some covers as a male character.

While Bilbrew gave his women distinctly female haircuts including beehives and bouffants, his men usually had either Elvis-style pompadour haircuts or were completely bald. Bilbrew's lecherous bald men, many of dwarfish stature, often had monstrous, sadistic expressions. Bilbrew's art stands out prominently among the sleaze paperback cover illustrations.

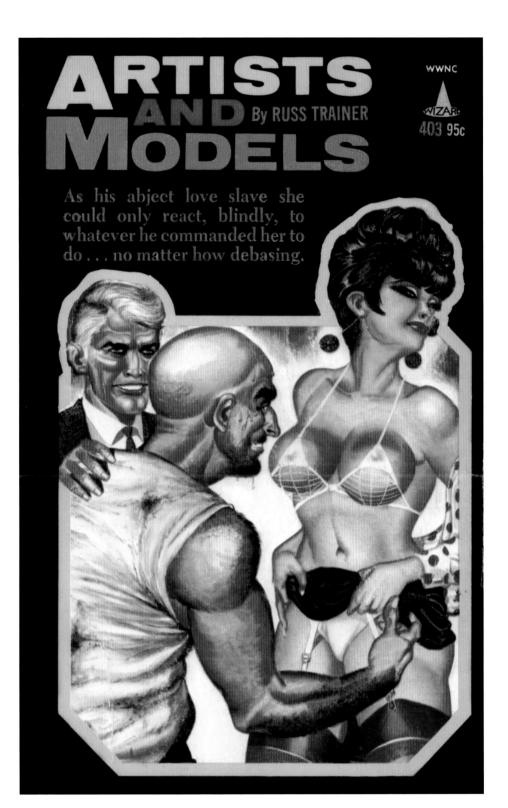

ARTISTS AND MODELS (1967)
Russ Trainer
Wizard
Cover Artist: Gene Bilbrew

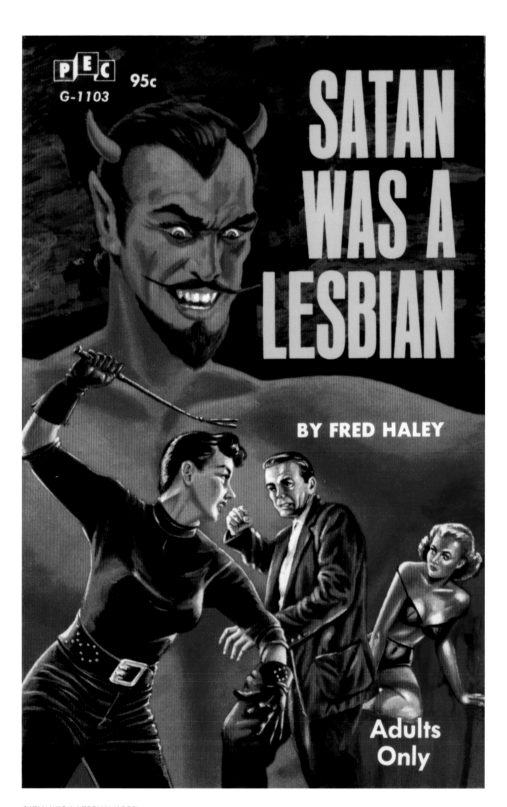

SATAN WAS A LESBIAN (1966)
By Fred Haley
P.E.C.
Cover Artist: Doug Weaver

THE LOST ARTISTS

The importance of cover artists to the sleaze industry cannot be overstated. Within the taboo world of the dirty bookstore, nervous customers only had so much time to pick out a title and leave sight unseen. Reviewing sexy jackets was the easiest way for a customer to decide on a purchase without having to linger too long. Sexy covers provided by these remarkable, and often forgotten, illustrators were significant sales tools for the sleaze publishers.

Dozens of artists illustrated sex sleaze paperbacks of the '60s, but many remain unknown. Some artists, like those profiled below, are known but limited information remains available.

Publisher's Export Company, known as P.E.C., featured almost exclusively one artist—a man named **Douglas B. Weaver**, who signed only a few of the covers he painted. Most of Weaver's work was for P.E.C., but he also painted covers for Rapture, All Star, Raven, and Epic Books. Weaver began doing commercial art in the '40s, illustrating everything from advertising to men's adventure magazines. Today, he is well-known for painting the Old West, different cultures, and portraits. Weaver currently resides in Roswell, New Mexico.

Another prolific artist, **John Healey**, was best known for the lesbian covers he painted for the imprints Private Edition, All Star, Raven Books, and Scarlet Readers. Healey's trademark was to paint two or more women on a bed or framed within a sparse background. His women were often a bit plump, and he usually clothed them in bra and panties. Healey is also known for painting his women with a sort of dingy, dirty-looking skin color.

Bill Edwards painted sleaze covers for Sanford Aday's imprints Fabian, Saber, and Vega. From the early '60s until the early '70s, Edwards accomplished over a hundred covers for Aday. He characteristically painted moles on women's faces and, strangely, often painted Band-Aids on butts. He did interior illustrations for '70s girlie magazines and was an accomplished western artist. Edwards, a New Jersey native, was also a rodeo star and film and TV actor. He died in 1999 at the age of 81.

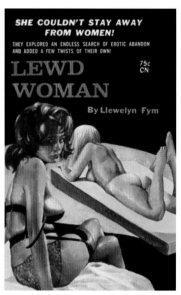

LEWD WOMAN (1964)
By Llewelyn Fym
Nite Lite Books
Cover Artist: John Healey

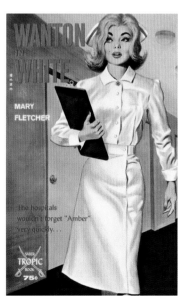

WANTON IN WHITE (1966)
By Mary Fletcher
Saber Books
Cover Artist: Bill Edwards

Asphalt

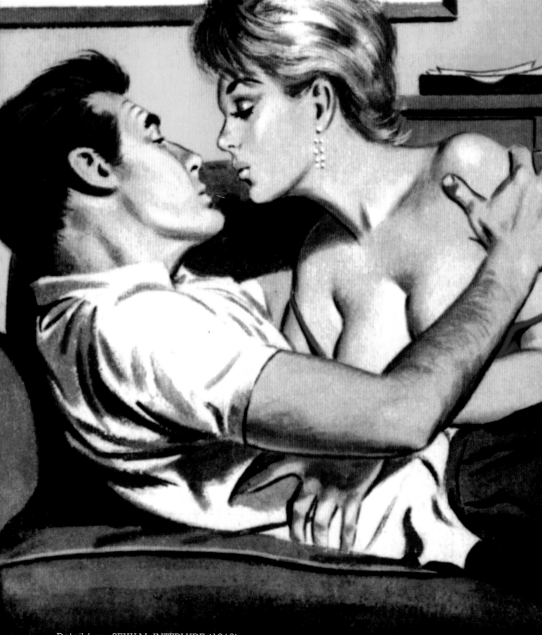

Detail from SEXUAL INTERLUDE (1963)
By Frederick Dessiers
Europa Books
Cover artist: Bill Edwards

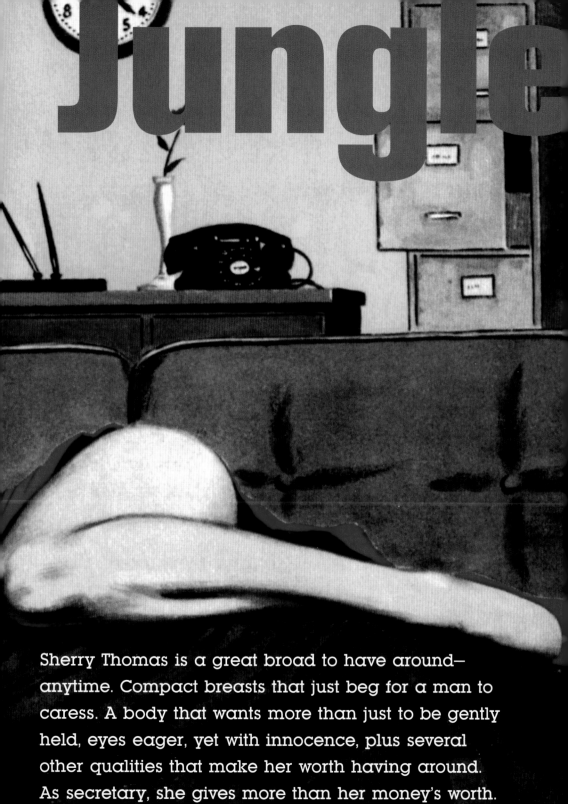

Jungle

Sherry Thomas is a great broad to have around—
anytime. Compact breasts that just beg for a man to
caress. A body that wants more than just to be gently
held, eyes eager, yet with innocence, plus several
other qualities that make her worth having around.
As secretary, she gives more than her money's worth.
She's all for a little overtime—free of charge.

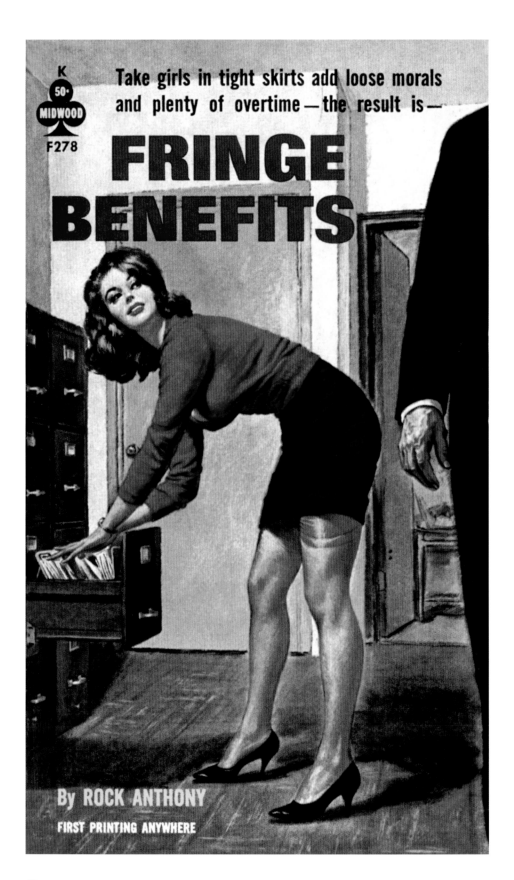

Take girls in tight skirts add loose morals and plenty of overtime—the result is—

FRINGE BENEFITS

K 50¢ MIDWOOD F278

By ROCK ANTHONY

FIRST PRINTING ANYWHERE

PARTY GIRL (1965)
By Jack Moore
Saber Books
Cover Artist: Bill Edwards

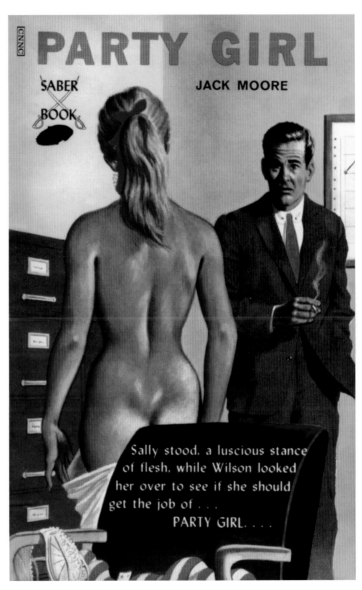

FRINGE BENEFITS (1963)
By Rock Anthony
Midwood
Cover Artist: Paul Rader

HORIZONTAL SECRETARY (1963)
By Amy Harris
Midwood
Cover Artist: Paul Rader

OFFICE WIFE (1961)
By Arnold Kane
Saber Books

She didn't believe him. She thought all a girl needed was looks and ability, and she knew that she possessed both.

"Plenty of girls would be willing to get laid to get this job, Susan," he said.

She felt his hand toying with the lace fringe of her panties.

"Why don't you be a good girl and let me take off your clothes, Susan?" Barnett prompted. "You'll like it. Once a sexy girl like you gets a taste of it, you'll be begging for more."

"I don't want your goddamn job that bad, you ... you bastard!" she snapped.

Barnett had a sarcastic grin on his face.

"I can wait a few days, Susan. You'll be back. As soon as you think it over, you'll be back."

Jack Moore, *Her Soul Went First* (Saber Books, 1965)

LADY BOSS (1967)
By Shawna deNelle
After Hours
Cover Artist: Eric Stanton

LADY BOSS

95c

AH 157

by Shawna deNelle

AN ORIGINAL AFTER HOURS BOOK

SIDE STREET (1966)
By Arlene Duval
After Hours
Cover Artist: Bill Ward

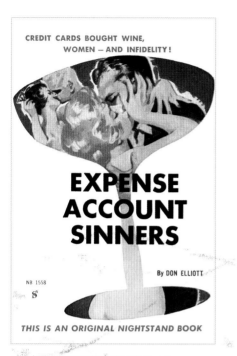

EXPENSE ACCOUNT SINNERS (1961)
By Don Elliott (Robert Silverberg)
Nightstand Books
Cover Artist: Harold W. McCauley

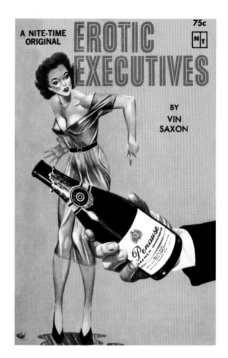

EROTIC EXECUTIVES (1964)
By Vin Saxon (Ron Haydock)
Nite-Time Books

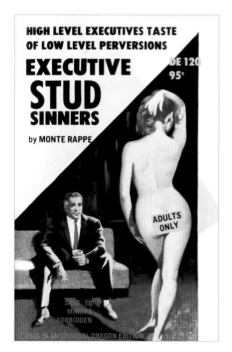

EXECUTIVE STUD SINNERS (1966)
By Monte Rappe
Dragon Editions

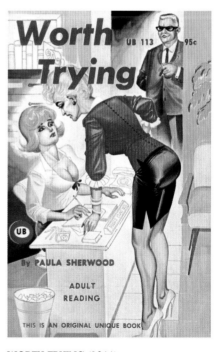

WORTH TRYING (1966)
By Paula Sherwood
Unique Books
Cover Artist: Gene Bilbrew

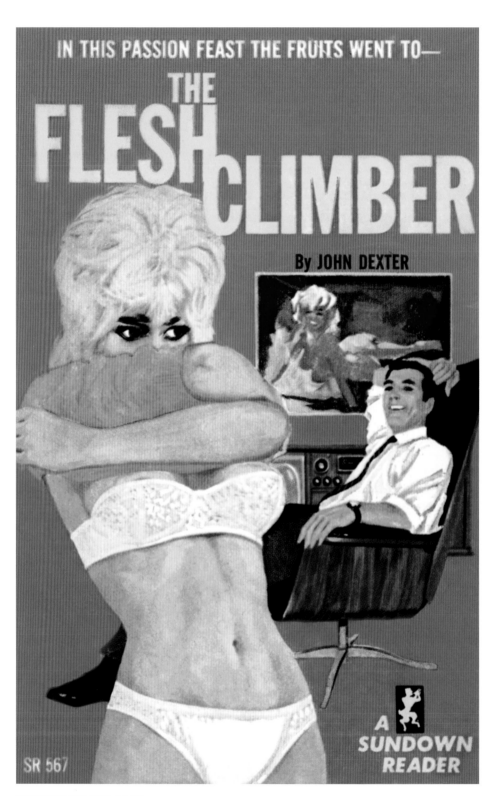

THE FLESH CLIMBER (1965)
By John Dexter
Sundown Readers

PERVERTED LOVER (1962)
By Bill Lauren
Merit Books

EXECUTIVE PAD (1967)
By J.D. Blake
Rapture Books

2-4-SEX (1960)
By Adam Snavely
Kozy Books

You would take a second look at the stenographers and errand girls and realize what it was that bothered you. They were trying to be noticed. They were exuding a musk that was much less subtle than you'd find at The Little Club. These girls were interested in being discovered, in being noticed, in having their pretty little faces etched on film or appearing on the screen of your tv set. If they had to plunk their pretty little bodies on your sofa or bed or the back seat of your car to do it, they'd go along with that. But they were shrewd and hard and if they did not think it meant something to be seen with you, if they did not think you could do something for them, they had the ability to be able to look at you and not see you, as though you were a pane of glass, as though you did not exist. And if you saw something that you liked, if the swell of a thigh or the jut of a breast or the pout of a lip got to you and excited you, and made the sap run hot in your veins, why that was too damned bad, sucker.

Adam Snavely, *2-4 Sex* (Kozy Books, 1960)

THE SEX SPREE (1962)
By Clyde Allison (William Knoles)
Midnight Readers

HE HAD A CREDIT CARD WITH PASSION, INC.!

The
SEX SPREE

By CLYDE ALLISON

60¢

MR 439

MR 7601

A PROFESSIONAL STUD IN
THE BIG CITY LUST JUNGLE!

LOVER

By ANDREW SHAW

75c

NB 1551

THIS IS AN ORIGINAL NIGHTSTAND BOOK

MALE NYMPHO (1962)
By Duke Shannon
France
Photographer: Ralph Poole

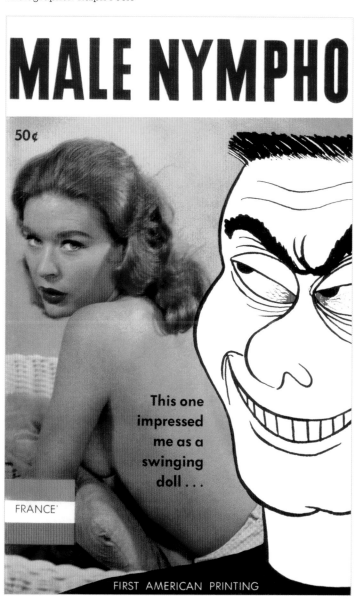

MALE NYMPHO

50¢

This one
impressed
me as a
swinging
doll . . .

FRANCE'

FIRST AMERICAN PRINTING

LOVER (1961)
By Andrew Shaw
Nightstand Books
Cover Artist: Harold W. McCauley

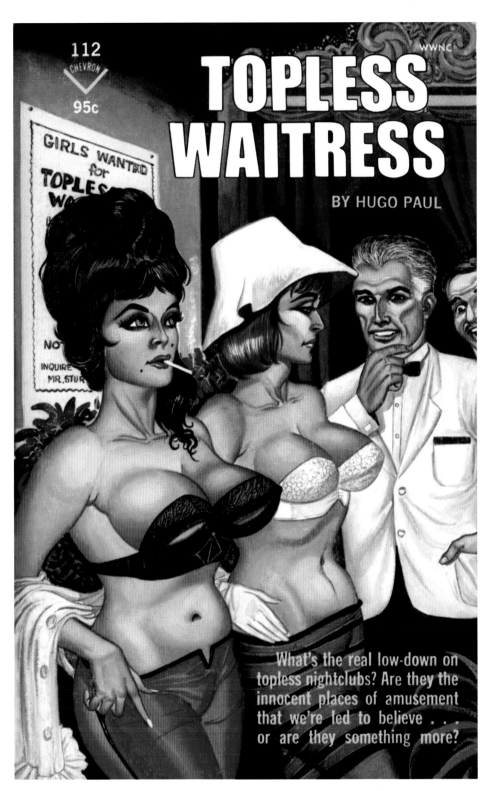

TOPLESS WAITRESS (1967)
By Hugo Paul
Chevron
Cover Artist: Gene Bilbrew

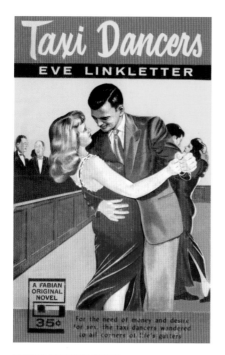

TAXI DANCERS (1958)
By Eve Linkletter
Fabian Books

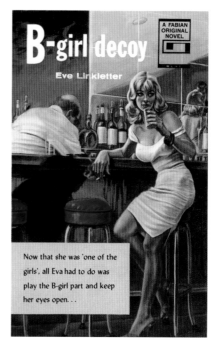

B-GIRL DECOY (1961)
By Eve Linkletter
Fabian Books

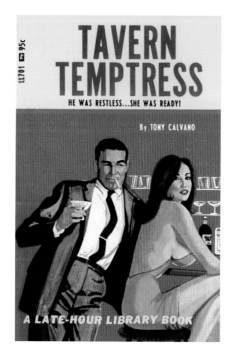

TAVERN TEMPTRESS (1967)
By Tony Calvano
Late-Hour Library

IN AND OUT (1967)
By Glenn Allison
Unique Books
Cover Artist: Bill Ward

CALL GIRL (1965)
By Joan Reyes
P.E.C.
Cover Artist: Doug Weaver

SEXCORT SERVICE (1966)
By Anton Wylas
Royal Line Novels

"Anything, Veda," he said later. "A Cadillac, furs, sparklers, whatever your delicious heart wants, just name it. But I can't bear to have you leave me."

"I don't want any gifts like that. You should know how I operate by now."

He fondled and caressed me again. I felt the white-hot stirrings renewed in my thighs and I reached for my underclothes. "We'd better get started for the bar, Jasper."

"You—you haven't answered me," he pleaded boyishly. "Be my mistress and make my joys complete."

John Nemec, *Pleasure Girl* (Tuxedo Books, 1962)

HOUSECALL OF SIN (1964)
By Curt Sands
Stardust Readers

THE VICE CAME C.O.D. ON THEIR

HOUSECALL OF SIN

75c
SR112

by CURT SANDS

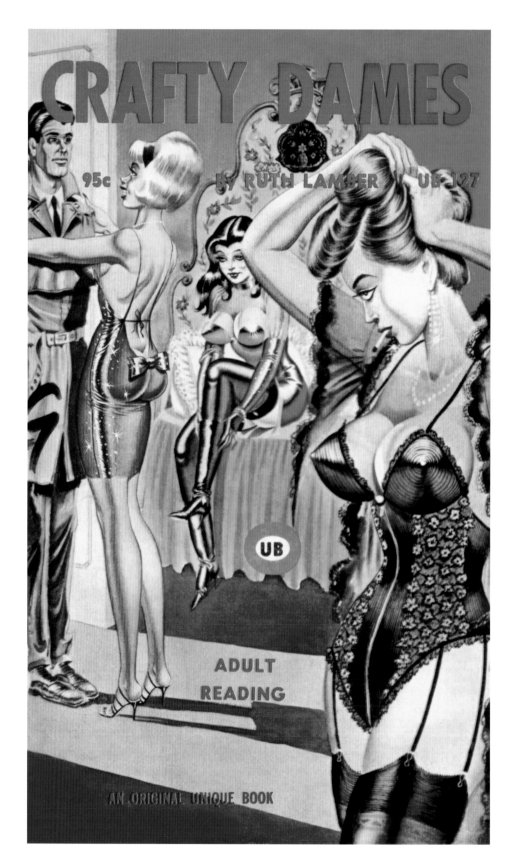

CRAFTY DAMES

95c BY RUTH LAMBER UB 127

UB

ADULT
READING

AN ORIGINAL UNIQUE BOOK

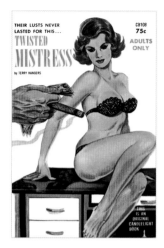 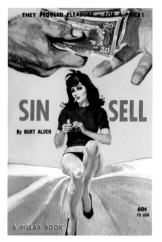 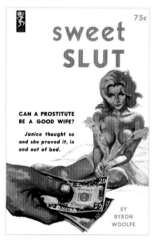

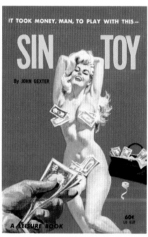 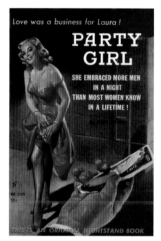 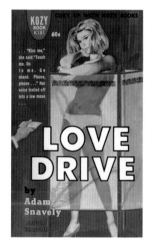

TWISTED MISTRESS (1964)
By Terry Handers
Candlelight Books

SIN SELL (1963)
By Burt Alden
Pillar Books
Cover Artist: Robert Bonfils

SWEET SLUT (1964)
By Byron Woolfe
Playtime Books
Cover Artist: Robert Bonfils

SIN TOY (1964)
By John Dexter
Leisure Books
Cover Artist: Robert Bonfils

PARTY GIRL (1960)
By Don Elliott (Robert Silverberg)
Nightstand Books
Cover Artist: Harold W. McCauley

LOVE DRIVE (1963)
By Adam Snavely
Kozy Books

CRAFTY DAMES (1967)
By Ruth Lamber
Unique Books
Cover Artist: Bill Ward

To sum it up, she didn't really look like a whore. And yet, what else could she be? A non-professional wouldn't dare walk down Water Street dressed in such a fashion, with her breasts bounding inside her bodice, with her legs inviting the attention and eventual assault of a man, so nakedly. Even the round hill of her belly drew the eye with its soft curve, and caused the immediate and inevitable response in the beholder.

She had to be a whore. Suitcase, beauty, uniqueness not withstanding, she just had to be a whore.

Jed Bennett, *The Street* (Magenta Books, 1965)

PICKUP (1967)
By Jon Parker
Wee Hours
Cover Artist: Bill Ward

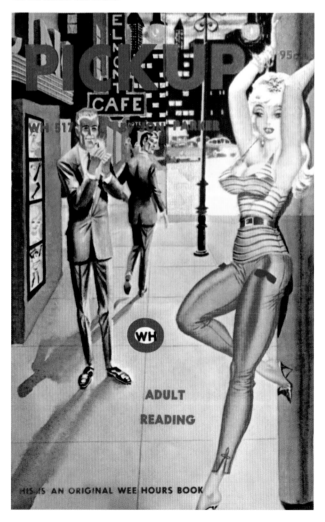

THE FLESH HUSTLE (1967)
By Alan Marshall
Greenleaf Classics
Cover Artist: Robert Bonfils

THE
FLESH HUSTLE

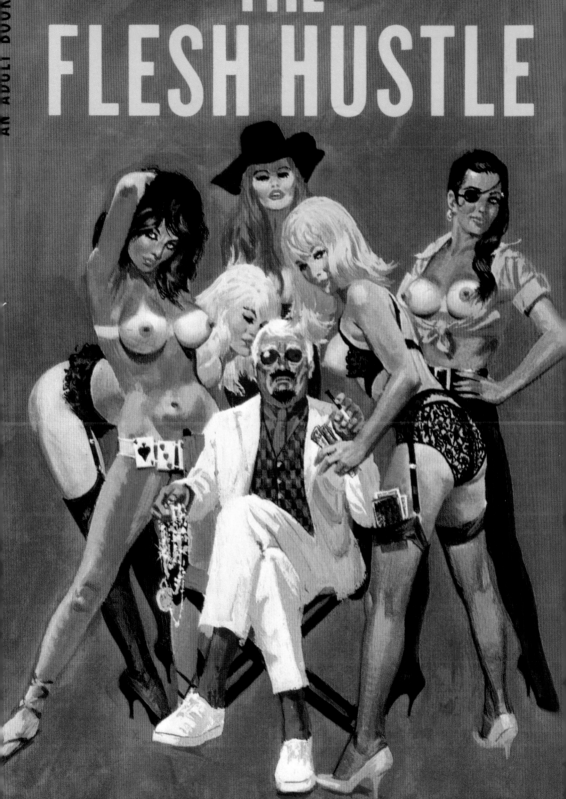

CARNAL CON GAMES IN A SCHOOL FOR SINNERS!

BY ALAN MARSHALL

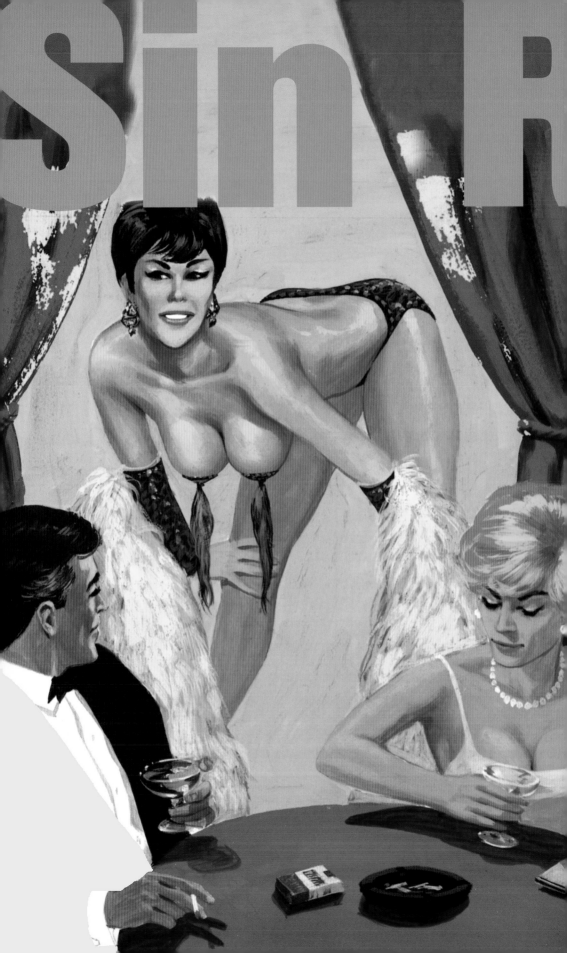

A kettledrum began throbbing, slowly, rhythmically.
From the curtains in back of the stage, a leg
appeared. The foot of the leg wore black high-heeled
shoes. The leg itself was black stockinged. It was a
very shapely leg. It moved back and forth in time
with the slow drumbeats. Back and forth, back and
forth, my eyes following the movements with intense
fascination.

In a sudden movement, the curtains were ripped
apart, and there was another shapely, black
stockinged leg, and hips covered by black panties
and a garter belt, and full, sensuous breasts straining
the fibers of a black bra. It was a beautiful female
body, and by the intakes of breath around me I knew
I wasn't alone in thinking so. The leg kept moving
in time to the throbbing of the drum, back and forth,
back and forth.

Eric Thomas, *Strip for Murder* (Kozy Books, 1961)

Original Art from SOS FOR SIN (1967)
By Marcus Miller
Companion Books
Cover Artist: Darrel Millsap
From the Collection of Jeff Rich

Not So Funny

BY CHARLENE WHITE

AH 145 95¢

ADULT READING

AH

AN ORIGINAL AFTER HOURS BOOK

Her hubby Jason's a clown. And a good one. A dumb one, too, if an old man like me can get to her. But that's beside the point for now. He's a clown and she's a pony rider.

Jason's been out of sorts lately; been boozing quite a bit. Something's been bugging him, and his wife's lonely; circus life is lonely. No one wants to know from you when you're in the circus. You're a freak, an oddball, so you have your own kind, and that's it. Jason's been goofed up and Mary's been lonely, and I know a good thing when I see it.

Jon Parker, *Sex Carnival* (First Niter, 1965)

THE HUNGRY ONES (1966)
By Craig Douglas
Crescent
Cover Artist: Elaine Duillo

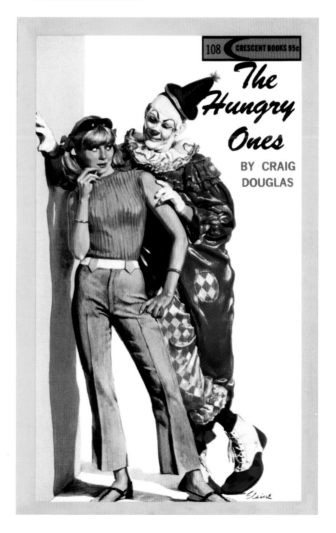

NOT SO FUNNY (1966)
By Charlene White
After Hours
Cover Artist: Eric Stanton

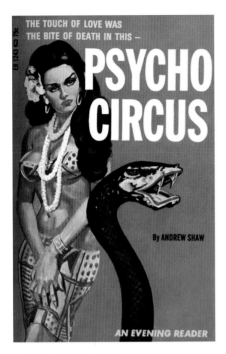

PSYCHO CIRCUS (1966)
By Andrew Shaw
Evening Readers

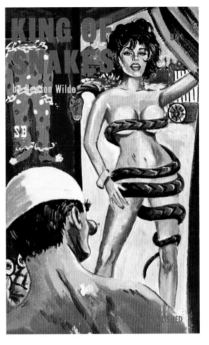

KING OF SNAKES (1968)
By Newton Wilde
Spotlight Books

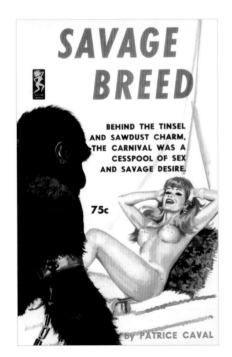

SAVAGE BREED (1964)
By Patrice Caval
Playtime Books
Cover Artist: Robert Bonfils

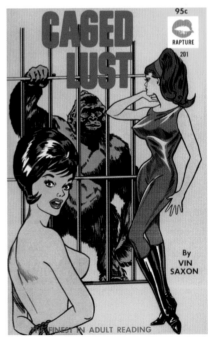

CAGED LUST (1967)
By Vin Saxon (Ron Haydock)
Rapture Books

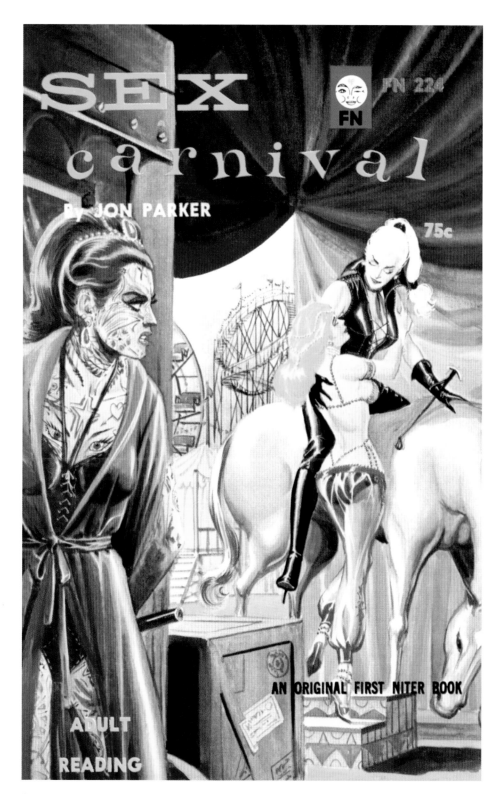

SEX CARNIVAL (1965)
By Jon Parker
First Niter
Cover Artist: Eric Stanton

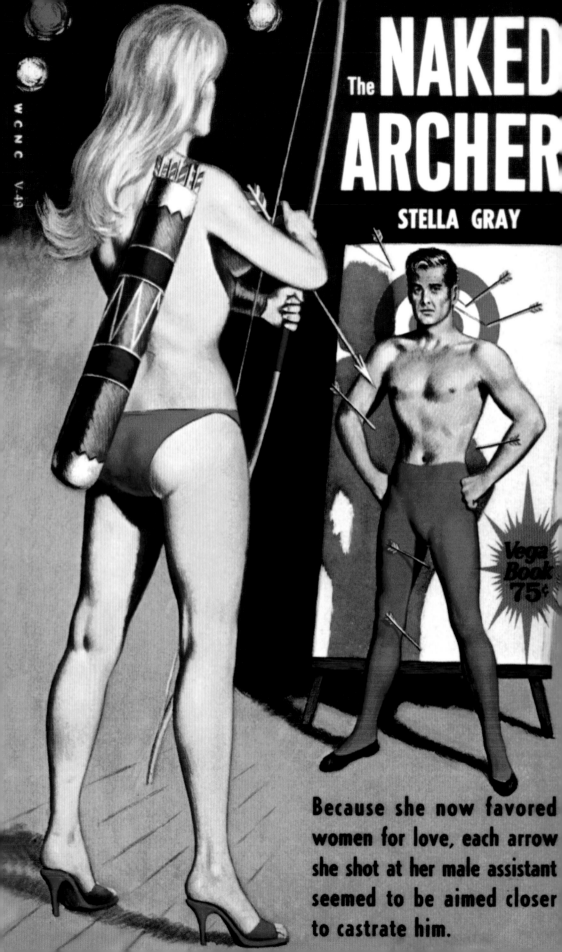

The NAKED ARCHER

STELLA GRAY

Vega Book 75¢

Because she now favored women for love, each arrow she shot at her male assistant seemed to be aimed closer to castrate him.

They came in droves, their jeans jingling with expendable cash, and their eyes gleamed with the desire to see wonders, to experience the thrills of the exotic. They paid to see freaks that would give them nightmares for weeks: a woman with four arms or four breasts, a girl whose head tapered to a grotesque cone, a man with skin the texture of cobblestones. They stood in line and paid good money to see a tired nudie's bobbling breasts and jiggling buttocks. They bought cotton candy that rotted their teeth and gave them no nourishment. They sat on hard splintery benches under the Big Top, half hoping that the pretty trapeze girl would fall thirty feet head-first, half hoping that the bulky bears would seize the tormenting little clowns and rip them to bloody shreds, half hoping that the entire tent would go up in flames and provide them with the biggest kick of all.

John Dexter, *Sex Circus* (Nightstand Books, 1961)

PASSION CARNIVAL (1965)
By Tony Calvano
Evening Readers

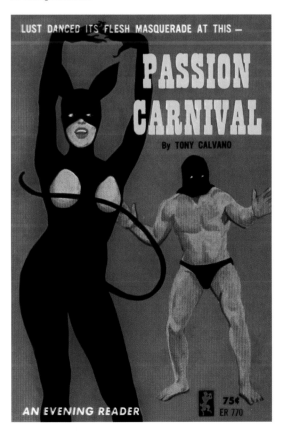

THE NAKED ARCHER (1966)
By Stella Gray
Vega Books
Cover Artist: Bill Edwards

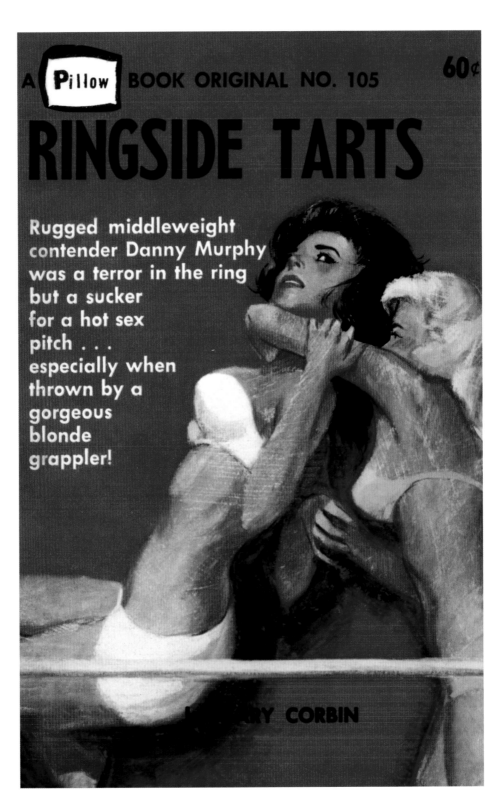

A **Pillow** BOOK ORIGINAL NO. 105

60¢

RINGSIDE TARTS

Rugged middleweight contender Danny Murphy was a terror in the ring but a sucker for a hot sex pitch . . . especially when thrown by a gorgeous blonde grappler!

BY GARY CORBIN

RINGSIDE TARTS (1962)
By Gary Corbin
Pillow Books

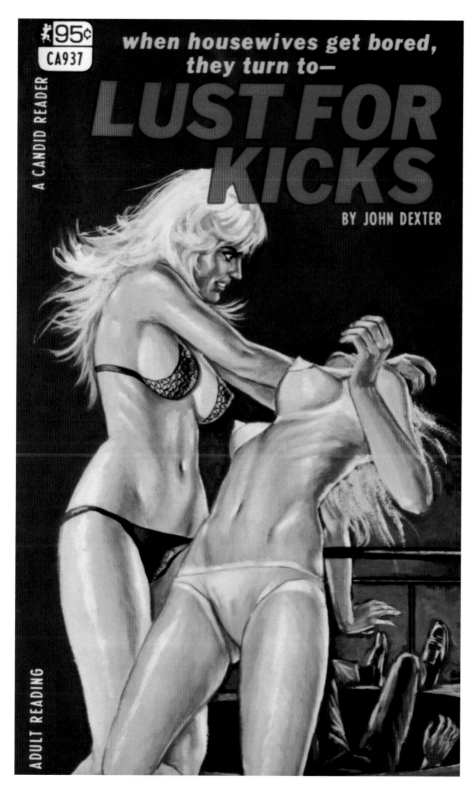

LUST FOR KICKS (1968)
By John Dexter
Candid Reader
Cover Artist: Ed Smith

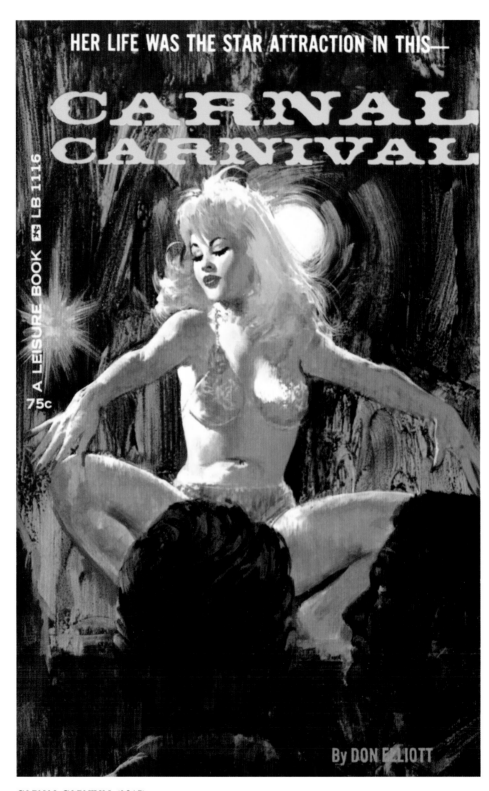

CARNAL CARNIVAL (1965)
By Don Elliott (Robert Silverberg)
Leisure Books
Cover Artist: Robert Bonfils

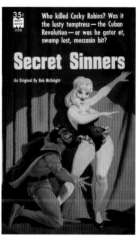

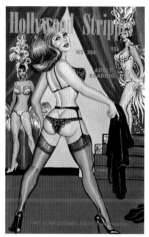

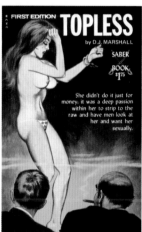

ESCAPE INTO VICE (1962)
By Fletcher Bennett
Playtime Books

BURLESQUE GIRL (1958)
By Orrie Hitt
Beacon Books

SIN STRIPPERS (1964)
By Robert Justin
First Niter
Cover Artist: Eric Stanton

SECRET SINNERS (1960)
By Bob McKnight
Merit Books

HOLLYWOOD STRIPPER (1966)
By Michael Starr
Night Shadow

TOPLESS (1970)
By D.J. Marshall
Saber Books
Cover Artist: Bill Edwards

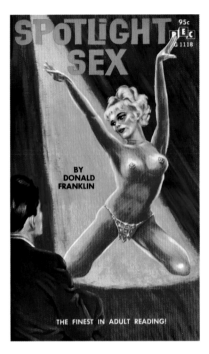

SPOTLIGHT SEX (1966)
By Donald Franklin
P.E.C.
Cover Artist: Doug Weaver

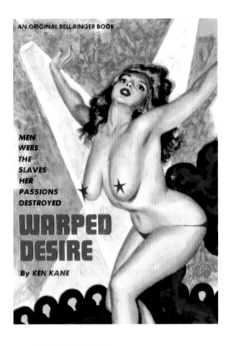

WARPED DESIRE (1964)
By Ken Kane
Bell-Ringer Books

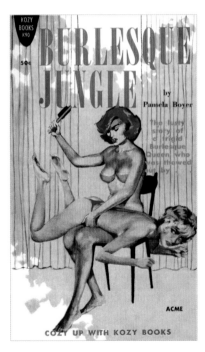

BURLESQUE JUNGLE (1960)
By Pamela Boyer
Kozy Books

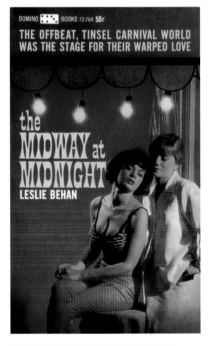

THE MIDWAY AT MIDNIGHT (1964)
By Leslie Behan (Ted Gottfried)
Domino Books

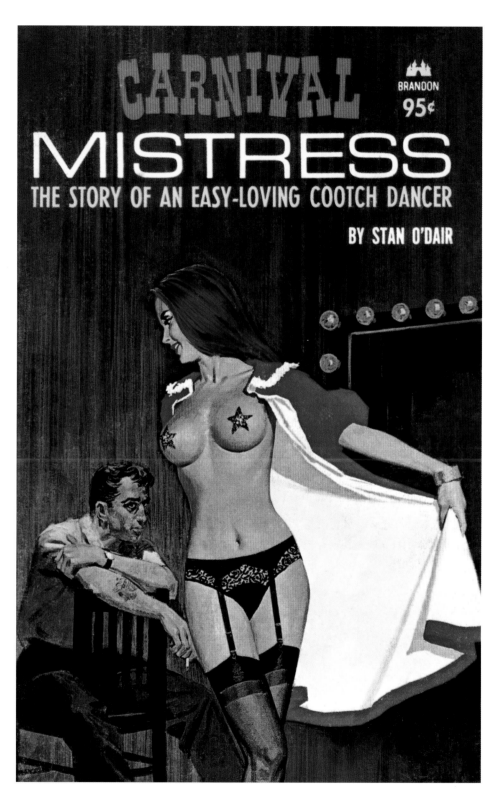

CARNIVAL MISTRESS (1965)
By Stan O'Dair
Brandon House
Cover Artist: Fred Fixler

Regina was no virgin... she took on
the beauty contest judges one at
a time... and
sometimes
all at once!

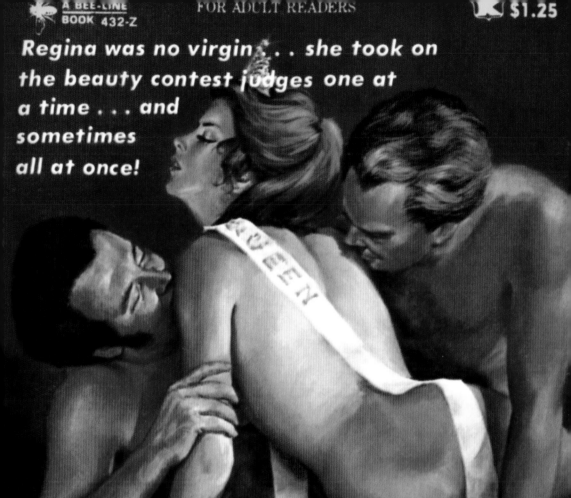

BEAUTY QUEEN ORGIES

By Regina Reardon

WINNER TAKE ALL (1965)
By Mark Clements
Midwood
Cover Artist: Paul Rader

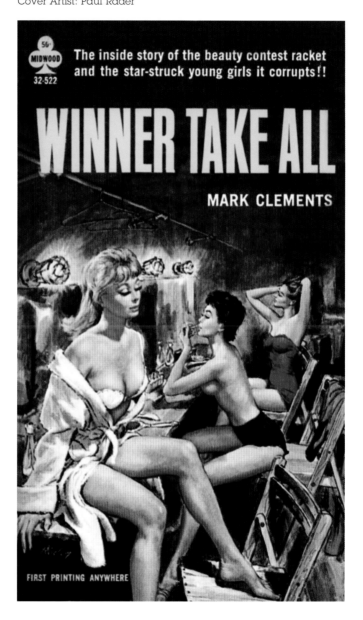

BEAUTY QUEEN ORGIES (1970)
By Regina Reardon
Bee-Line Books

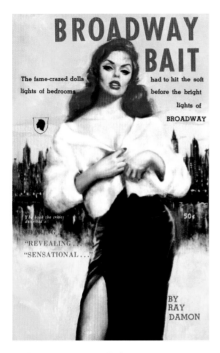

BROADWAY BAIT (1959)
By Ray Damon
Chariot Books

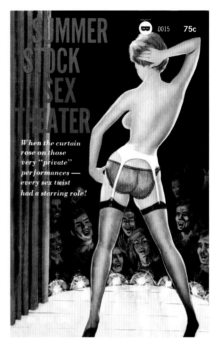

SUMMER STOCK SEX THEATER (1964)
By Sam Ord
Boudoir Books

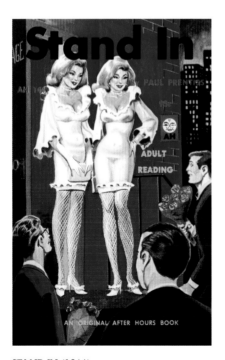

STAND IN (1966)
By Paul Prentiss
After Hours
Cover Artist: Eric Stanton

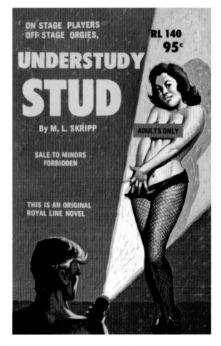

UNDERSTUDY STUD (1966)
By M.L. Skripp
Royal Line Novels

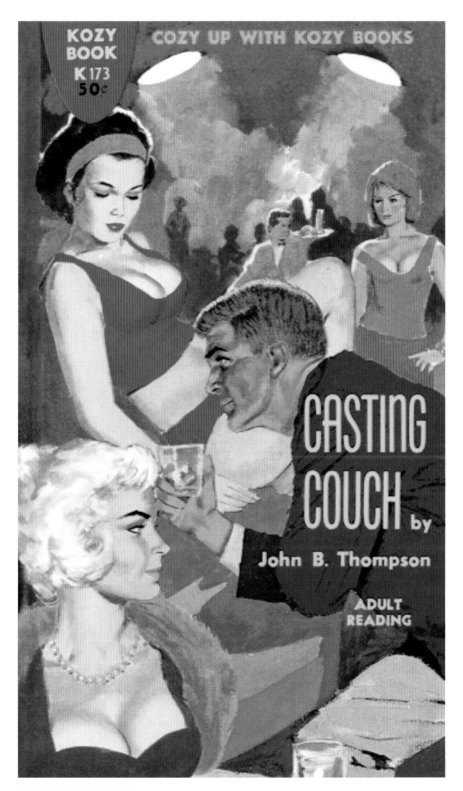

CASTING COUCH (1962)
By John B. Thompson
Kozy Books

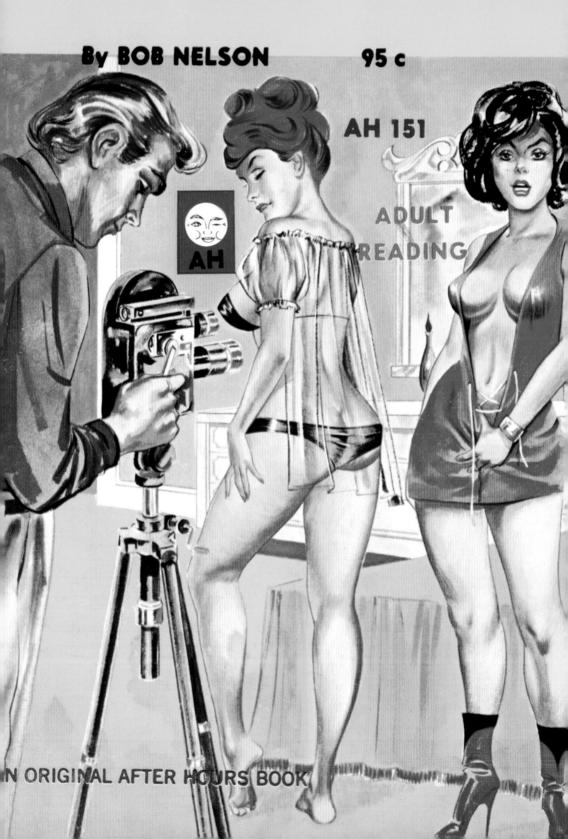

Private Pose

By BOB NELSON

95 c

AH 151

ADULT READING

I opened the door for her, followed her into the small room, closed
the door behind us. A roll of white seamless paper hung from one
wall and in the middle of the floor a set of photofloods were aimed at it.
Miscellaneous props cluttered one corner. A nearby door bore the sign
DARKROOM—KEEP OUT. It was a simple layout, since I prefer location
shots, but Mary Louise Miller seemed impressed. I grabbed a loaded
Rollei from the camera equipment.

"Okay, take off your clothes and we can get started."

She hesitated. "I—I didn't bring a bathing suit with me."

"You won't need a bathing suit," I said, "Bathing suit shots are passé.
What we want are nudes, semi-nudes, lingerie stuff."

She gulped. I nodded.

Eric Thomas, *Virgin on the Rocks* (All Star Books, 1961)

F.-STOP SWAP (1969)
By Scott Grant
P.E.C.

PRIVATE POSE (1967)
By Bob Nelson
After Hours
Cover Artist: Bill Alexander

GODDESS OF VICE (1967)
By J.X. Williams
Pleasure Readers
Cover Artist: Ed Smith

DEGRADATION TRAIL (1966)
By Alan Marshall
Leisure Books
Cover Artist: Robert Bonfils

ORGY LAIR (1965)
By Clyde Allison (William Knoles)
Sundown Readers

SIN-EMA QUEEN (1961)
By Adam Coulter
Epic Books

the **SEX PEDDLER**

60c

by **WADE HUNTER**

He was always chasing the rainbow . . . usually a fast buck or a fast broad?

THE SEX PEDDLER (1963)
By Wade Hunter
Playtime Books
Cover Artist: Robert Bonfils

Radio

al Sex

Linda Slack, Mac's thirtyish wife, rested her head on his thighs and idly massaged his body through his worn Levi's as he spoke weird thoughts...

"I was so lousy sick of everything, life, screwing, eating—you know—that my brain felt black it was so dirty straining square muck through it year after year. So, man, I opened up my skull by cutting around the crown with an exacto knife... a leftover from my model-airplane days... like opening a pumpkin, see, dig? ... and verrry carefully disconnected all the wires and lifted my brain out. Man, it's surprising how much my brain weighs. Then I put it to soak in the bathroom washbowl in hot water and Oxydol all night.

It came out all white and kind of ... well ... pure looking, you know? But one thing keeps bugging me. Did I put it back in backwards?"

Richard E. Geis, *Bongo Bum* (Brandon House, 1966)

STREETS OF SIN

By Mark Ryan

A powerful novel
of wild delinquents
on the prowl...
delving into the
fruits of forbidden
desires and violents
passions!

THIS IS
AN ORIGINAL
BEDSIDE BOOK

THE TENEMENT KID (1959)
By Karl Edd
Newsstand Library

the tenement kid

50¢

by karl edd

Unwatched and unwanted, kids spawned from drunken orgies throng the streets. They live by their own code, respect only the law of the knife and the knuckle, and the whore is their emblem of womanhood. . . .

STREETS OF SIN (1959)
By Mark Ryan (Robert Silverberg)
Bedside Books

GANG GIRLS (1963)
By Rand Crawford
Playtime Books
Cover Artist: Robert Bonfils

THE YOUNG CATS (1967)
By Robert Kornfield
New Library

He glanced around, hoping to see some faces who would loan him a
buck. But the faces were all cold tonight, familiar, yet not intimate.
Dark faces, unshaven, perched sullenly above the leather of their jackets,
or faces made up, seemingly, of deep-set eyes, blankly staring, waiting
for the connection that never comes. Here an eye, bright, indiscrete gay,
searching for an instant of revelation in a subway john with hustler for
a quarter a throw. And there, now and then passing, a woman, her
buttocks inviting whistles, her hair reflecting the myriad glitter of the
neon lights, and her profession—the oldest one—clearly etched in the
lines around her eyes.

David Spencer, *All Kinds of Loving* (Brandon House, 1965)

NEON JUNGLE (1966)
By J.D. Blake
P.E.C.
Cover Artist: Doug Weaver

NEON JUNGLE

BY
J. D. BLAKE

95c

P E C
N 146

THE FINEST IN ADULT READING!

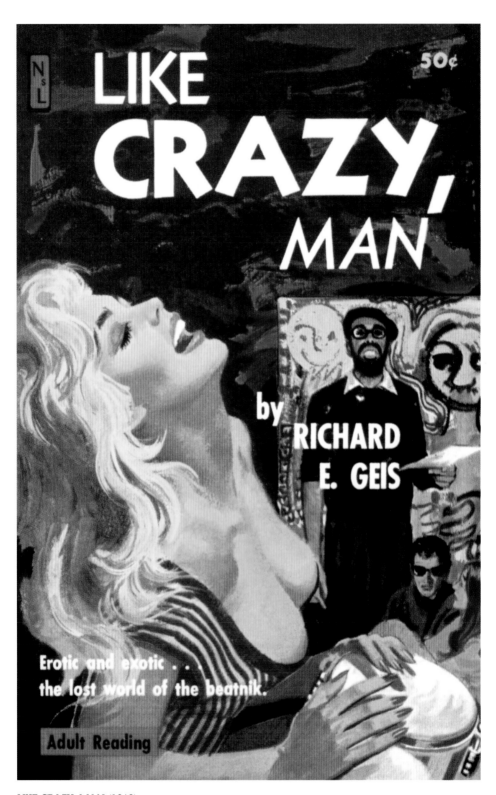

LIKE CRAZY, MAN (1960)
By Richard E. Geis
Newsstand Library
Cover Artist: Robert Bonfils

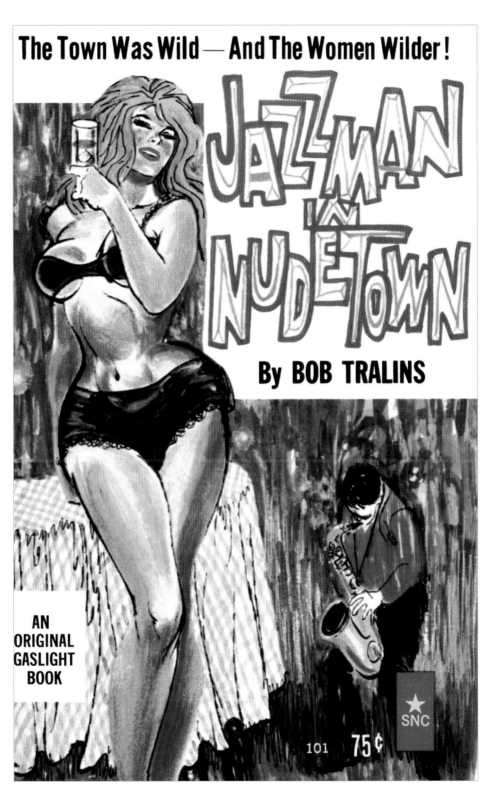

JAZZMAN IN NUDETOWN (1964)
By Bob Tralins
Gaslight Books

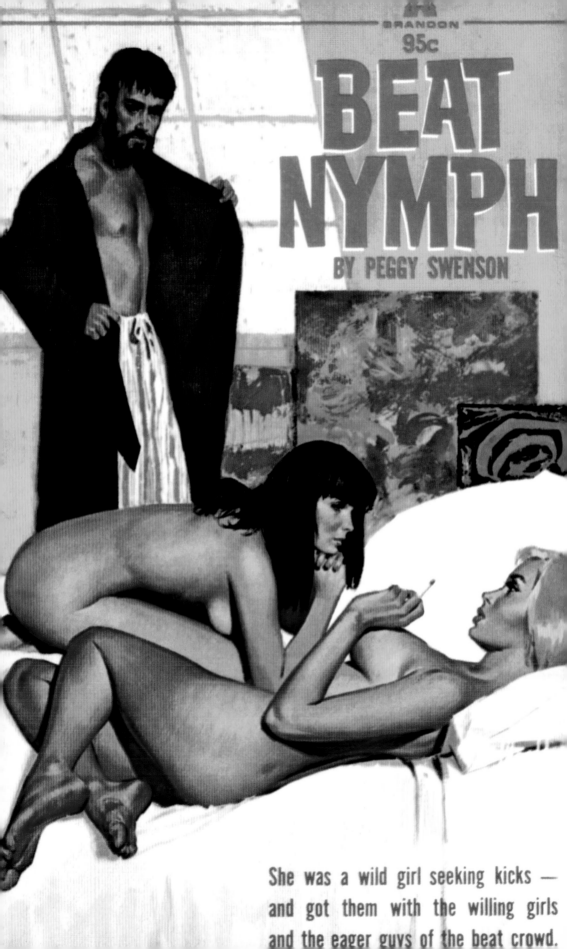

BRANDON

95c

BEAT NYMPH

BY PEGGY SWENSON

She was a wild girl seeking kicks —
and got them with the willing girls
and the eager guys of the beat crowd.

The Beats are free. Not chained by a social shuck like the marriage vows. They stick as long as they enjoy life together. Why louse up a relationship with 'Til death do us part' a twenty thousand dollar house, a fifteen thousand dollar mortgage, and a lifetime of slavery to bigger cars, bigger refrigerators, and a carload of mechanical junk you're constantly yakked at to buy buy buy? Who benefits from those sacred marriage vows? The guy who marries you, the state and city, and the shysters who make it when you break up. They've got you by the balls with their laws.

Richard E. Geis, *Like, Crazy Man* (Newsstand Library, 1960)

THE BEATNIKS (1962)
By Richard E. Geis
Dollar Double
Cover Artist: Robert Bonfils

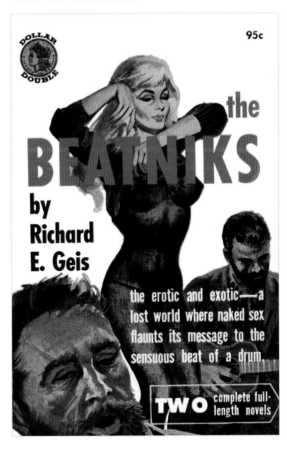

the
BEATNIKS
by Richard E. Geis

95c

the erotic and exotic——a lost world where naked sex flaunts its message to the sensuous beat of a drum.

TWO complete full-length novels

BEAT NYMPH (1965)
By Peggy Swenson (Richard E. Geis)
Brandon House
Cover Artist: Fred Fixler

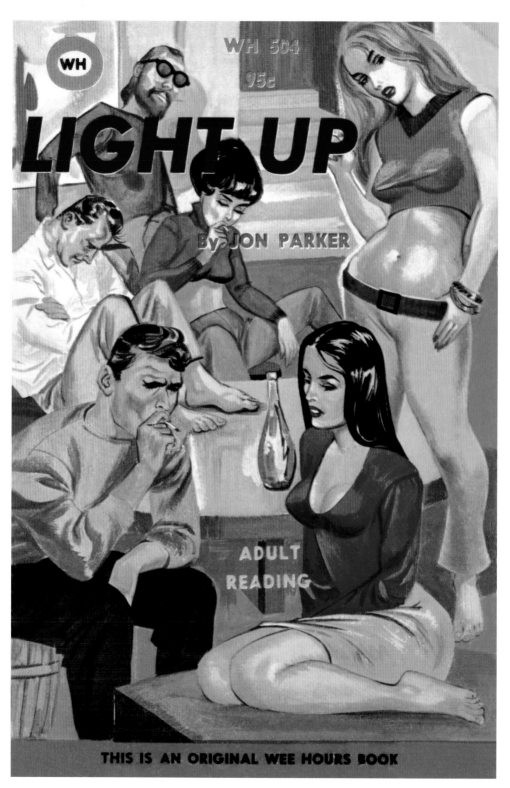

LIGHT UP (1966)
By Jon Parker
Wee Hours
Cover Artist: Bill Alexander

THE JAZZ SINNER (1966)
By Andrew Shaw
Leisure Books
Cover Artist: Robert Bonfils

PADS ARE FOR PASSION (1961)
By Sheldon Lord
Beacon Books

FRATERNITY OF LUST (1964)
By Wilton Grady
Saber Books

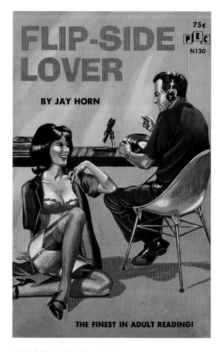

FLIP-SIDE LOVER (1966)
By Jay Horn (Ron Haydock)
P.E.C.
Cover Artist: Doug Weaver

ROCK ME BABY! (1963)
By Greg Randolph
Intimate Edition

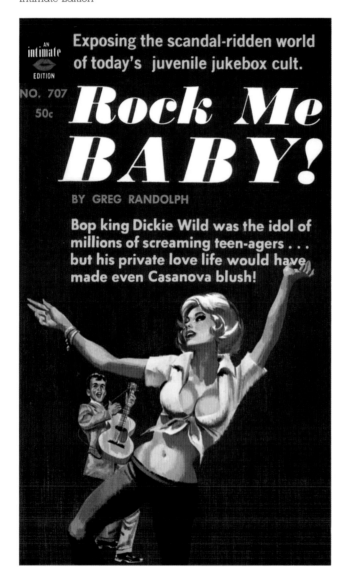

SEX A GO GO (1966)
By Russ Trainer
Exotik

Sex·A·GoGo

By RUSS TRAINER

The famous rock 'n' roll group played cool songs to kindle hot passions. And their young fans wouldn't deny them anything.

W-22 95c

EB

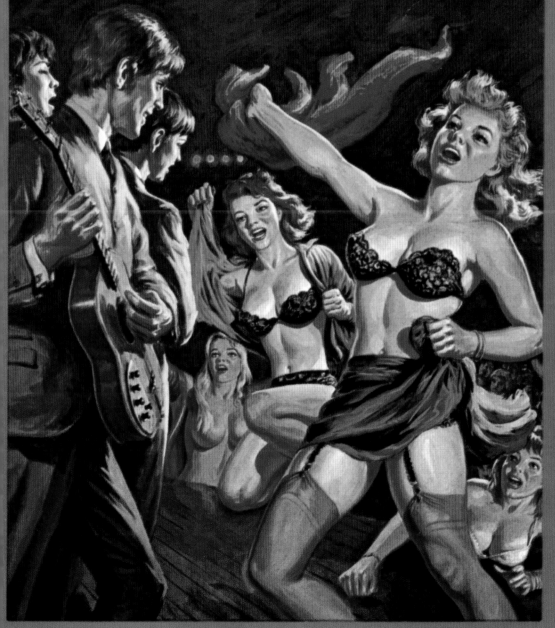

EXOTIK BOOK COLLECTORS EDITION

SHE WAS THE SIN-QUEEN
OF A THRILL-CRAZED RENEGADE BAND!

HOT ROD
ROGUES

—By ANDREW SHAW—

95¢

EL375

ADULT READING

CYCLE FURY (1967)
By Reggie Carr
Chevron

COED FOR HIRE (1966)
By Bud Masters
Satan Press
Cover Artist: Gene Bilbrew

Everyone inside the cramped Spoke Bar and Grill looked remote, as
though they'd been sketched from some dreamer's lethargy.

Big, sweaty faces laughed raucously, while the smells of sweat and
sweet perfume and cigarette smoke filled the murky, hot air.

Ace Bishop was at the end of the bar, leering at a young girl. His
leather jacket was unzipped, his shirt clinging to his thick chest. The
motorcycle cap was pushed back on his head, allowing the greasy
curls to coil about his forehead.

Two other Diamond-Backs, one that toad-faced guy, were hovering
nearby, guzzling beer.

I saw Lucky hunched over the pinball machine, his back to Ace and
the girl as though he were hiding. The colored lights blinked crazily above
the machine, and he turned away with a pained look.

Then he spotted me.

Neil Egri (John Gilmore), *Strange Fire* (France, 1963)

HOT ROD ROGUES (1967)
By Andrew Shaw
Ember Library
Cover Artist: Robert Bonfils

HIPPIE HARLOT (1967)
By Tom O'Brien
Cougar Publications

Now, Lila felt the effects of LSD. "Mmmm, this is good...a sultan in a harem ... my shadow ... I want to love my shadow..." Nervous fingers tugged at her own sweater.

In a moment, it was over her head and on the floor. Her enormous breasts plopped free, then came to a dizzy bounce, pointing forward. Already, her nipples were as rigid as red crayons; moist crevices with droplets of scented perspiration dominated the enormity of the twin globes. The nipples were like bright red strawberries, capping the milky white breasts.

"I want my rider ... ride me like a horse..." She was babbling now, hurling herself at Lloyd who always hated her when she was like this. He had a good idea of what she wanted. "Ride me in the race..."

At one party of LSD and reefers, she got so high, she started crawling all over the floor while other hopheads would ride her like a horse... and then use her like some farm animal! It was sickening.

Jon Parker, *Light Up* (Wee Hours, 1966)

SEX, POT AND ACID (1968)
By George Bailey
Viceroy

VP 290 / $1.75

SEX, POT AND ACID

LSD and marijuana: are their powers
over our youth really meant for
mind awakenings or for sex cravings?

by GEORGE BAILEY

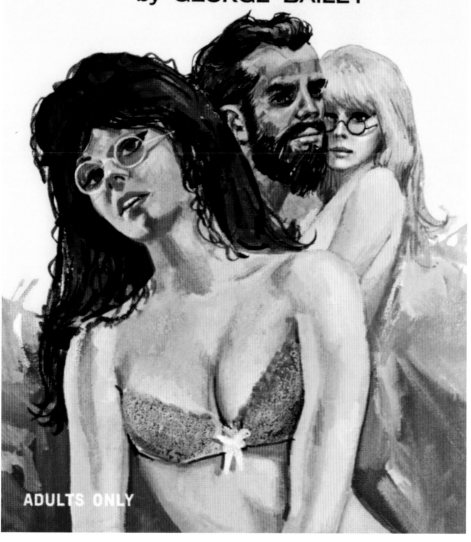

ADULTS ONLY

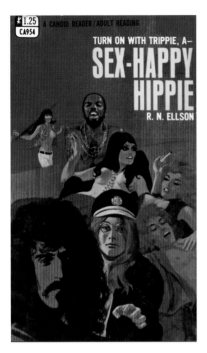

SEX-HAPPY HIPPIE (1968)
By R.N. Ellson
Candid Reader
Cover Artist: Darrel Millsap

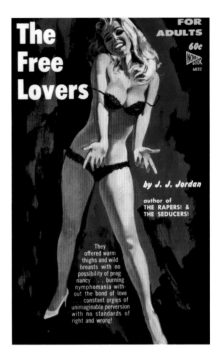

THE FREE LOVERS (1962)
By J.J. Jordan
Novel Books
Cover Artist: Robert Bonfils

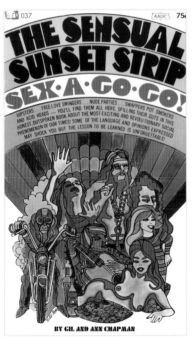

THE SENSUAL SUNSET STRIP (1967)
By Gil and Ann Chapman
Century Books

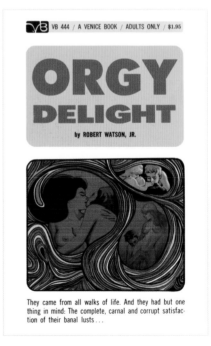

ORGY DELIGHT (1970)
By Robert Watson Jr.
Venice Books

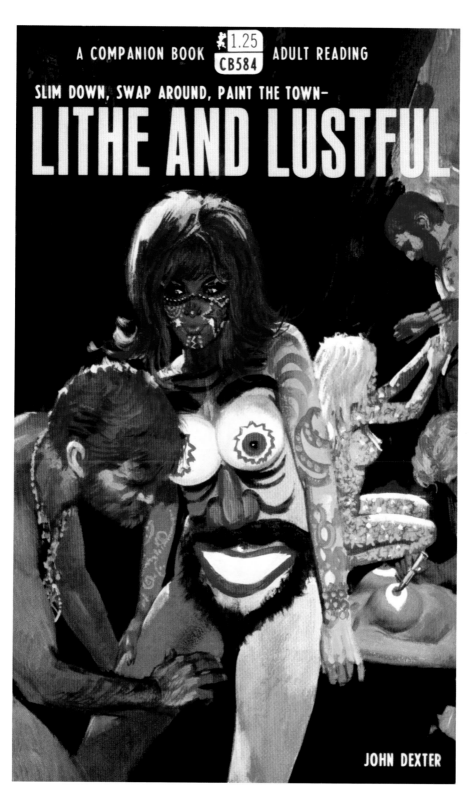

LITHE AND LUSTFUL (1968)
By John Dexter
Companion Books
Cover Artist: Robert Bonfils

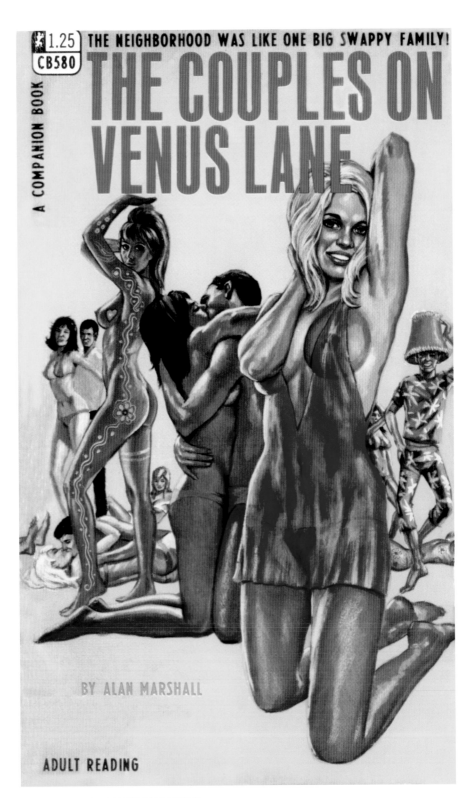

THE COUPLES ON VENUS LANE (1968)
By Alan Marshall
Companion Books
Cover Artist: Ed Smith

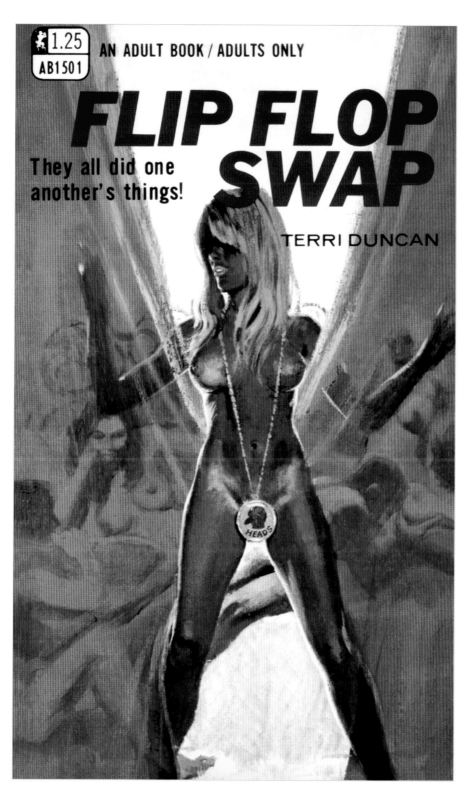

1.25
AB1501

AN ADULT BOOK / ADULTS ONLY

FLIP FLOP SWAP

They all did one
another's things!

TERRI DUNCAN

FLIP FLOP SWAP (1969)
By Terri Duncan
Greenleaf Classics

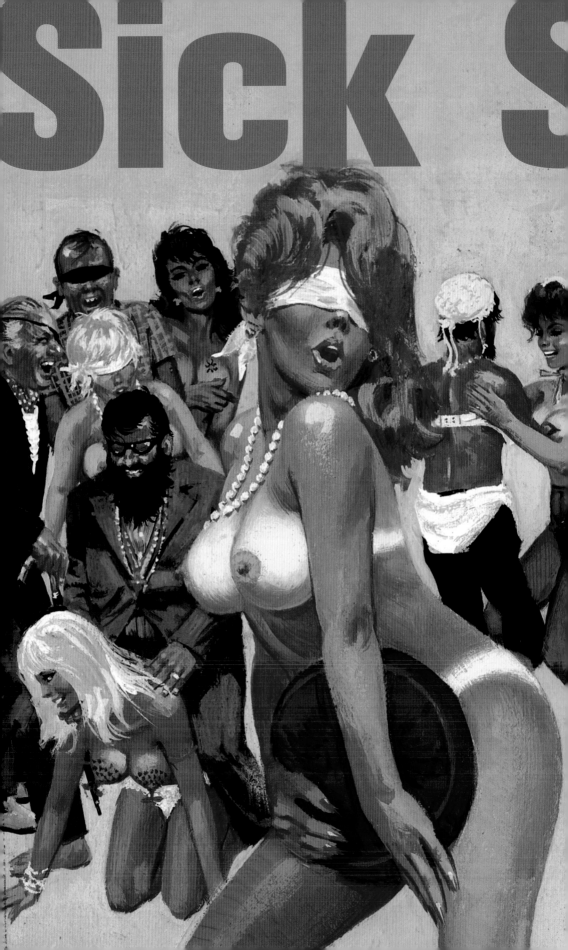

uburb

Tammy and Candy woke their brothers,
Floyd and Tod.

"Come on!" Tammy said, "We've some-
thing to show you!" The four youngsters
crept downstairs, opening the kitchen door
a crack to peep through the living room.
Their parents were having an orgy.
The wives had mounted other husbands'
shoulders—backwards—the men staggering
blindly, faces between lush female thighs.

Amanda Fife, *Multi-Swap* (Rapture Books, 1968)

Original Art from LUST AND CONSEQUENCES (1967)
By John Dexter
Pleasure Readers
Cover Artist: Robert Bonfils
From the Collection of Jeff Rich

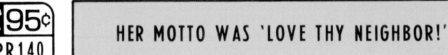

HER MOTTO WAS 'LOVE THY NEIGHBOR!'

SEXUS SUBURBIA

JOHN DEXTER

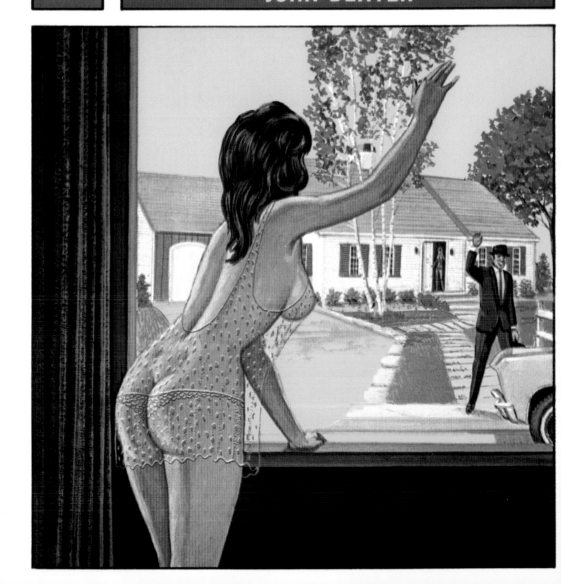

LUST TRADERS (1962)
By Tony Calvano
Nightstand Books
Cover Artist: Harold W. McCauley

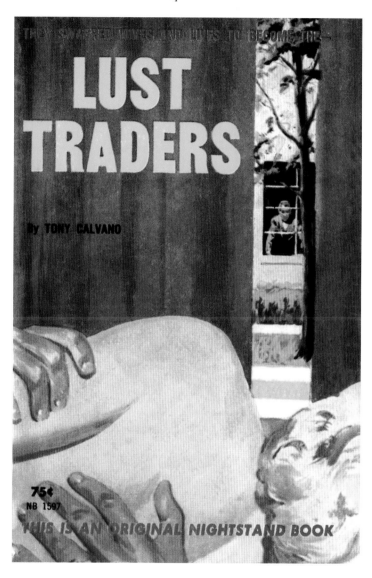

SEXUS SUBURBIA (1967)
By John Dexter
Pleasure Readers
Cover Artist: Ed Smith

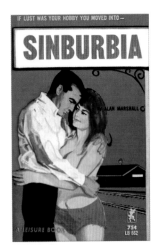

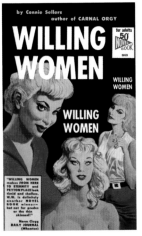

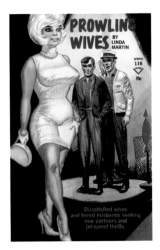

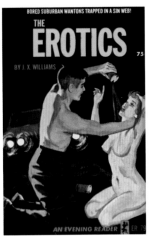

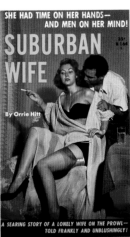

SINBURBIA (1964)
By Alan Marshall
Leisure Books
Cover Artist: Robert Bonfils

WILLING WOMEN (1960)
By Connie Sellers
Novel Books

PROWLING WIVES (1967)
By Linda Martin
Chevron
Cover Artist: Gene Bilbrew

THE EROTICS (1965)
By J.X. Williams
Evening Readers

SUBURBAN WIFE (1958)
By Orrie Hitt
Beacon Books

SUBURBAN SEX (1963)
By Greg Caldwell
Bedside Books

CB
194

IS ADULTERY THE ANSWER
TO A FRIGID HUSBAND?

SUBURBAN

the shocking story of GINA, whose
affairs blew the lid off a ritzy
town!

SEXPOT

by

E. S. Seeley Jr.

SUBURBAN SEXPOT (1961)
By E.S. Seeley Jr.
Chariot Books

She stepped out of her clothes and into trouble.

Operation: SEX

By KIMBERLY KEMP

FIRST
PRINTING
ANYWHERE

K
50¢
MIDWOOD

NO. F181

Working undercover was Colleen's duty
playing between the covers, her pleasure.

He broke out in a beaded sweat. He could not control his urges
much longer. In a few moments, with his high powered binoculars
in hand, he would dart in and out of doorways, searching for
parked autos along this darkened lover's lane, and peep upon
passionate amour.

John preferred looking through bedroom windows where erotica
had more room and exploratory ground but such opportunities
were infrequent.

Richard Allen, *Peeping John* (After Hours, 1964)

THE PEEPING SWAPPER (1968)
By Rex Weldon
P.E.C.

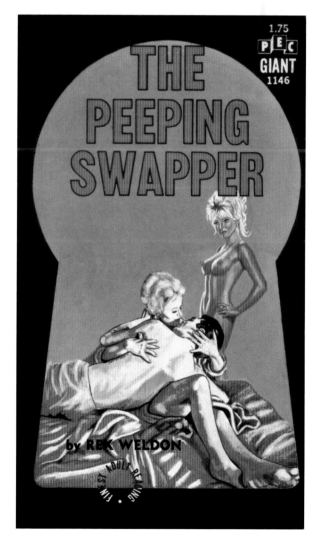

OPERATION: SEX (1962)
By Kimberly Kemp (Gil Fox)
Midwood
Cover Artist: Paul Rader

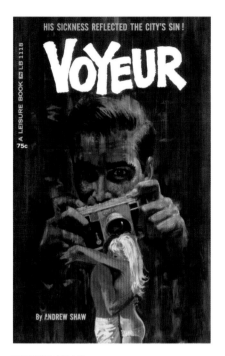

VOYEUR (1965)
By Andrew Shaw
Leisure Books
Cover Artist: Robert Bonfils

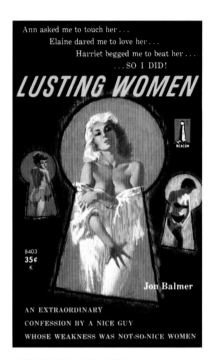

LUSTING WOMEN (1961)
By Jon Balmer
Beacon Books

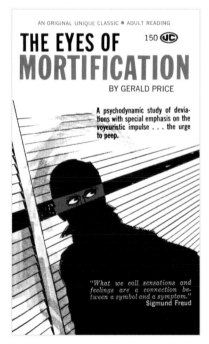

THE EYES OF MORTIFICATION (1967)
By Gerald Price
Unique Books

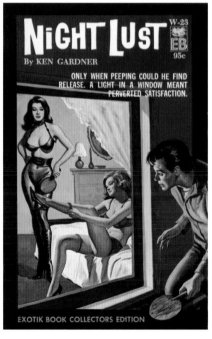

NIGHT LUST (1966)
By Ken Gardner
Exotik

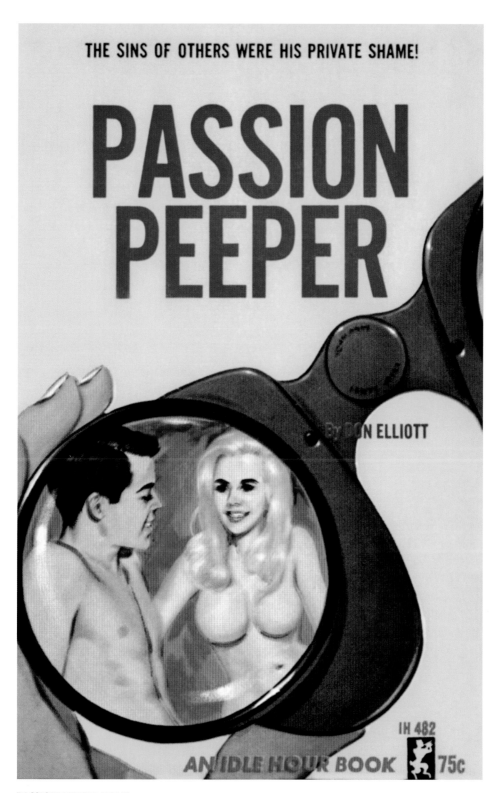

PASSION PEEPER (1965)
By Don Elliott (Robert Silverberg)
Idle Hour
Cover Artist: Darrel Millsap

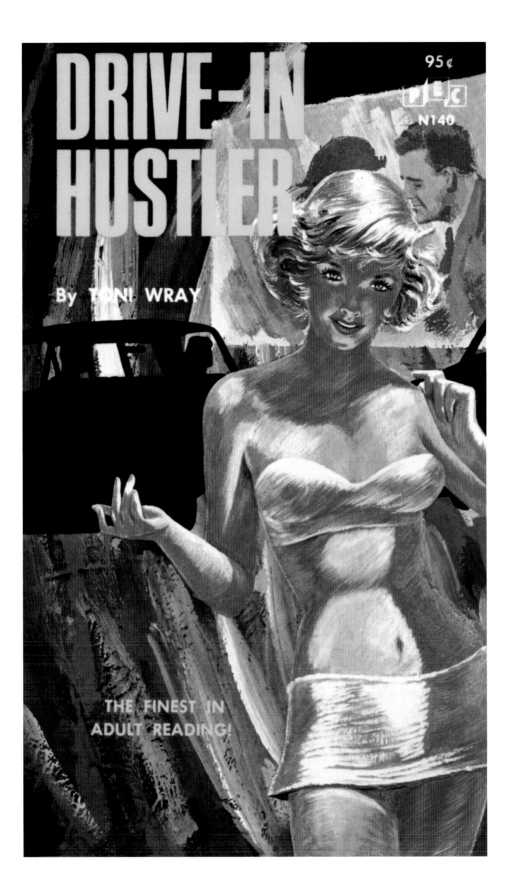

DRIVE-IN HUSTLER

By TONI WRAY

THE FINEST IN
ADULT READING!

95¢

PEC

N140

Fran went to work that night with a heavy heart. Gary had left on a sales trip into Arizona and would be gone for about three weeks. Until he returned she was stuck to her job at the drive-in movie. She would have to put her love for Gary out of her mind and try to steel herself to selling her body. Cold, without feeling.

Don't think about it, Fran, she told herself. Think about something else. Anything. Get it over with fast. Pretend you're someone else. Do something. Anything. Watch the movie. That's it! Watch the movie while they're getting their money's worth. As long as you can...

Tony Wray, *Drive-In Hustler* (P.E.C., 1966)

SEX ALLEY (1966)
By Ron Gold
P.E.C.
Cover Artist: Doug Weaver

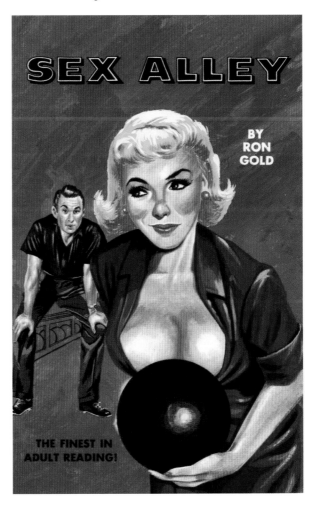

DRIVE-IN HUSTLER (1966)
By Tony Wray
P.E.C.

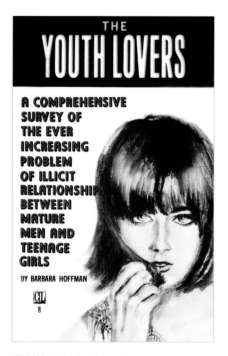

THE YOUTH LOVERS (1965)
By Barbara Hoffman
Classics Library

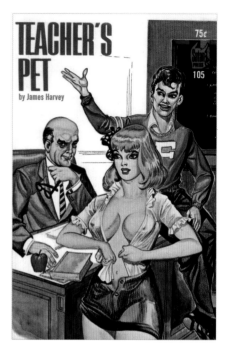

TEACHER'S PET (1965)
By James Harvey
Satan Press
Cover Artist: Gene Bilbrew

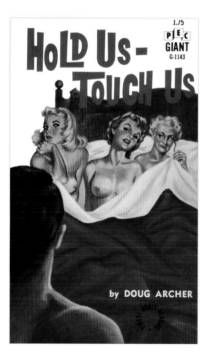

HOLD US–TOUCH US (1968)
By Doug Archer
P.E.C.
Cover Artist: Doug Weaver

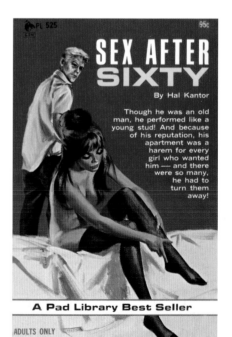

SEX AFTER SIXTY (1966)
By Hal Kantor
Pad Library

MOTHER IN LAW (1967)
By Peter Willow
Wee Hours
Cover Artist: Bill Ward

FALLING IN LUST

WHEN HUBBY WASN'T HANDY, SHE CALLED MISTER FIXIT!

By ANDREW SHAW

A COMPANION BOOK

CB518 95¢

FALLING IN LUST (1967)
By Andrew Shaw
Companion Books
Cover Artist: Ed Smith

148

TO SWAP A WANTON (1967)
By Gil Marlowe
Nightstand Books
Cover Artist: Darrel Millsap

THE MINI MINX (1967)
By Steve Langley
Late Hour Library

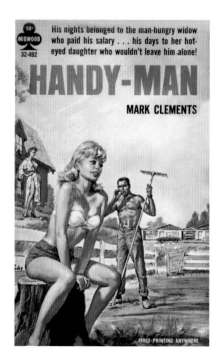

HANDY-MAN (1965)
By Mark Clements
Midwood
Cover Artist: Paul Rader

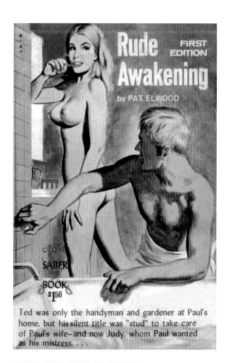

RUDE AWAKENING (1970)
By Pat Elwood
Saber Books
Cover Artist: Bill Edwards

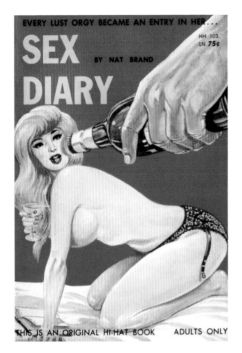

SEX DIARY (1963)
By Nat Brand
Hi-Hat

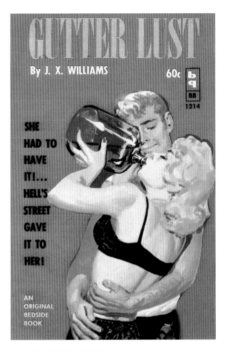

GUTTER LUST (1962)
By J.X. Williams
Bedside Books

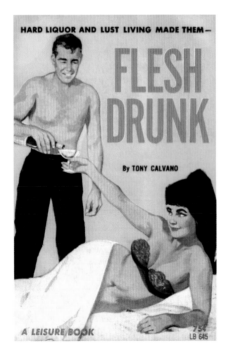

FLESH DRUNK (1964)
By Tony Calvano
Leisure Books

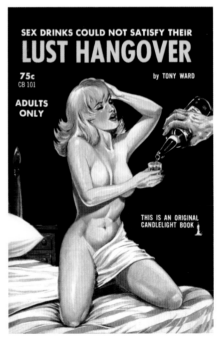

LUST HANGOVER (no date)
By Tony Ward
Candlelight Books

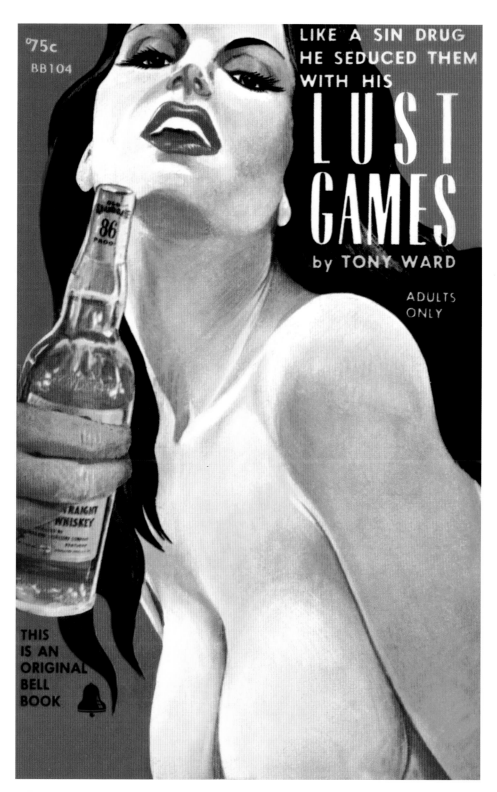

LUST GAMES (1964)
By Tony Ward
Bell Books

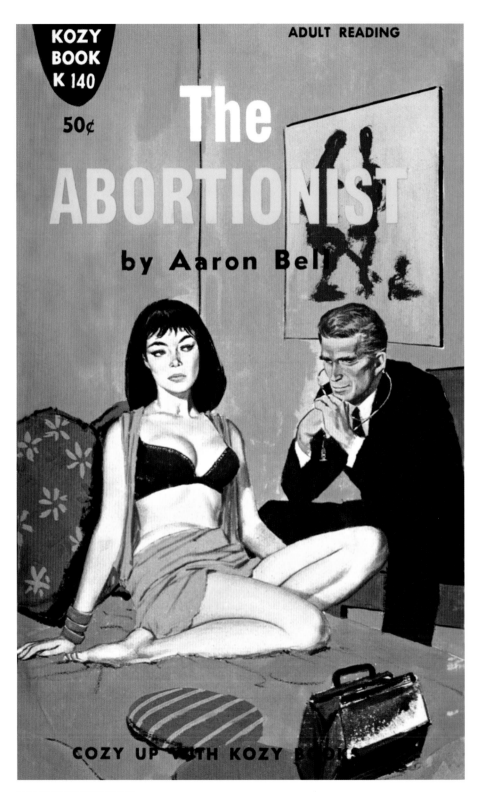

THE ABORTIONIST (1961)
By Aaron Bell
Kozy Books

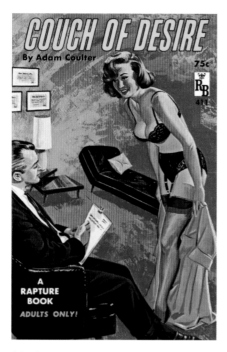

COUCH OF DESIRE (1965)
By Adam Coulter
Rapture Books

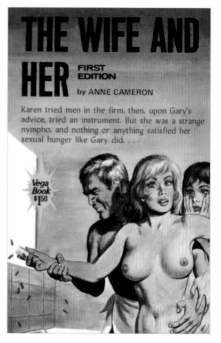

THE WIFE AND HER (1971)
By Anne Cameron
Vega Books
Cover Artist: Bill Edwards

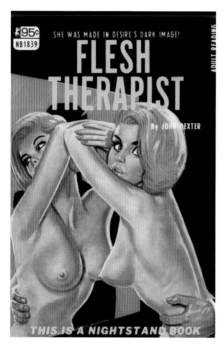

FLESH THEPAPIST (1967)
By John Dexter
Nightstand Books
Cover Artist: Tomas Cannizarro

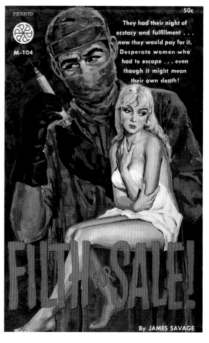

FILTH FOR SALE! (1961)
By James Savage
Period Books

I am what I am and that's that. He had a lot of big words to explain it, but I can cut all his big words down into three little ones:

I like sex.
I like men.
I like the things men do to me.
I like the things I do to men.
And it all adds up to three little words.
I like sex.

John Dexter, *Sin Diary* (Evening Readers, 1965)

ANY MAN WILL DO (1963)
By Greg Hamilton
Midwood
Cover Artist: Paul Rader

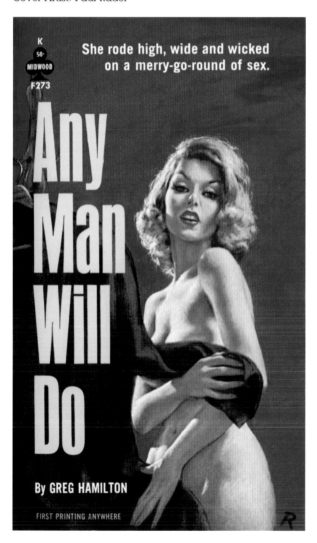

ANYTHING GOES (1960)
By Robert Carney
Newsstand Library
Cover Artist: Robert Bonfils

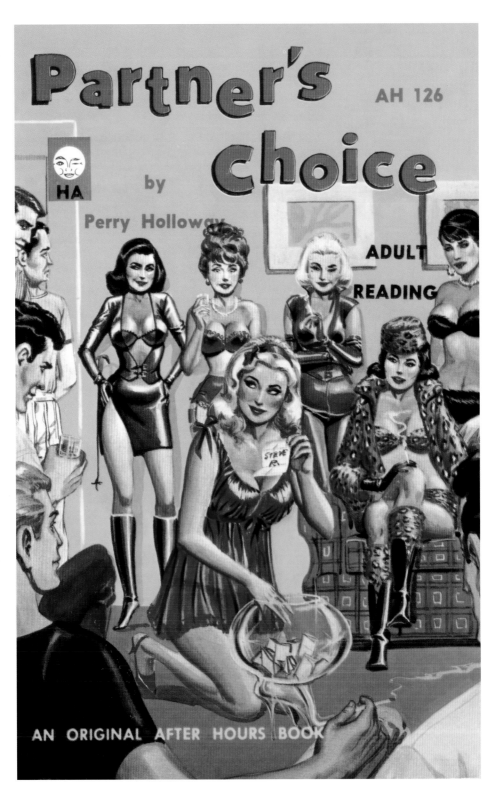

PARTNER'S CHOICE (1965)
By Perry Holloway
After Hours
Cover Artist: Eric Stanton

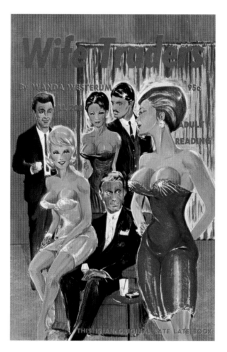

WIFE TRADERS (1967)
Wanda Westerum
Late Late Books

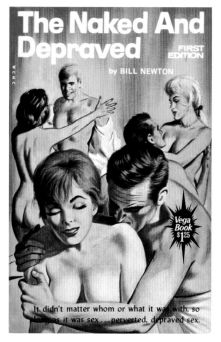

THE NAKED AND DEPRAVED (1969)
By Bill Newton
Vega Books
Cover Artist: Bill Edwards

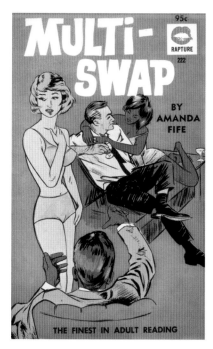

MULTI-SWAP (1968)
By Amanda Fife
Rapture Books

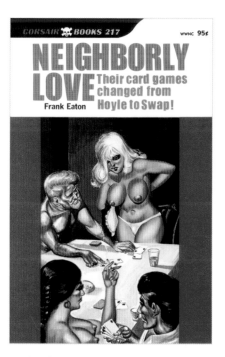

NEIGHBORLY LOVE (1968)
By Frank Eaton
Corsair
Cover Artist: Gene Bilbrew

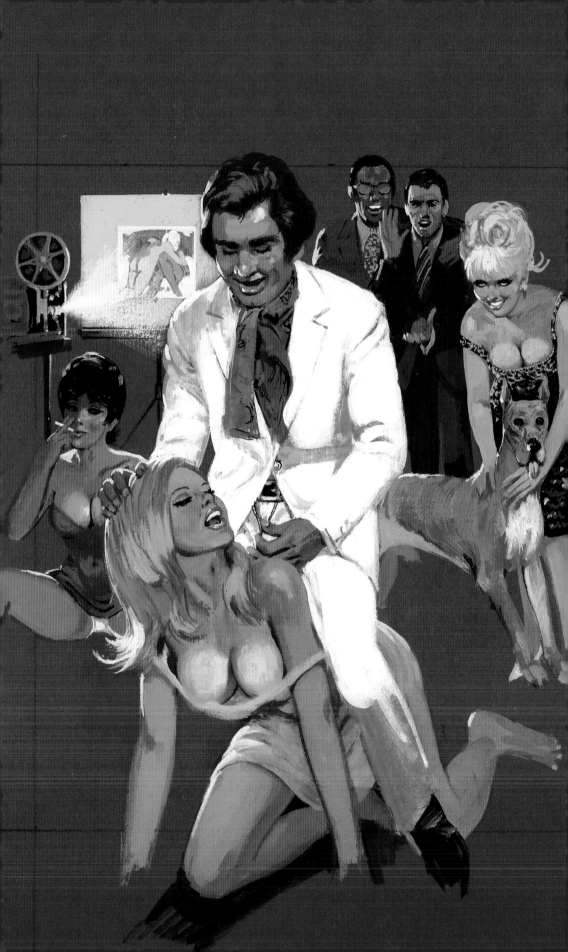

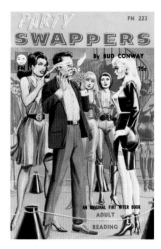 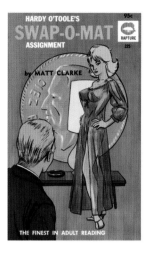 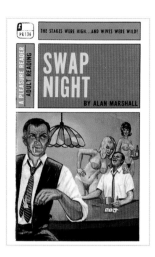

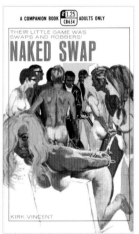 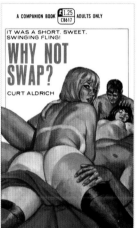 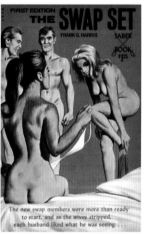

PARTY SWAPPERS (1965)
By Bud Conway
First Niter
Cover Artist: Eric Stanton

HARDY O'TOOLE'S SWAP-O-MAT ASSIGNMENT (1968)
By Matt Clarke
Rapture Books

SWAP NIGHT (1967)
By Alan Marshall
Pleasure Readers
Cover Artist: Ed Smith

NAKED SWAP (1969)
By Kirk Vincent
Companion Books
Cover Artist: Robert Bonfils

WHY NOT SWAP? (1969)
By Curt Aldrich
Companion Books
Cover Artist: Ed Smith

THE SWAP SET (1969)
By Frank G. Harris
Saber Books
Cover Artist: Bill Edwards

Original *La Dolce Vita*-influenced art from unknown title
Cover Artist: Robert Bonfils
From the Collection of Jeff Rich

"I was talking to Barb today... about us," she began. "She thinks all we need is a little change, a chance to get rid of our frustrations and get back to thinking normally again. She and Dave suggested that we spend the evening with them."

Frank set his glass down on the table beside him and turned to face her. "How is that going to help?"

Sue had been hesitant to come out with the offer, but she knew it was now or never.

"You know as well as I do that they have a pretty free sex life. They want us to join them."

Frank took a second to be sure he'd heard her correctly, then he shook his head. "You mean swap partners?"

Sue hadn't expected him to be for it, and she wasn't discouraged by the look of disbelief on his face.

"Yes... I guess that's about it," she admitted.

Frank leaned back against the couch and reached for his drink. His thoughts went to Barbara. He'd often wanted to find out how good she was in bed, but he'd never even imagined himself actually doing it, especially with Sue's blessing.

Don Bellmore, *Swap Fever* (Companion Books, 1968)

1,2,3... SWAP! (1969)
By Curt Aldrich
Greenleaf Classics
Cover Artist: Darrel Millsap

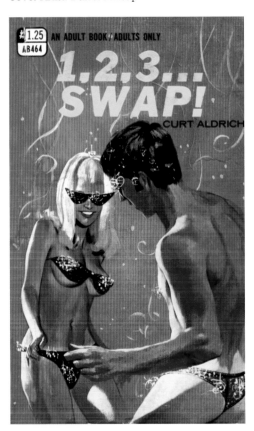

Original Art From SWAPEROO (1969)
By Curt Aldrich
Companion Books
From the Collection of Jeff Rich

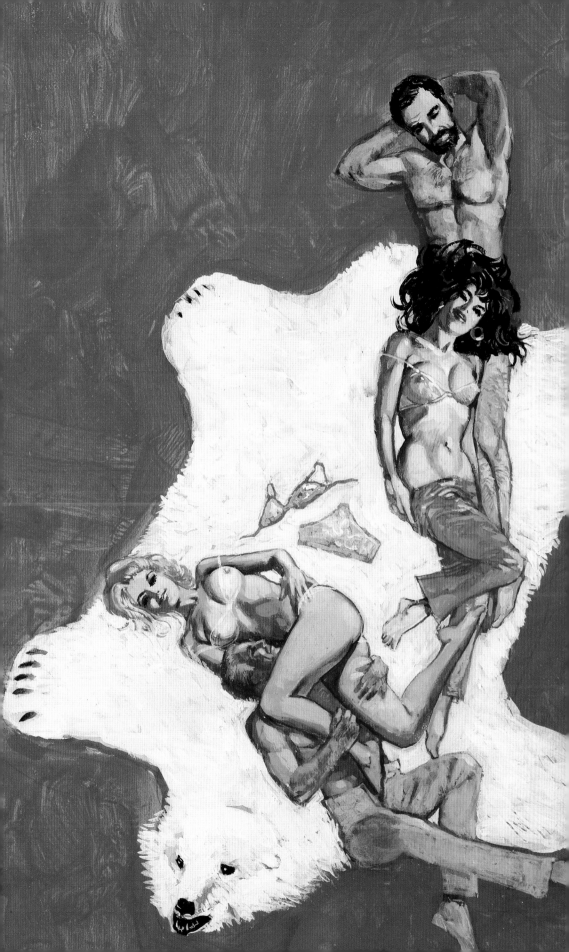

Sex A

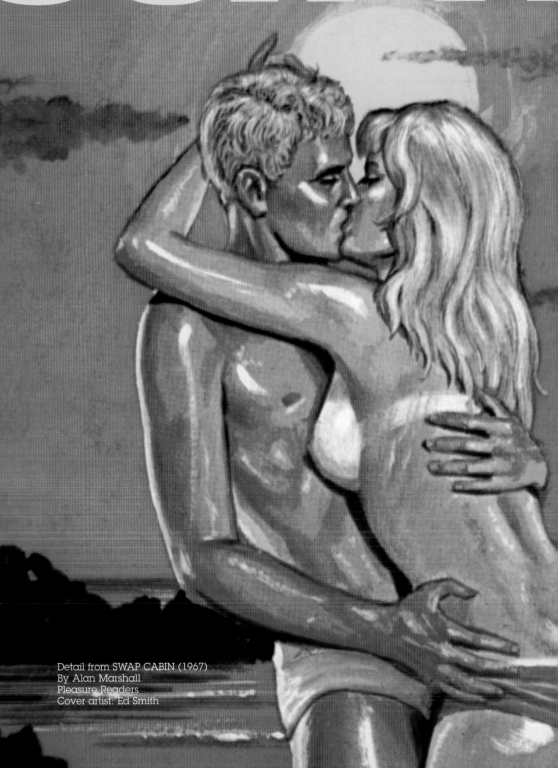

Detail from SWAP CABIN (1967)
By Alan Marshall
Pleasure Readers
Cover artist: Ed Smith

t Play

He listened. Not that he had to be told. He'd seen the giggling girls and swaggering young punks hopped up by reefers or goofballs. He'd watched other kids and older couples pawing each other in shameless abandon too drunk to realize—or care—what they were doing or who was watching them, as they cuddled in disreputable dives. There were too many lake front bars. Too many cars filled with teenagers parked alongside roads.

The Sleepy Hollow Motel, where Ben stayed, was a good example of what had happened to the medium-sized community. It was also the hangout for at least some of the pimps, prostitutes, and hoods who'd infested the town like a soul-consuming plague. Susan had told him about the dingy, unattractive motel being operated as a front for more lucrative, illegal activities such as gambling, dope peddling, and selling liquor to minors.

Marcus Miller, *Lake of Lust* (Nightstand Books, 1967)

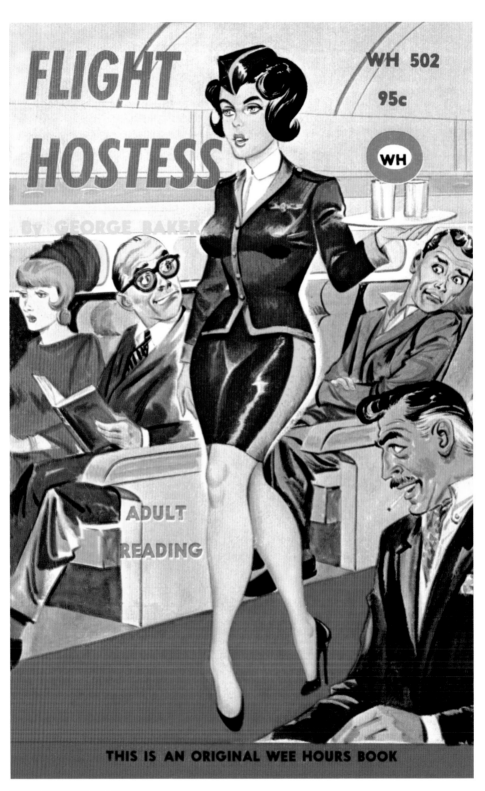

FLIGHT HOSTESS (1966)
By George Baker
Wee Hours
Cover Artist: Bill Alexander

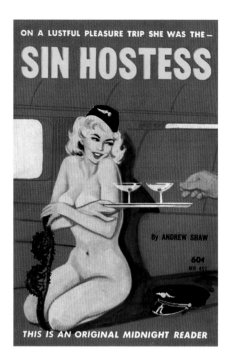

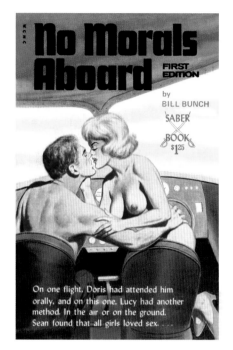

SIN HOSTESS (1963)
By Andrew Shaw
Midnight Readers

NO MORALS ABOARD (1970)
By Bill Bunch
Saber Books
Cover Artist: Bill Edwards

"It's good, Bob. This is so good," Clarita moaned.

"Shhh, or someone will hear us," I whispered as I met the force of her passion on an equal basis.

"This is the first time I've ever done this twenty thousand feet in the air!" she said as she sat up and adjusted her skirt.

As I quickly began to put things back in order and get rid of the evidence, I grinned at her.

"Sure, baby. We were really 'flying high' and in more ways than one!"

Eve Linkletter, *Flying High* (Fitz Publications, 1964)

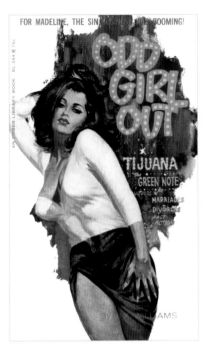

ODD GIRL OUT (1966)
By J.X. Williams
Ember Library
Cover Artist: Robert Bonfils

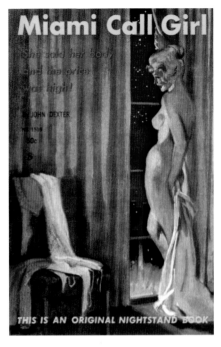

MIAMI CALL GIRL (1960)
By John Dexter
Nightstand Books
Cover Artist: Harold W. McCauley

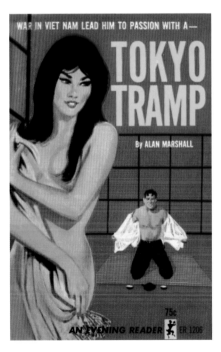

TOKYO TRAMP (1965)
By Alan Marshall
Evening Readers

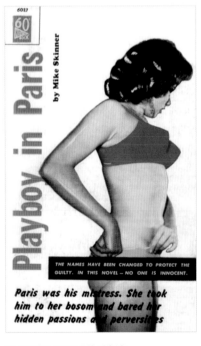

PLAYBOY IN PARIS (1962)
By Mike Skinner
Novel Books

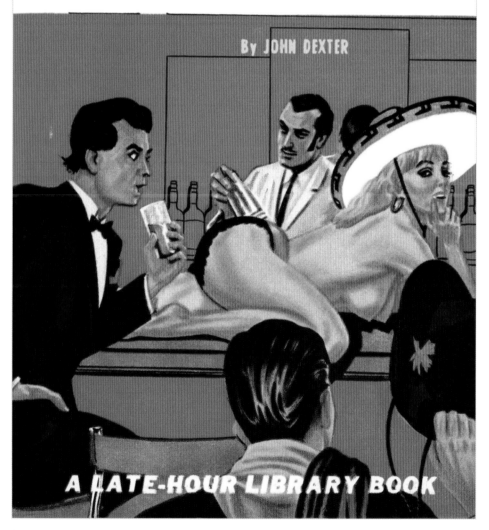

CARNAL CANTINA (1967)
By John Dexter
Late Hour Library
Cover Artist: Tomas Cannizarro

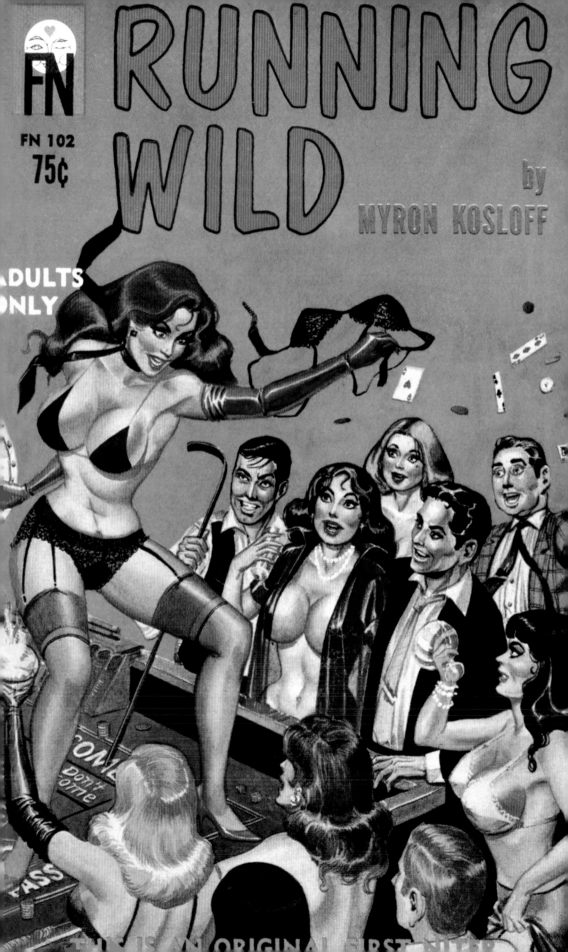

PUSSYCAT CASINO (1966)
By Wes Fields
P.E.C.
Cover Artist: Doug Weaver

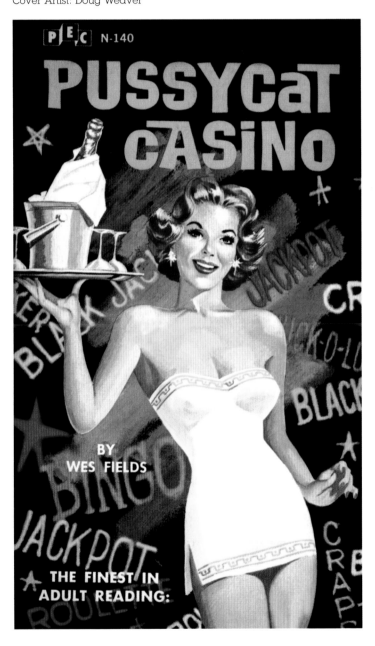

RUNNING WILD (1964)
By Myron Kosloff
First Niter
Cover Artist: Eric Stanton

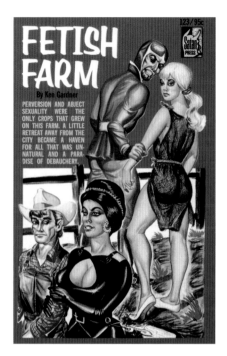

FETISH FARM (1966)
By Ken Gardner
Satan Press
Cover Artist: Gene Bilbrew

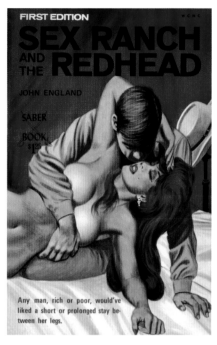

SEX RANCH AND THE REDHEAD (1968)
By John England
Saber Books
Cover Artist: Bill Edwards

JOY RIDE (1966)
By Jon Parker
After Hours
Cover Artist: Eric Stanton

THE HOUSE AT POON CORNERS (1968)
By Alan Marshall
Greenleaf Classics
Cover Artist: Ed Smith

THE UPPER HAND (1967)
By Eve Marlowe
Unique Books
Cover Artist: Eric Stanton

NAKED WITCH (1966)
By Ed O'Rourke
Room Mate Books

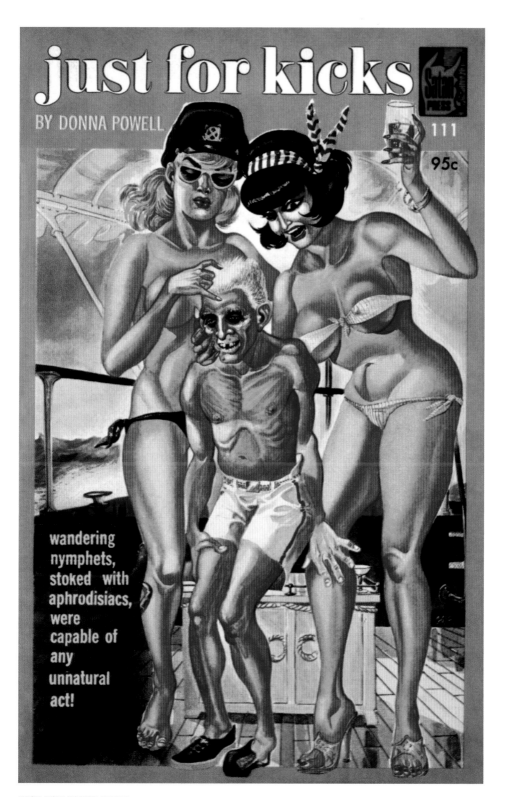

JUST FOR KICKS (1965)
By Donna Powell
Satan Press
Cover Artist: Gene Bilbrew

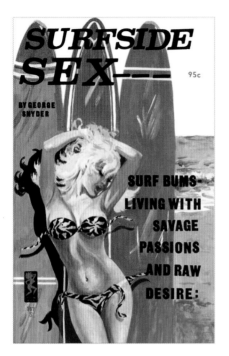

SURFSIDE SEX (1966)
By George Snyder
Playtime Books
Cover Artist: Robert Bonfils

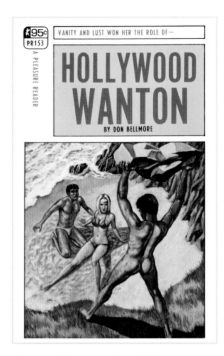

HOLLYWOOD WANTON (1968)
By Don Bellmore
Pleasure Readers
Cover Artist: Ed Smith

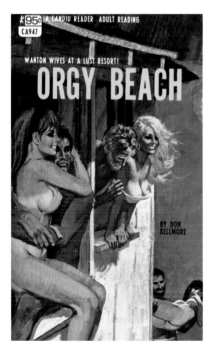

ORGY BEACH (1968)
By Don Bellmore
Candid Reader
Cover Artist: Robert Bonfils

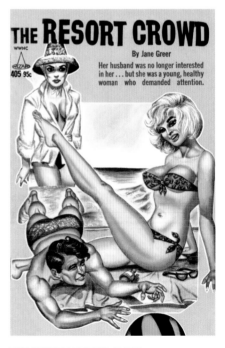

THE RESORT CROWD (1967)
By Jane Greer
Wizard
Cover Artist: Gene Bilbrew

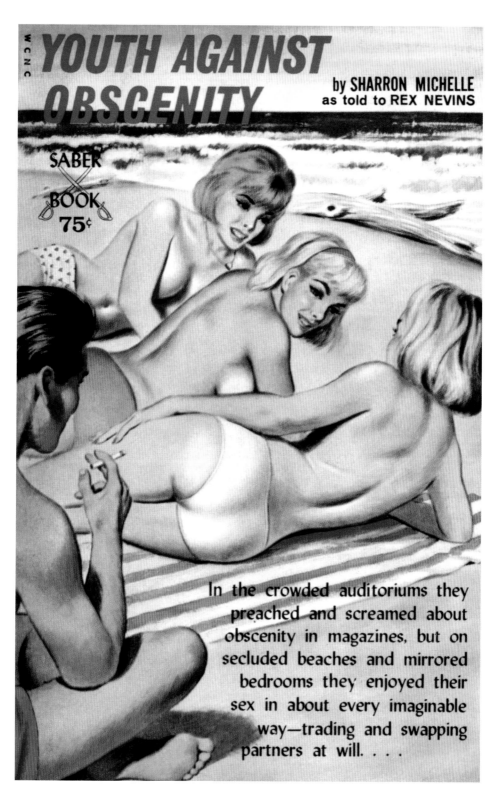

YOUTH AGAINST OBSCENITY

by SHARRON MICHELLE
as told to REX NEVINS

WCNC

SABER
BOOK
75¢

In the crowded auditoriums they preached and screamed about obscenity in magazines, but on secluded beaches and mirrored bedrooms they enjoyed their sex in about every imaginable way—trading and swapping partners at will. . . .

YOUTH AGAINST OBSCENITY (1965)
By Sharron Michelle as told to Rex Nevins
Saber Books
Cover Artist: Bill Edwards

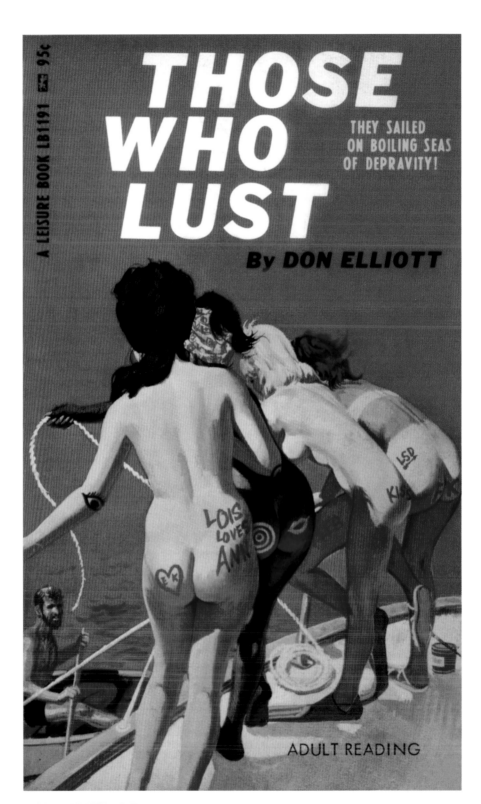

THOSE WHO LUST (1967)
By Don Elliott (Robert Silverberg)
Leisure Books
Cover Artist: Robert Bonfils

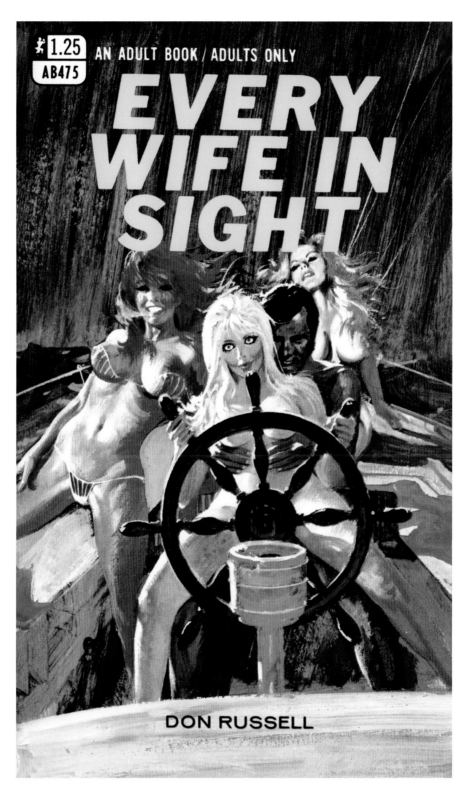

EVERY WIFE IN SIGHT (1969)
By Don Russell
Greenleaf Classics
Cover Artist: Robert Bonfils

Original Art from: SWAP SMORGASBORD (1970)
By Don Bellmore
Candid Reader
Cover Artist: Harry Bremner
From the Collection of Jeff Rich

LAKE OF LUST (1967)
By Marcus Miller
Nightstand Books

THE LUST ASSASSIN (1968)
By David Lynn
Pleasure Readers
Cover Artist: Tom Cannizarro

SINNERS IN THE SUN (1964)
By Ron Cary
Royal Line Novels

SEX SPA (1967)
By Ray Wilde
Rapture Books

I brought her to her senses with another slap on her cheek, which slightly cut her lower lip.

"Hit me more!!" she said. "Slap me as much as you can!"

Then she experienced another orgastic spasm. She was collapsing, trembling all over. I was attaining a new height of sensation!

"Darn bitch!" I said while savagely riding—plumbing her depths.

"Yes my darling," she said feeling my excitement. "I am a bitch forever, forever I shall be your bitch, as long as you want me to."

The storm in me calmed down. I took her in my arms and kissed her passionately, drinking the blood oozing from her lip.

Philippe Blanchont, *Confessions of a Ski Instructor* (P.E.C., 1967)

CONFESSIONS OF A SKI INSTRUCTOR (1967)
By Philippe Blanchont
P.E.C.
Cover Artist: Doug Weaver

SNOWBOUND SWAP (1969)
By Marty Machlia
Greenleaf Classics

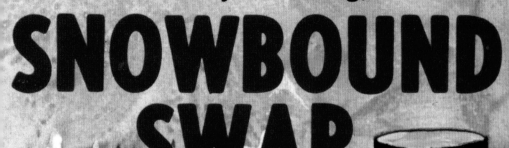

e Sex

Her eyes flared with interest. "The Kinoro country? Where is that? And why is it too rough?"

"It's up near the Abyssinian border, and it's wonderful game country, just about the last unspoiled territory left in this part of Africa. Unfortunately, they're having trouble up there now. A Mau-Mau-like group hacking up all the whites they can find and a lot of natives, too. They call themselves the Wild Goats."

"The Wild Goats. What a delectable name."

"Yes, they're a savage secret society. I imagine there'll be some wild times up there before they're wiped out. More rape and murder."

Barbara smiled, "I think that sounds just wonderful."

William Kane, *Sin Safari* (Sundown Readers, 1966)

Detail from FLESH ITINERARY (1967)
By Tony Calvano
Pleasure Readers
Cover Artist: Ed Smith

PEC G 1122

95c

DELTa MisTReSS

BY
T. R. YOUNG

THE FINEST IN
ADULT READING!

DEVIL SEX (1967)
By Bill Breedlove
P.E.C.
Cover Artist: Doug Weaver

DELTA MISTRESS (1966)
By T.R. Young
P.E.C.
Cover Artist: Doug Weaver

DEVILS' CULT (1960)
By Jacques Louis
Headline Books

EXOTICA (1964)
By Andrew Shay
Evening Readers

THE GAY SOUND (1967)
By Duane Davis
First Niter
Cover Artist: Bill Alexander

LEOPARD LUST (1967)
By Don Bellmore
Nightstand Books
Cover Artist: Darrel Millsap

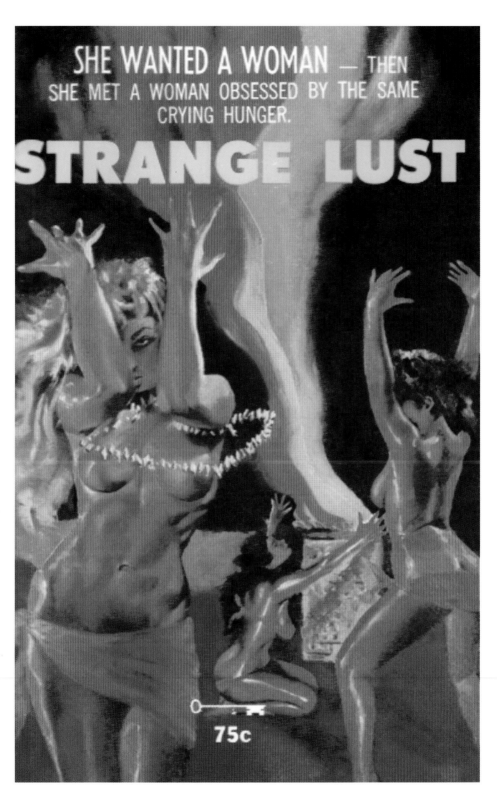

STRANGE LUST (1963)
Anonymous
Private Edition

NITE TIME ORIGINAL #114

75c
GSN

SEX BURNS LIKE FIRE

N T

By

JIM HARMON

A BLAZE OF PASSION (1967)
By J.X. Williams
Leisure Books
Cover Artist: Robert Bonfils

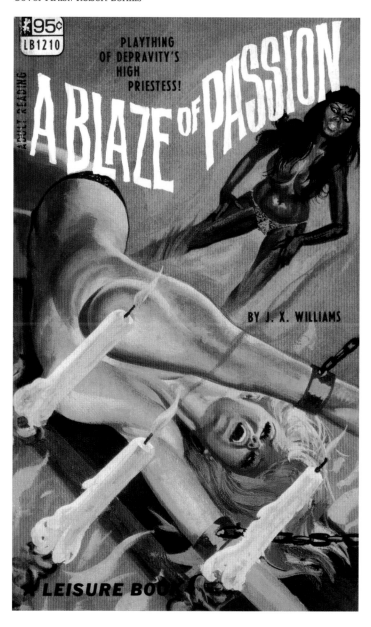

SEX BURNS LIKE FIRE (1964)
By Jim Harmon
Nite Time Books

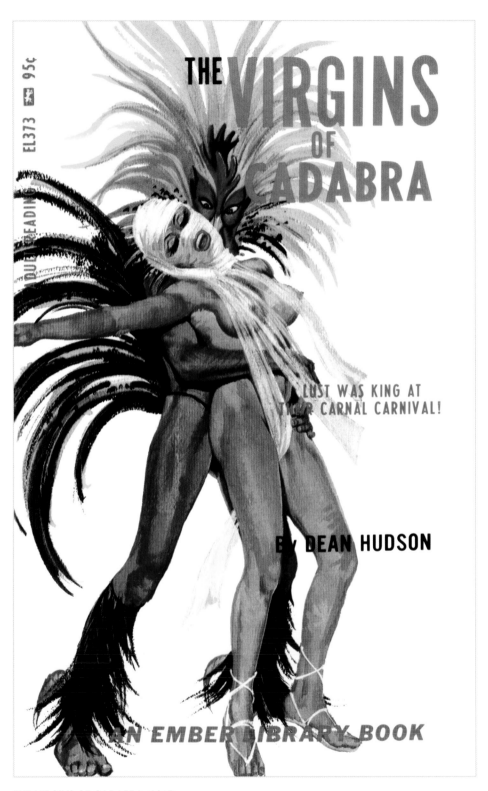

THE VIRGINS OF CADABRA (1967)
By Dean Hudson
Ember Library
Cover Artist: Robert Bonfils

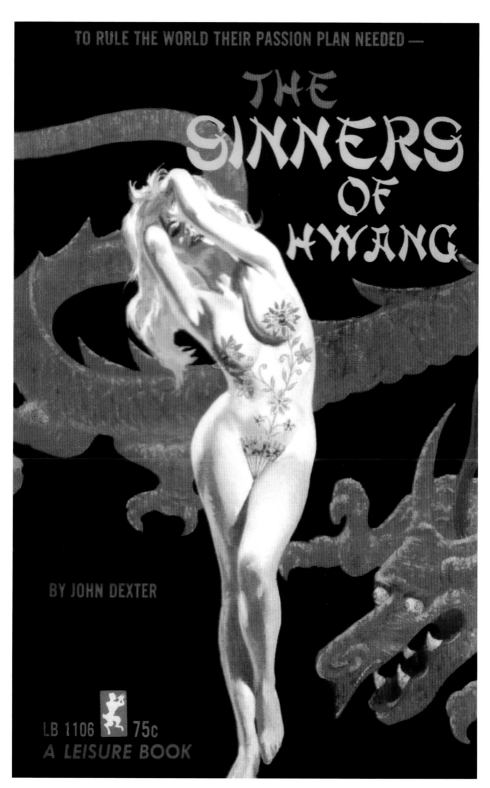

THE SINNERS OF HWANG (1965)
By John Dexter
Leisure Books
Cover Artist: Robert Bonfils

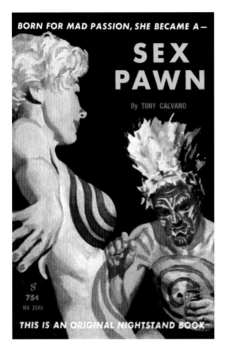

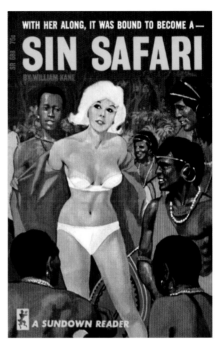

SEX PAWN (1961)
By Tony Calvano
Nightstand Books
Cover Artist: Harold W. McCauley

SIN SAFARI (1966)
By William Kane
Sundown Readers

Kenton was silent for a moment. Then: "What do you intend to do with us?"

"Of course you all must die," Kuroso said easily. "but first my men will have the women. And I think it will be amusing for you to watch that, Bwana. So we will let you live until it is over. In fact, you will be the last to die. I myself will attend to the killing of you. There are a thousand petty humiliations I have to revenge myself for. The many times I've waited, knowing you were in the brush with a white woman, knowing what was going on—and that I'd be slaughtered if I touched her, though she might have rubbed herself on me and made advances, and though my body might be aching with need," he paused. "The thousands of orders, the Kuroso do this, Kuroso fetch that. Well, I was your servant then, but no longer. Now I am master. Now you will address me as Bwana."

William Kane, *Sin Safari* (Sundown Readers, 1966)

SOFT & SAVAGE PUZZIE MCKILL (1967)
By David Lynn
Ember Library
Cover Artist: Robert Bonfils

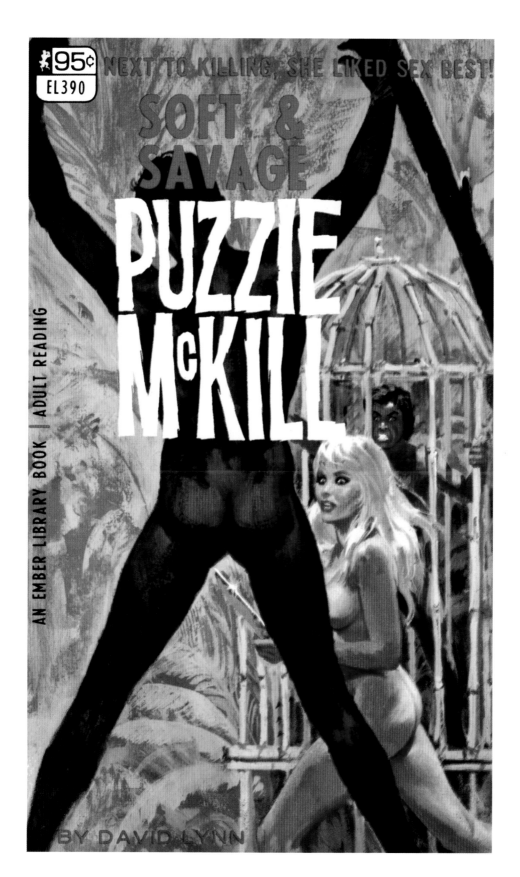

95¢

EL390

AN EMBER LIBRARY BOOK | ADULT READING

NEXT TO KILLING, SHE LIKED SEX BEST!

SOFT & SAVAGE

PUZZIE McKILL

BY DAVID LYNN

THE SIN VELDT (1966)
By John Dexter
Leisure Books
Cover Artist: Robert Bonfils

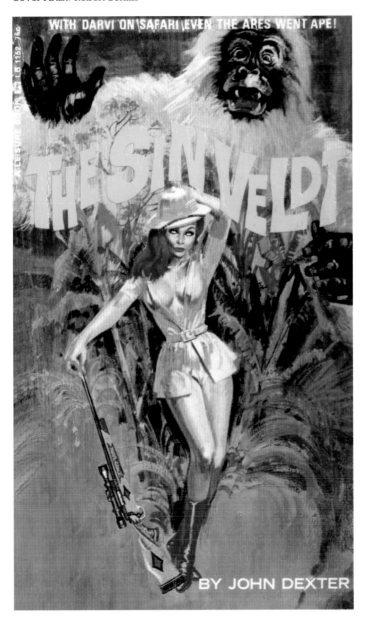

CAPTURED (1966)
By Lisa Braun
First Niter
Cover Artist: Gene Bilbrew

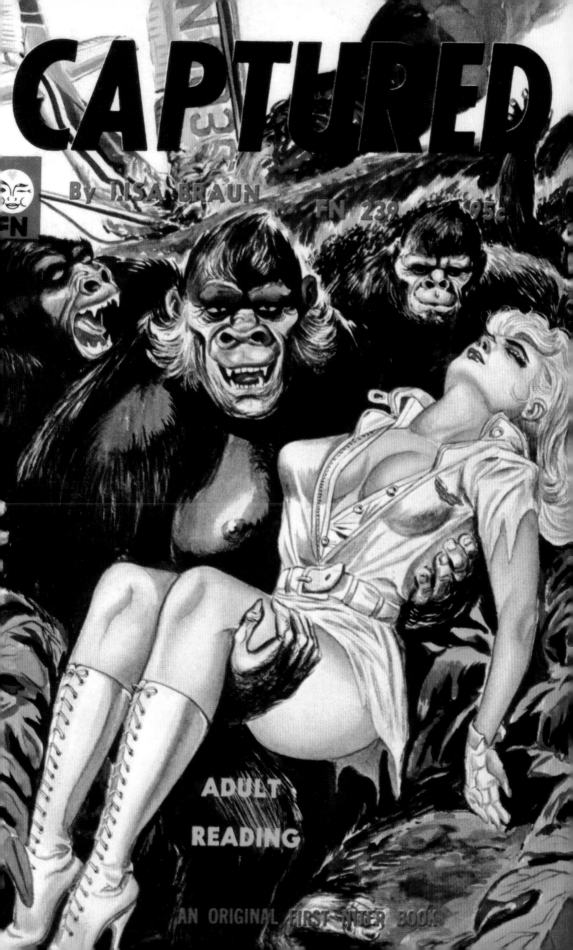

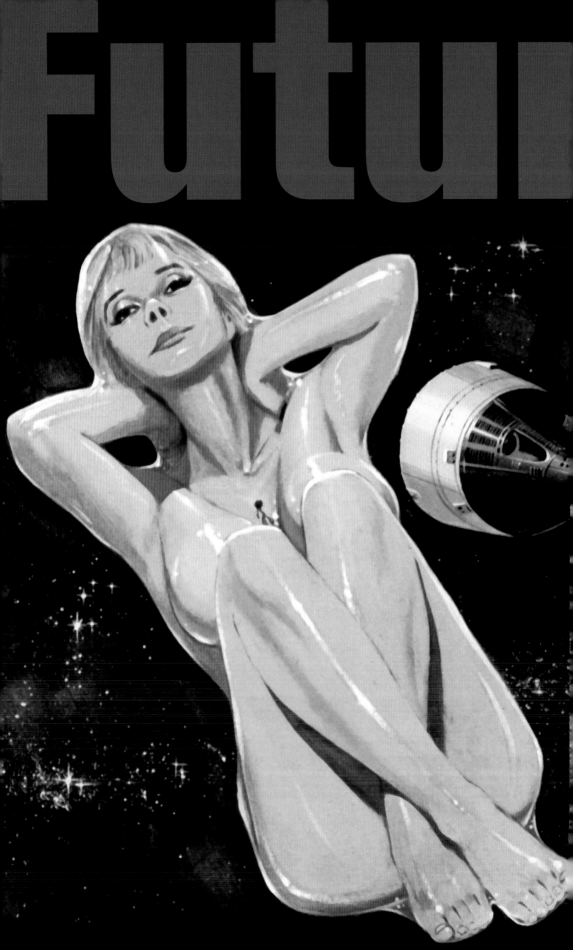

e Sin

"Come off it, Penny," he said—and his voice was sort of a croak because of his dry throat—"do you think a red-blooded man can spend a week in a cramped spaceship with a beautiful girl like you and not—"

"But that's why you were chosen, Doctor!" said Penny, wiggling her ass in an effort to escape that heat and hardness, and only succeeding in sliding it closer to her virginal quim. "You're above reproach—you and Captain Windage—they picked you precisely because they knew you'd behave yourself—"

"God, were they wrong!" groaned Simon, gripping her around the waist with his arm now while his other hand began peeling her sweater up over her lovely white back.

"Dr. Stewart, don't you realize—you'll ruin me! I've never done anything—anything bad in my entire life. I'm still a virgin."

Arthur Faber, *Outerspace Sex Orgy* (Barnaby Press, 1970)

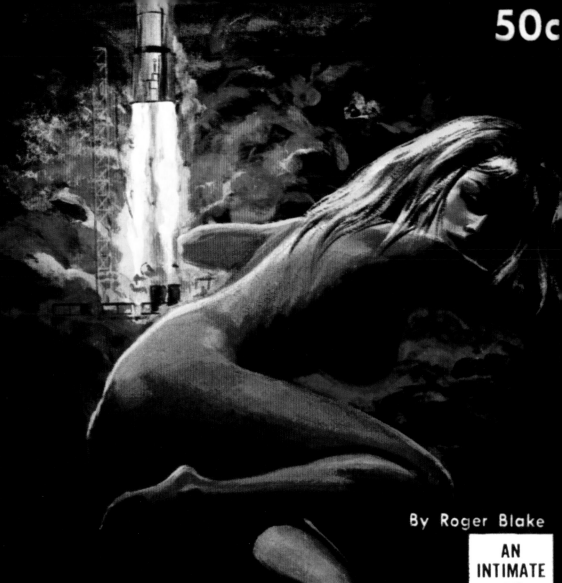

50c

By Roger Blake

AN
INTIMATE
EDITION
No. 724

HOW SAFE ARE
U.S. ROCKET PLANS?

CAPER at CANAVERAL!

Bolder than today's headlines! Cuban Commies use the fiery desires of a lush nympho to try to gain American missile secrets!

SIN IN SPACE (1961)
By Cyril Judd (C.M. Kornbluth and Judith Merril)
Beacon Books
Cover Artist: Robert Stanley

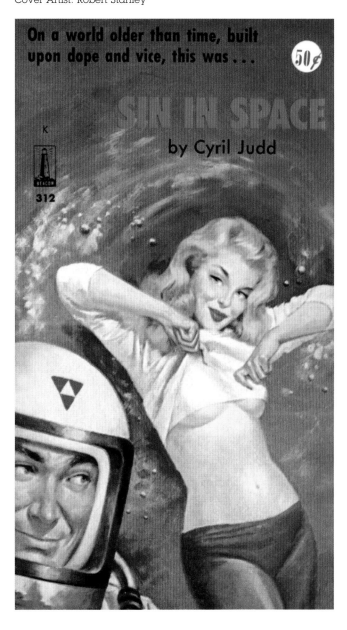

On a world older than time, built upon dope and vice, this was . . .

50¢

K

312

SIN IN SPACE
by Cyril Judd

CAPER AT CANAVERAL! (1963)
By Roger Blake
Intimate Edition

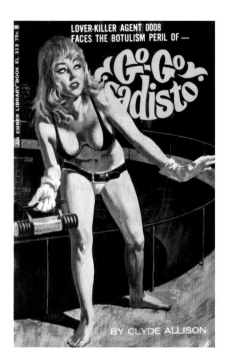

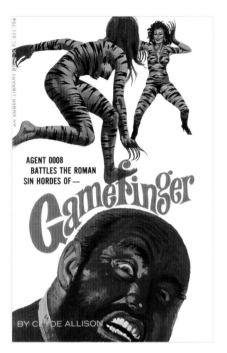

GO-GO SADISTO (1966)
By Clyde Allison (William Knoles)
Ember Library
Cover Artist: Robert Bonfils

GAMEFINGER (1966)
By Clyde Allison (William Knoles)
Ember Library
Cover Artist: Robert Bonfils

"To begin with," began Cantwell, "I don't pit nude girls against each other in fights to the death just for kicks—my kicks. Not at all."

Remembering the casual way in which he'd had the brunette skewered through her left breast just to make a point, I doubted him —but kept silent.

"No," continued Cantwell, "although I have had perhaps a couple hundred American, European, Chinese, Japanese, African, Arabian, Polynesian, and other young men and girls kidnapped, brainwashed and made into slaves—the bulk of whom have since hacked, stabbed, or shot each other to death, or been torn to shreds by wild animals—and although I intend to kidnap, brainwash, and, uh, amusingly destroy several hundred more—still, I do what I do for the sake of humanity."

Clyde Allison (William Knoles), *Gamefinger* (Ember Library, 1966)

SEX TOY (1968)
By J.X. Williams
Greenleaf Classics
Cover Artist: Ed Smith

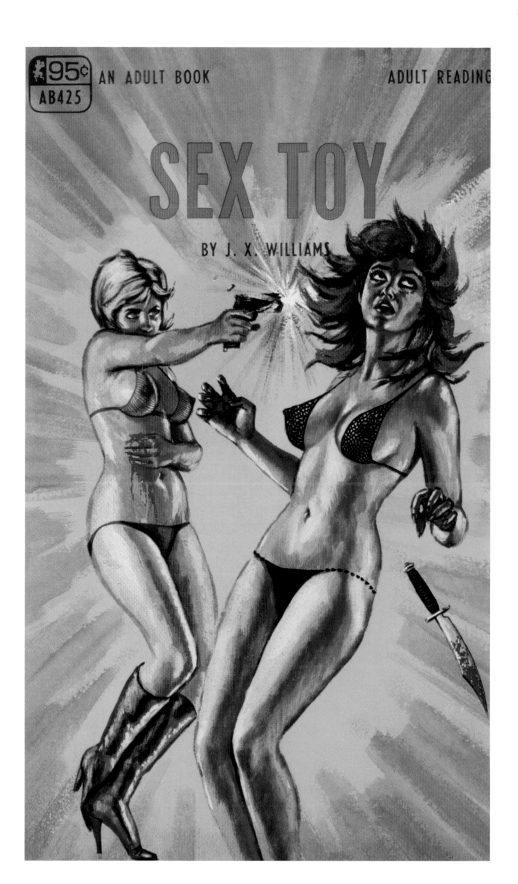

SEX TOY

BY J. X. WILLIAMS

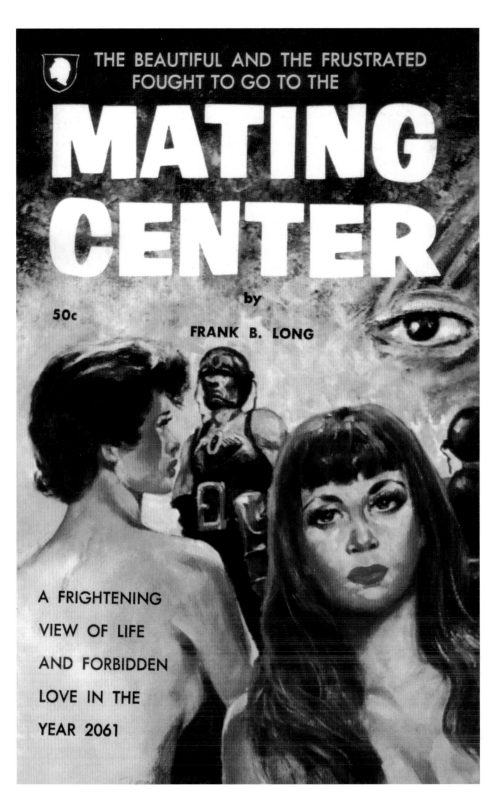

THE BEAUTIFUL AND THE FRUSTRATED
FOUGHT TO GO TO THE

MATING CENTER

by

FRANK B. LONG

50c

A FRIGHTENING
VIEW OF LIFE
AND FORBIDDEN
LOVE IN THE
YEAR 2061

MATING CENTER (1961)
By Frank B. Long
Chariot Books

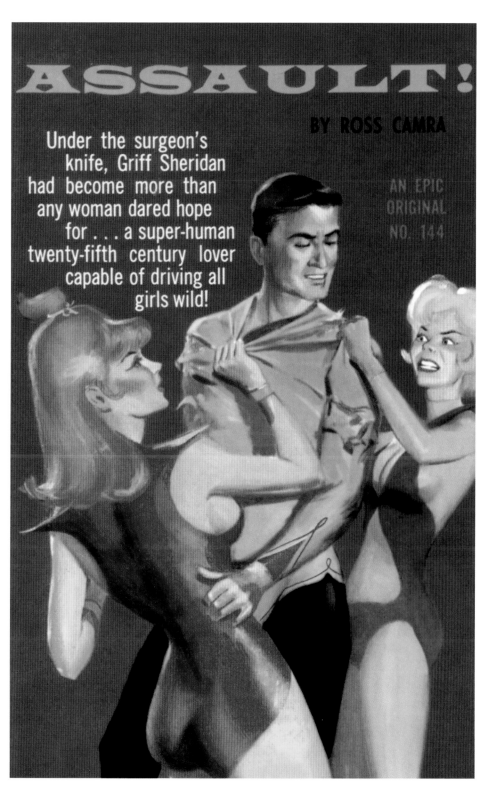

ASSAULT! (1962)
By Ross Camra
Epic Books

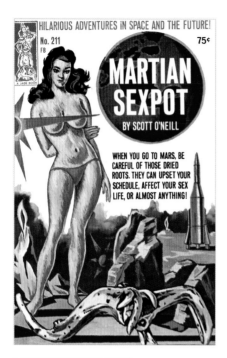

MARTIAN SEXPOT (1963)
By Scott O'Neill
Jade Books

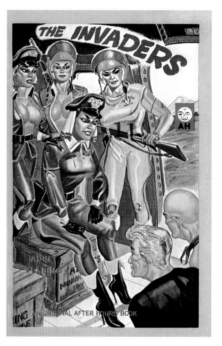

THE INVADERS (1966)
By Anthony Dean
After Hours
Cover Artist: Gene Bilbrew

The women?

Kind of hard to explain the women, if they were women, that is. They were, at least many of them, three and four way crosses between Earth, Martian Bipes, and Quads and scaly Venusians.

The male members grew either hideous or handsome. The females were damn near all ravishing.

The sheer beauty of Martian Bipes was incredible, minus their stink. The green eyes and lithe grace—and the cold, reasoning, logical mentality of the scaly Venusians—all of this with the conniving minds and lustrous hair of the Earth woman.

There were all sorts of curious mixtures to be found, and there's no reason talking about it. Name it, any possible combination, and you could find it.

But the women—boy, the women! Fantastic. Lovely, beautiful, supple, pneumatic, pliable, willing and anxious!

The whole damn planet was completely amoral, immoral and rotten to the core. And lots of fun.

Scott O'Neill, *Martian Sexpot* (Jade Books, 1963)

THOSE SEXY SAUCER PEOPLE (1967)
By Jan Hudson (George H. Smith)
Greenleaf Classics
Cover Artist: Ed Smith

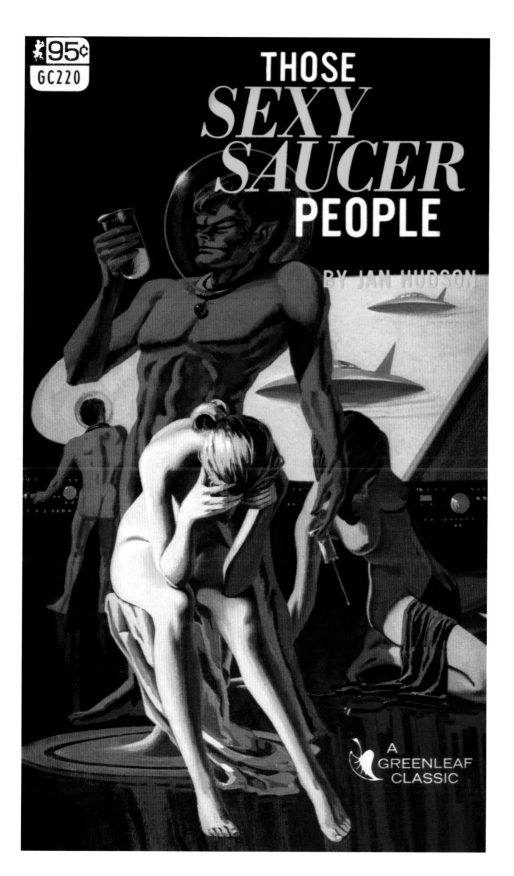

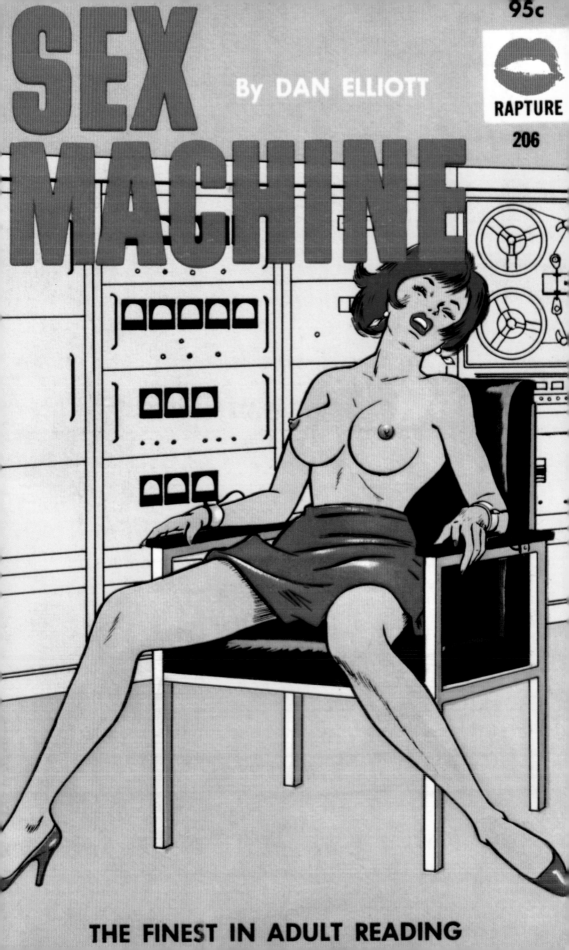

SEX MACHINE

By DAN ELLIOTT

95c

RAPTURE

206

THE FINEST IN ADULT READING

"Let's put the orgamometer in place now."

He took the instrument into his right hand and stepped between Melissa's thighs, held wide apart by the stirrups. A rich scent of lusty womanhood rose to his nostrils as he stood between her legs— the scent of an aroused woman ready for the mating.

"Ahhh," she moaned. "That's real good; if only it were about three inches across!"

Richard B. Long, *Dr. Dildo's Delightful Machine* (Nitime Swapbooks, 1971)

TWISTED TULIPS (1966)
By Dean Hudson
Leisure Books

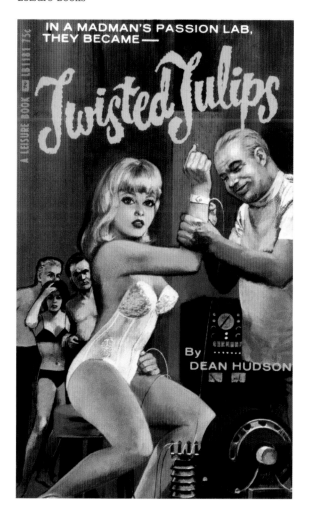

SEX MACHINE (1967)
By Dan Elliott (Robert Silverberg)
Rapture Books

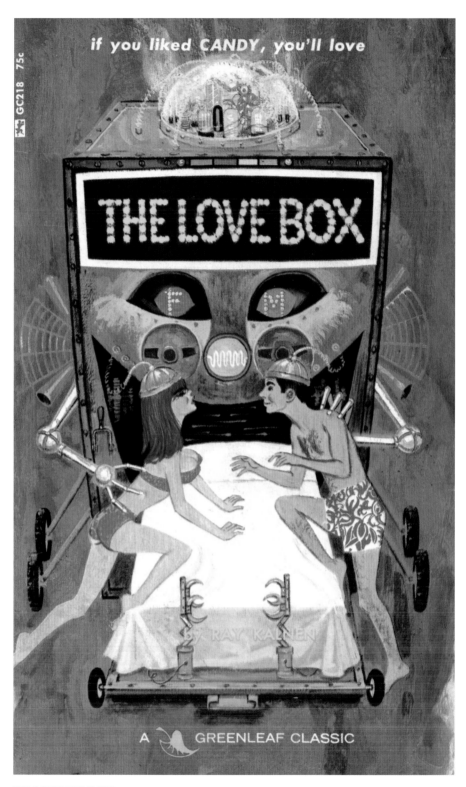

THE LOVE BOX (1967)
By Ray Kalnen
Greenleaf Classics

BUSY BODIES (1966)
By Dean Hudson
Leisure Books
Cover Artist: Robert Bonfils

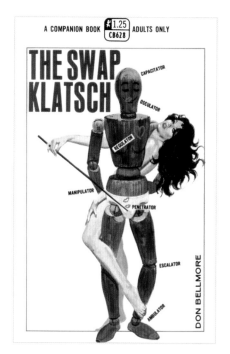

THE SWAP KLATSCH (1969)
By Don Bellmore
Companion Books
Cover Artist: Robert Bonfils

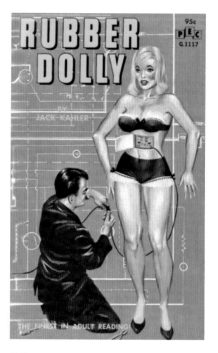

RUBBER DOLLY (1966)
By Jack Kahler
P.E.C.
Cover Artist: Doug Weaver

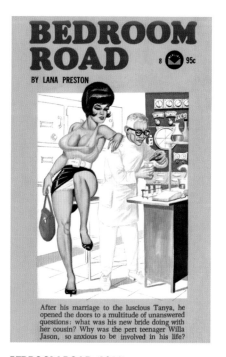

BEDROOM ROAD (1966)
By Lana Preston
Mercury
Cover Artist: Gene Bilbrew

"I don't believe we'll need to lubricate the tip," he said, noting the thick flow of lubricious fluid which Mrs. Winston had generated.

"No need for that," she murmured throatily. "Every time I think of that lovely machine I just about flood my panties!"

Richard B. Long, *Dr. Dildo's Delightful Machine* (Nitime Swapbooks, 1971)

DR. DILDO'S DELIGHTFUL MACHINE (1971)
By Richard B. Long
Nitime Swapbooks
Cover Artist: Robert Bonfils

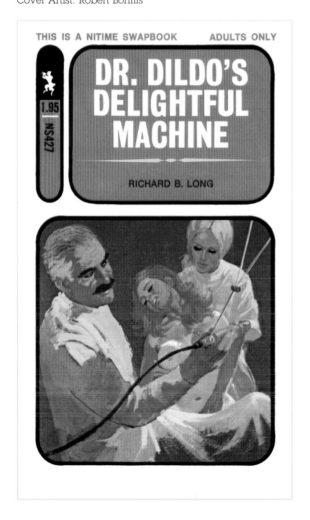

PLUG-IN PASSION (1967)
By John Dexter
Leisure Books
Cover Artist: Robert Bonfils

A WANTON LUST-CULT TAUGHT KAREN ABOUT

PLUG-IN
PASSION

By JOHN DEXTER

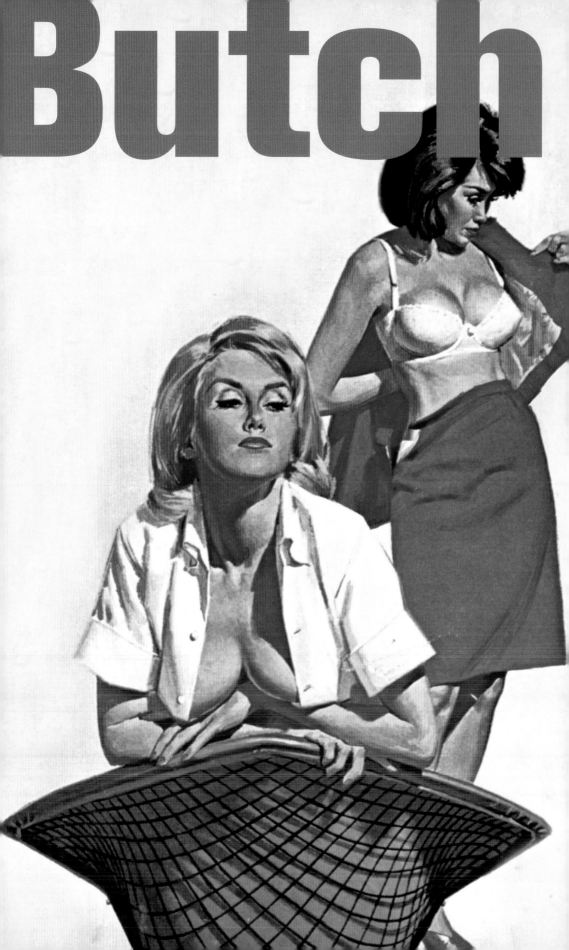

Butch

Swish

For a long time she did nothing but kiss Gail and caress her breasts, while Gail discovered sensations she had never known, never believed existed. No other touch had ever aroused her like this. Before, deep kissing had only seemed messy, somehow disgusting; with Marja it was warm, vital, life-giving. Marja's soft body pulsed as if with electrical current, charging Gail with vibrant force; suddenly she put her arms around Marja and pulled her down so that they laid side by side. Marja's soft fingers worked at her clothes; a passionate intuition told Gail what to do, where to touch...

Miriam Gardner (Marion Zimmer Bradley), *Twilight Lovers* (Monarch, 1964)

Detail from THE GAY PARTNERS (1964)
By Peggy Swenson (Richard E. Geis)
Brandon House
Cover Artist: Fred Fixler

PEC French Line FL 5

95c

WHISPER OF SILK

BY
VIN SAXON

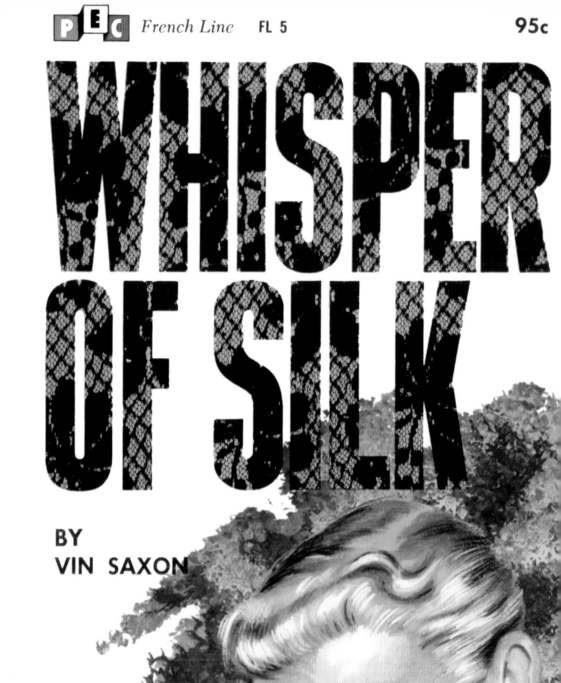

THE FINEST IN ADULT READING!

LUST FOR LACE (1964)
By Jeff King (Ron Haydock)
Rapture Books

WHISPER OF SILK (1966)
By Vin Saxon (Ron Haydock)
P.E.C.
Cover Artist: Doug Weaver

SIN SOILED (1965)
By Tony Calvano
Evening Readers

IN DRAG (1968)
By Bruce McLaren
P.E.C.

SIN-DEEP LOVER (1967)
By William Kane
Leisure Books
Cover Artist: Robert Bonfils

ABNORMALS ANONYMOUS (1964)
By Stella Gray
National Library Books

$1.75
DC 513

YOU...
FETISHIST

by Arnold Astin

A strange journey into the frantic libidinous realm of the fetishist. . . . Graphic details of exploitation, punishment, gratification; of the restricting leather, rubber, etc.

ADULT
READING

The bizarre search for new ways to satisfy unusual sex drives.

YOU... FETISHIST (1969)
By Arnold Astin
Documentary Classics

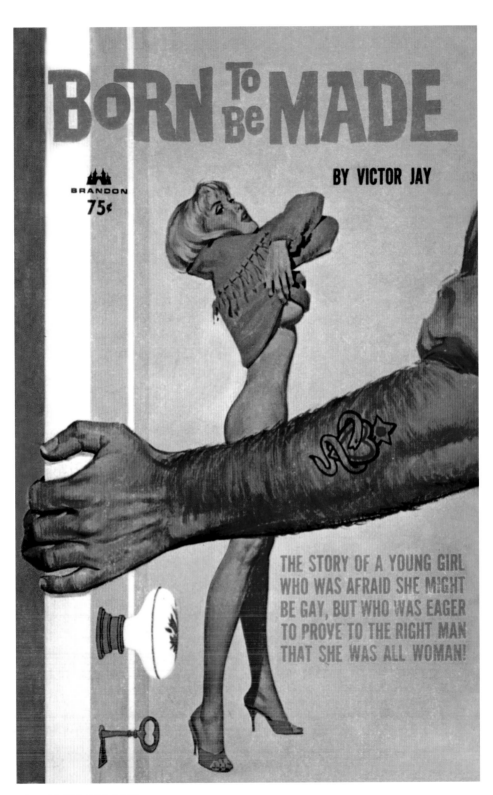

BORN TO BE MADE (1965)
By Victor Jay
Brandon House
Cover Artist: Fred Fixler

SECOND FIDDLE (1967)
By Jon Parker
Unique Books
Cover Artist: Bill Alexander

SWITCH HITTERS (1965)
By Laurence Fulton
After Hours
Cover Artist: Eric Stanton

HOT YOUNG LUST (1965)
By Robert E. Paynes
Fitz Publications

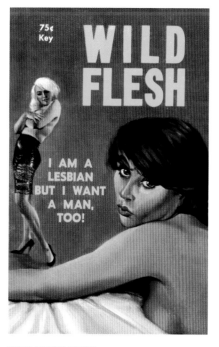

WILD FLESH (1963)
By Jack James
Private Edition
Cover Artist: John Healey

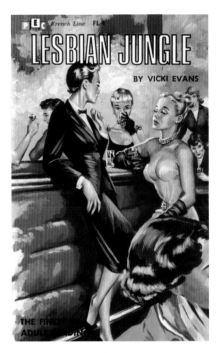

LESBIAN JUNGLE (1966)
By Vicki Evans
P.E.C.
Cover Artist: Doug Weaver

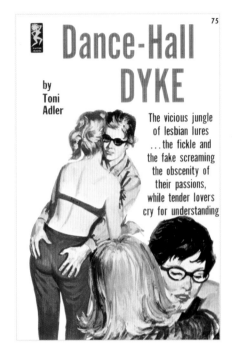

DANCE-HALL DYKE (1964)
By Toni Alder
Playtime Books
Cover Artist: Robert Bonfils

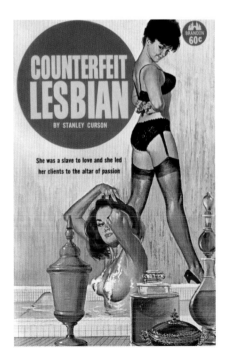

CONTERFEIT LESBIAN (1963)
By Stanley Curson
Brandon House
Cover Artist: Fred Fixler

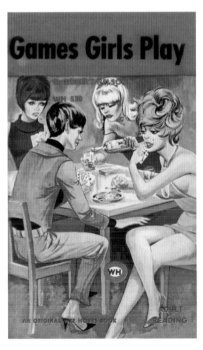

GAMES GIRL PLAY (1967)
By Robert Nelson
Wee Hours
Cover Artist: Bill Alexander

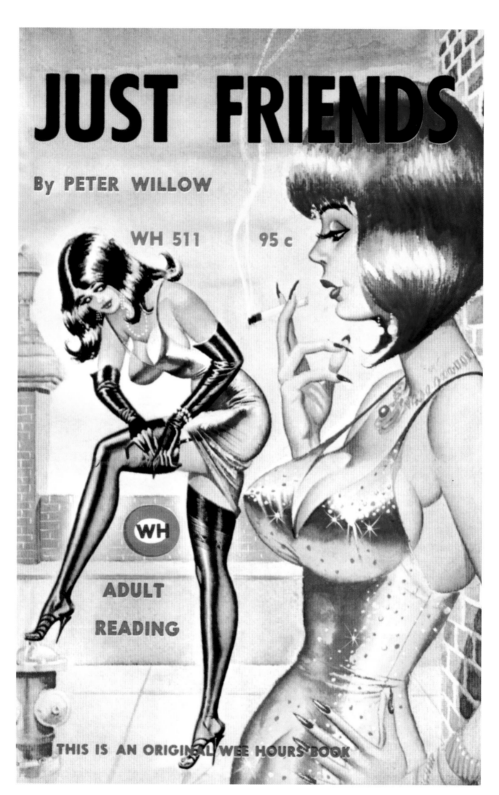

JUST FRIENDS (1967)
By Peter Willow
Wee Hours
Cover Artist: Bill Ward

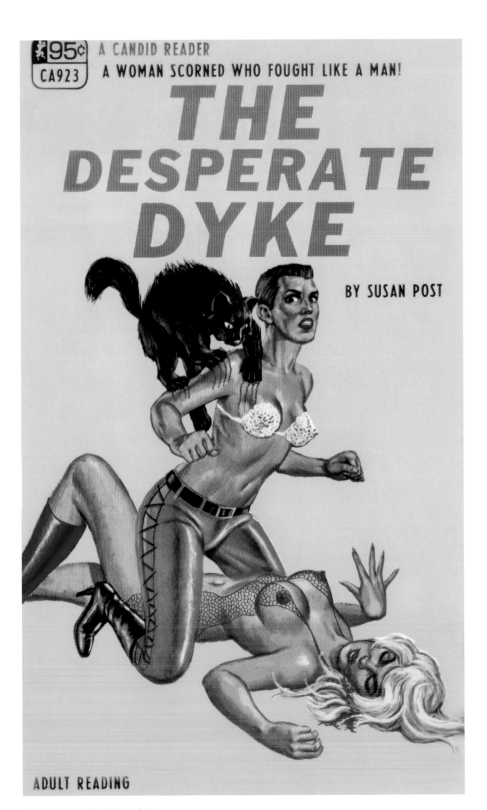

THE DESPERATE DYKE (1968)
By Susan Post
Candid Reader
Cover Artist: Tomas Cannizarro

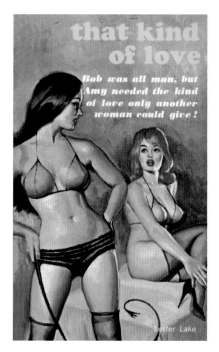

THAT KIND OF LOVE (1967)
By Lester Lake
Private Edition

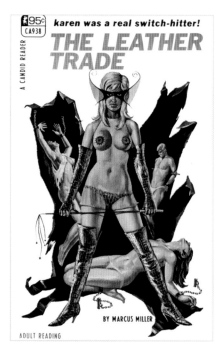

THE LEATHER TRADE (1968)
By Marcus Miller
Candid Reader
Cover Artist: Ed Smith

I grabbed her by the hair and sat her down on the nearby sofa. "I feel like doing a good deed today," I said. "And I can't think of anything more worthwhile for mankind than the transformation of one dyke. Baby, your troubles are over. After I get through with you, you will be a changed woman. I mean a changed woman. What I mean is you are a changed woman now. I'm going to change you from a changed woman into a *woman*. I mean one who isn't changed anymore."

"Keep the change, I'm not selling anything," she cracked and started to get up.

Dodine De Canard, *Lust in Leather* (Boudoir Books, 1964)

AC-DC STUD (1967)
By J.X. Williams
Ember Library
Cover Artist: Robert Bonfils

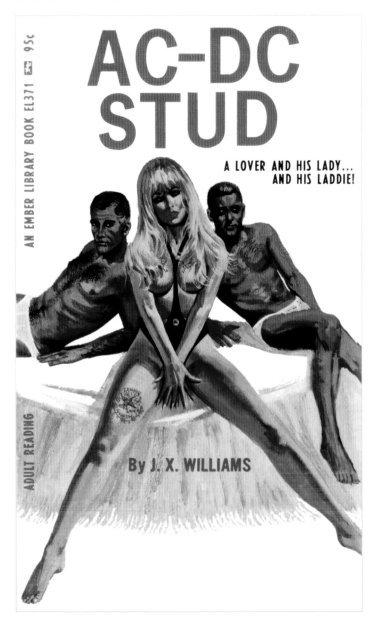

AC-DC SEX (1964)
By Rick Raymond
Playtime Books
Cover Artist: Robert Bonfils

AC-DC SEX

by RICK RAYMOND

She could switch
her current to
either sex,
but the result
was the same,
a sizzling charge
of hot and
heady lust.

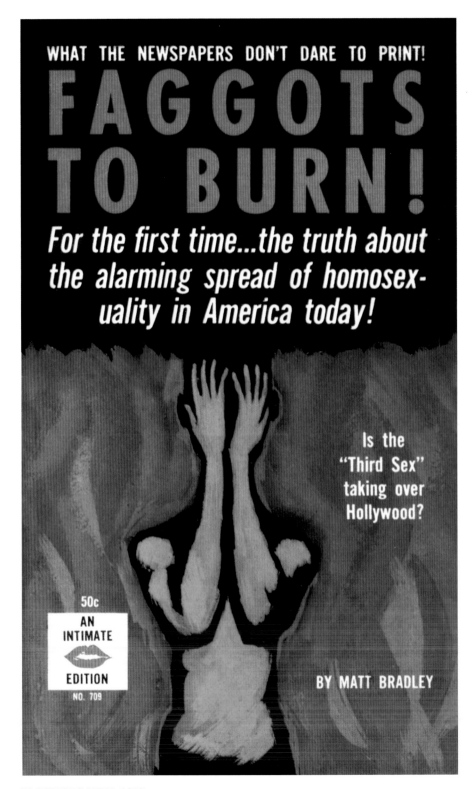

FAGGOTS TO BURN! (1962)
By Matt Bradley
Intimate Edition

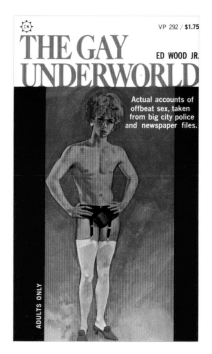

THE GAY UNDERWORLD (1968)
By Ed Wood Jr.
Viceroy

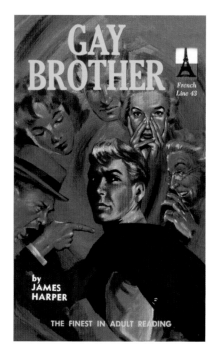

GAY BROTHER (1968)
By James Harper
P.E.C.
Cover Artist: Doug Weaver

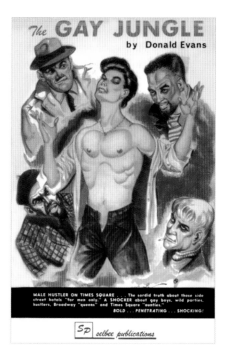

THE GAY JUNGLE (1965)
By Donald Evans
Selbee Publications
Cover Artist: Gene Bilbrew

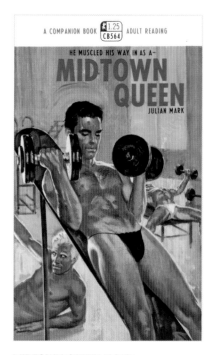

MIDTOWN QUEEN (1968)
By Julian Mark
Companion Books
Cover Artist: Robert Bonfils

"What an egotist you are! I've seen big cocks before."

"I'm sure of it. But none as perfect as mine. And I'm perhaps the greatest lover in the world. After I have made love to a woman or a man, I become the center of the universe for that person, until he or she realizes that I'm not theirs alone and cannot be. Then they hate me for a while, but cannot refuse me if I ever want them again."

"Do you like women better than men?"

Tom smiled. "Homosexuals always ask that."

Andy realized Tom wouldn't answer, so he asked, "How many sex partners have you had?"

"Since I was a boy... thousands."

Aaron Thomas, *Gay Orgy* (Adult Books, 1968)

GAY TWINS (1968)
By Marcus Miller
Greenleaf Classics
Cover Artist: Ed Smith

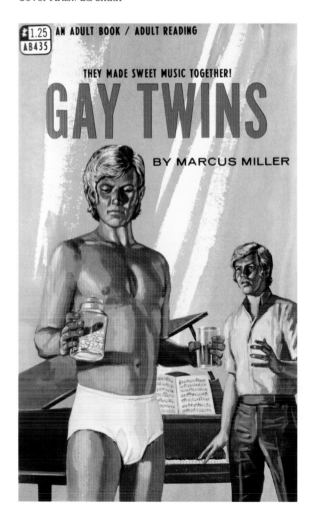

HIS BROTHER LOVE (1965)
By Russ Trainer
Satan Press
Cover Artist: Gene Bilbrew

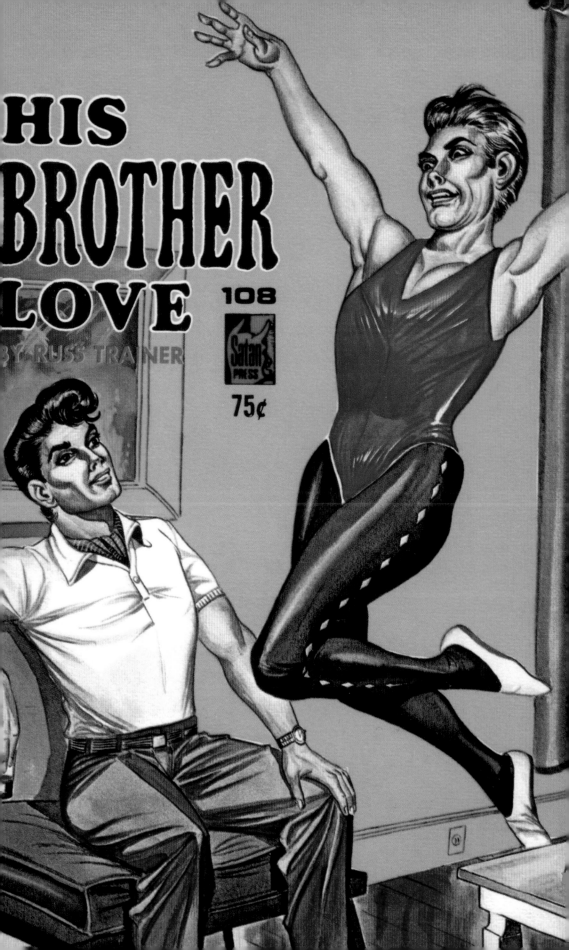

HIS BROTHER LOVE

108

BY RUSS TRAINER

75¢

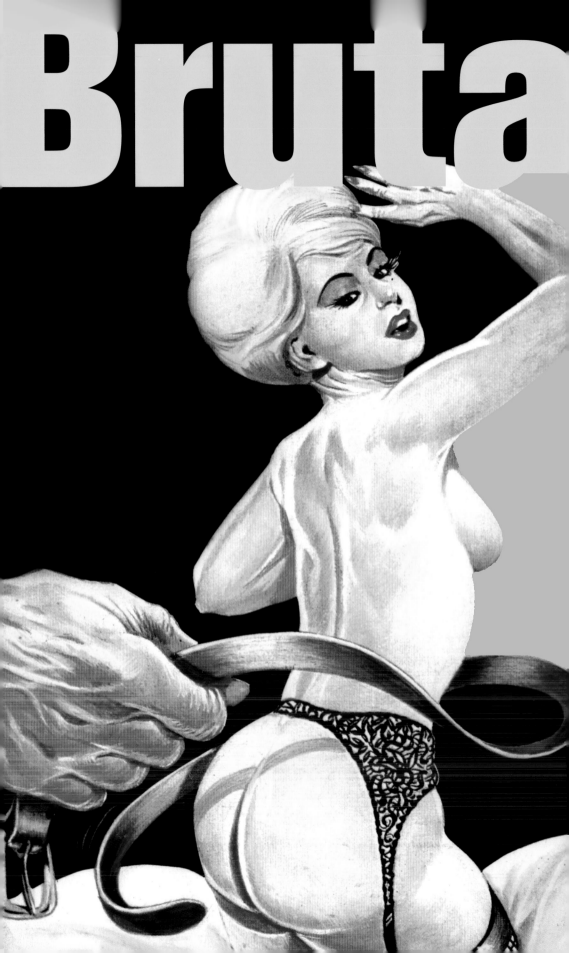

I Lust

"Bite me—bite me, you bastard," she cried.

The flesh was hot in Marsh's mouth and the nipple lolled against his tongue, demanding individual hurt.

"Ugh. Ahhhhhh," Zena cried in a gasp of pain-filled pleasure. "Harder, harder, harder, you bastard. Bite me hard."

Marsh responded and it was not from command nor compliance with a desperate woman's wishes. It came from his own hard, hurting, seeking.

"Ahhhh,. Good," she babbled. "Good, good, good. More. Hurt me more."

Marsh leaped away from her. He tore his robe from his body and lowered himself to find her.

"I'll hurt you, bitch," he growled. "I'll hurt you the way a woman should be hurt."

Russ Trainer, *The Seeker* (Satan Press, 1965)

Detail from BEAT ME LOVER!! (1964)
By Hank Bunman
Hi-Hat

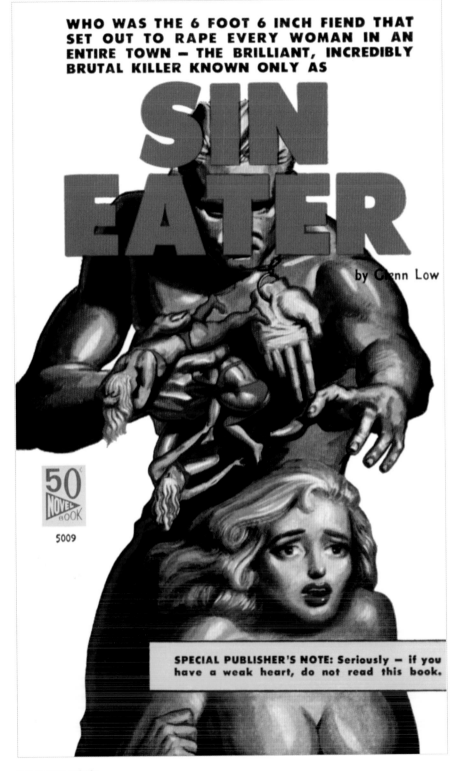

SIN EATER (1960)
By Glenn Low
Novel Books

BRUTE (1961)
By Con Sellers
Novel Books

BRUTE MADNESS (1961)
By Ledru Baker, Jr.
Novel Books

TORRID TWINS (1960)
By Jack Lynn
Novel Books

HONEY BLOOD (1961)
By Glenn Low
Novel Books

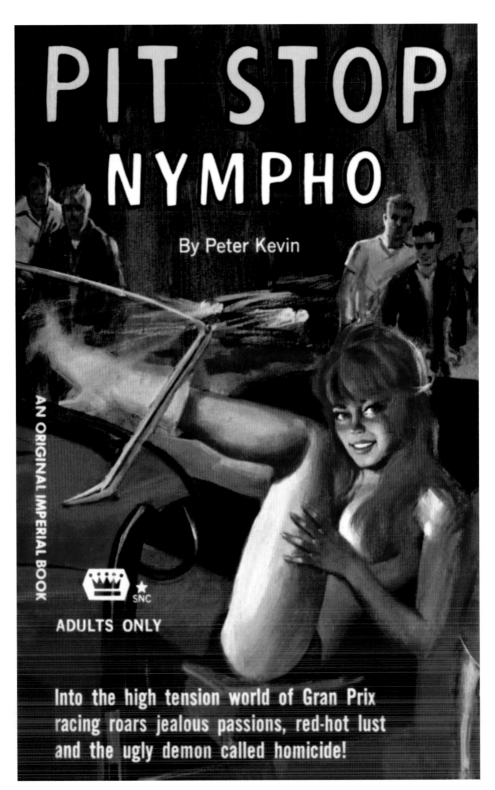

PIT STOP NYMPHO (1965)
By Peter Kevin
Imperial Books

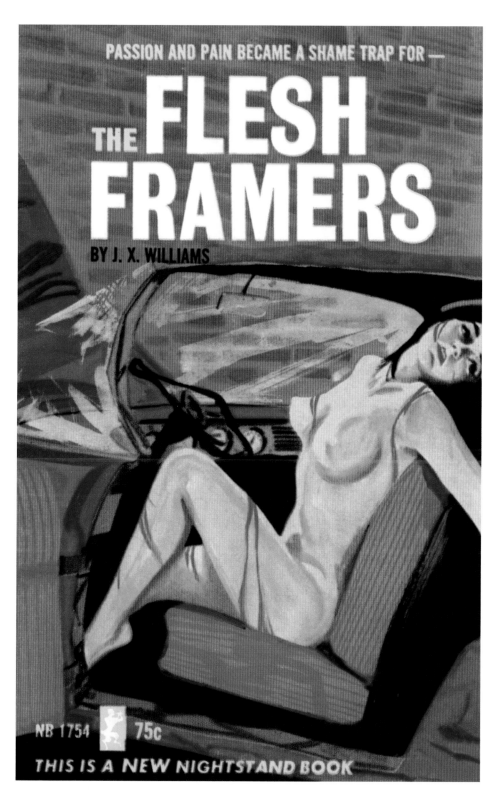

THE FLESH FRAMERS (1965)
By J.X. Williams
Nightstand Books

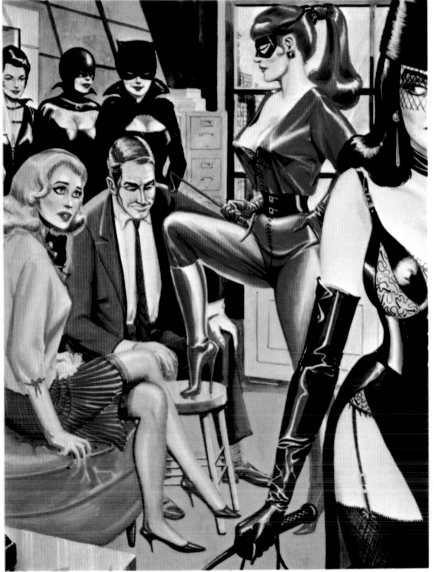

RENT PARTY

After Hours

AH 106
75c

An Original Book by Jon Parker

ADULT READING

PASSION NIGHTMARE (1962)
By Andrew Shaw
Midnight Readers

HUNGRY FOR MEN! (1961)
By Lou Fisher
Novel Books
Cover Artist: K. Freeman

She glared down at the cowering, naked man. He was on all fours
and his naked buttocks were quivering as they swayed vulnerable and
exposed. Rachel took a step forward toward the man momentarily
unsteady on the exaggerated heels of her boots. There was a wild smile
of satisfaction on Rachel's lovely face... yet a somehow cruel face...
A black leather whip was firmly held in her right hand.

"So," Rachel whispered to the naked man, "so, you had the guts to
disobey me. You shall suffer for that!"

"No!" the man whimpered.

"You weakling—you man. Men act as if they're strong, but in reality
they are weaklings. Just as you are, Jason. Now you will see that woman
is the better of man."

With those words, uttered in an icy voice, Rachel gave a flick
of her wrist and the whip in her hand came to life like a lazy, striking,
snapping snake.

Woody Craft, *Female Avengers* (Unique Books, 1968)

RENT PARTY (1964)
By Jon Parker
After Hours
Cover Artist: Eric Stanton

PASSION IN PAINT (1961)
By Andrew Shaw
Midnight Readers
Cover Artist: Harold W. McCauley

PROJECT GIRL (1965)
By Mark Lucas
Saber Books
Cover Artist: Bill Edwards

BRUTE LOVER (1966)
By John Dexter
Evening Readers
Cover Artist: Darrel Millsap

LUST CAMPUS (1961)
By Andrew Shaw
Midnight Readers
Cover Artist: Harold W. McCauley

SCARS OF LUST (1964)
By Don Holliday
Pillar Books
Cover Artist: Robert Bonfils

PASSION'S GREATEST TRAP (1966)
By jack Vast
Saber Books
Cover Artist: Bill Edwards

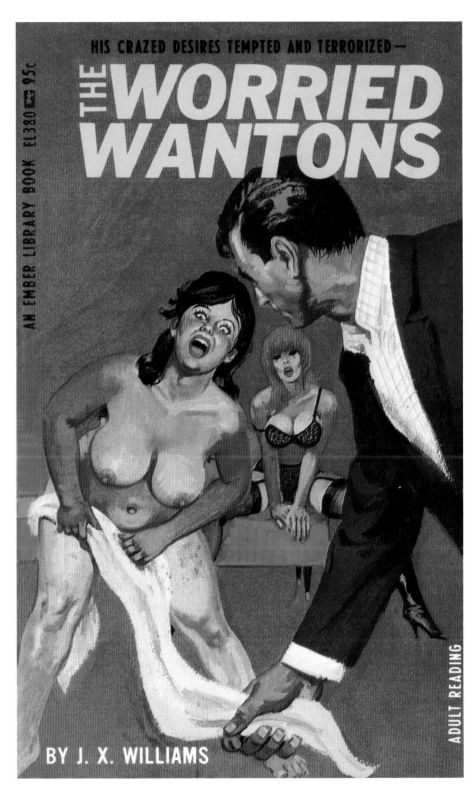

THE WORRIED WANTONS (1967)
By J.X. Williams
Ember Library
Cover Artist: Robert Bonfils

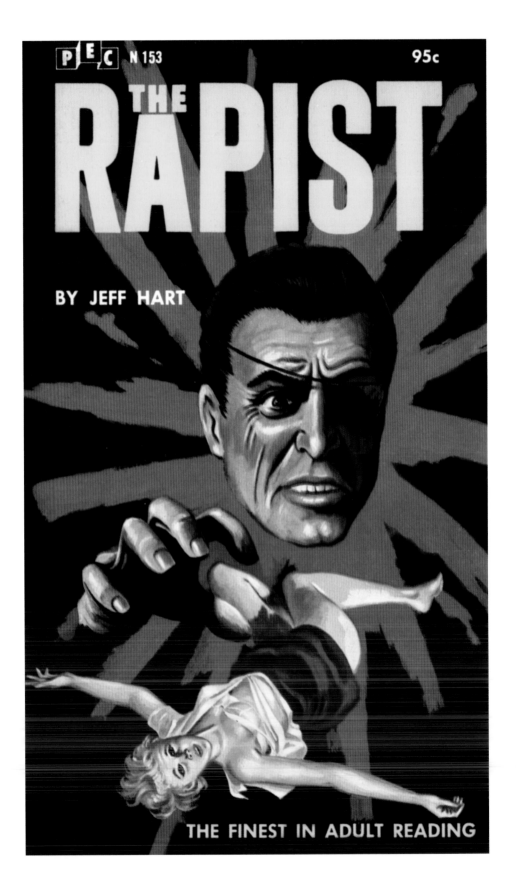

PEC N 153 95c

THE RAPIST

BY JEFF HART

THE FINEST IN ADULT READING

"You—make me feel like a real tramp."

He laughed aloud. "I make you feel that way? Come off it, honey."

Linda rose to her feet. She went to the chair where she had left her dress. She started to slip into it, but a hand caught her arm.

"You're not going anywhere, and you know it. You came here for sex, and baby, you're damn well gonna get it. The bedroom's that way."

"No," she said, pulling out of his grasp. "I've changed my mind. I want nothing to do with you."

"I get it. You dig the rape scene. Okay, I'll go along with the gag."

Linda didn't see the slap coming until it was there. His hand smacked against her cheek, causing stars to explode. She was swept into his arms, and he charged through the interior darkness. As they entered the equally-dark bedroom she began to strike at him. He heaved her on the unmade bed.

Jane Greer, *The Resort Crowd* (Wizard, 1967)

SEX TRAP (1965)
By Wolf Larkin
Satan Press
Cover Artist: Gene Bilbrew

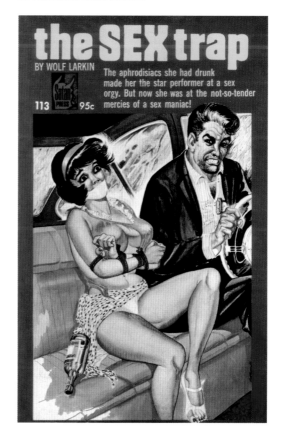

THE RAPIST (1967)
By Jeff Hart
P.E.C.
Cover Artist: Doug Weaver

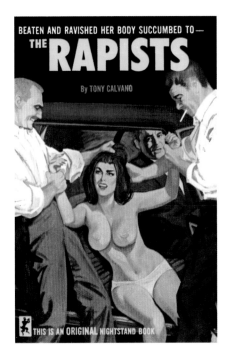

THE RAPISTS (1966)
By Tony Calvano
Nightstand Books

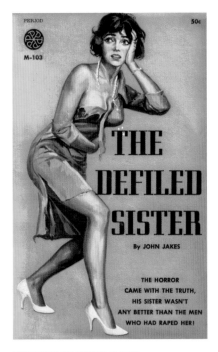

THE DEFILED SISTER (1961)
By John Jakes
Period Books

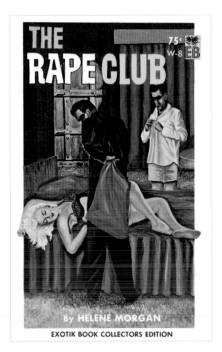

THE RAPE CLUB (1965)
By Helene Morgan
Exotik

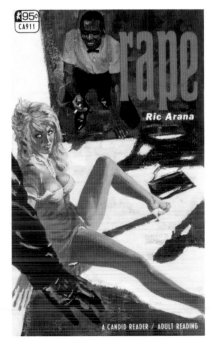

RAPE (1967)
By Ric Arana
Candid Reader
Cover Artist: Robert Bonfils

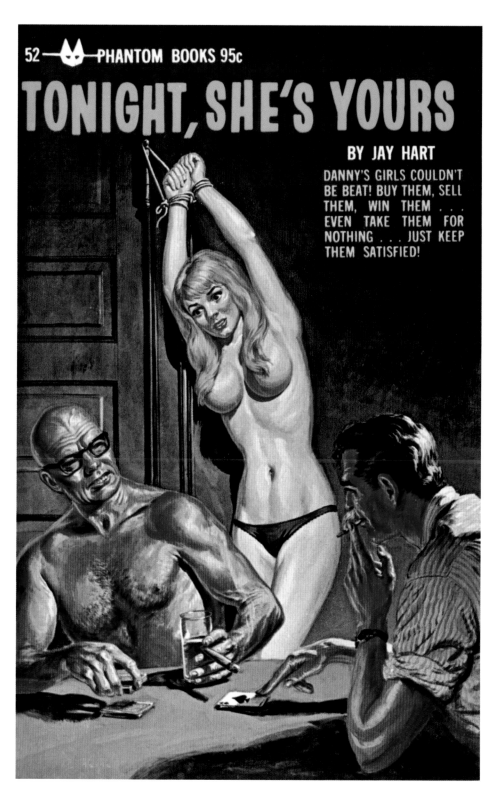

TONIGHT, SHE'S YOURS

BY JAY HART

DANNY'S GIRLS COULDN'T
BE BEAT! BUY THEM, SELL
THEM, WIN THEM . . .
EVEN TAKE THEM FOR
NOTHING . . . JUST KEEP
THEM SATISFIED!

TONIGHT. SHE'S YOURS (1965)
By Jay Hart
Phantom

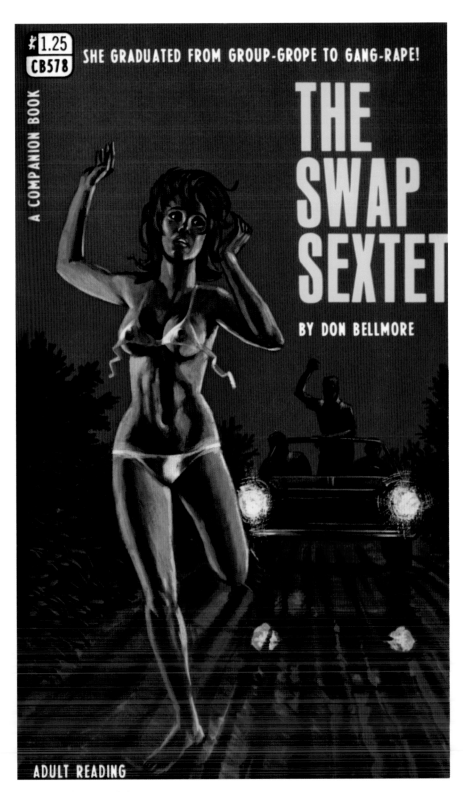

THE SWAP SEXTET (1968)
By Don Bellmore
Companion Books
Cover Artist: Ed Smith

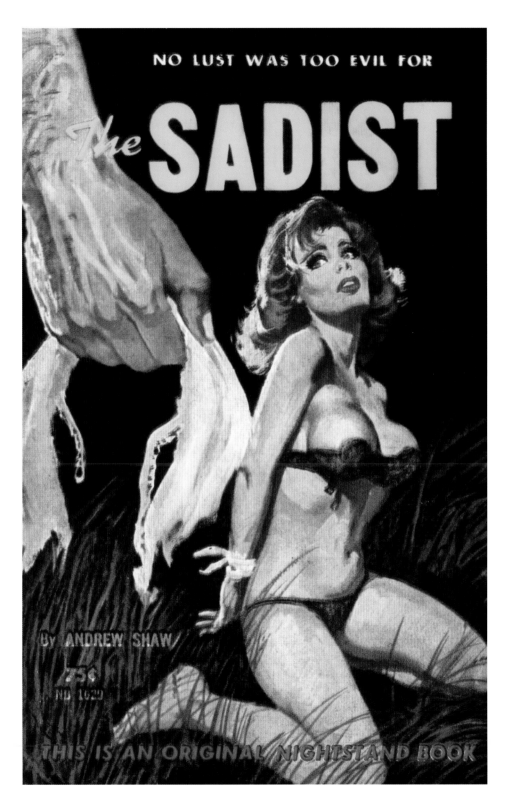

THE SADIST (1962)
By Andrew Shaw
Nightstand Books
Cover Artist: Robert Bonfils

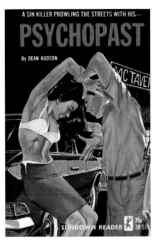
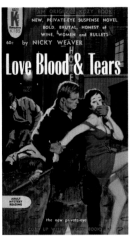
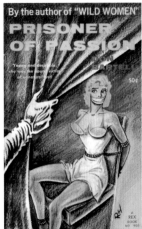
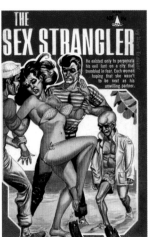

VICE ROW (1963)
By Fletcher Bennett
Playtime Books
Cover Artist: Robert Bonfils

SEX MADNESS (1966)
By Dave King
P.E.C.
Cover Artist: Doug Weaver

PSYCHOPAST (1965)
By Dean Hudson
Sundown Readers

LOVE BLOOD AND TEARS (1963)
By Nicky Weaver (Orrie Hitt)
Kozy Books

PRISONER OF PASSION (1962)
By Don Bartell
Rex Books
Cover Artist: Ric

THE SEX STRANGLER (1967)
By Russ Trainer
Wizard
Cover Artist: Gene Bilbrew

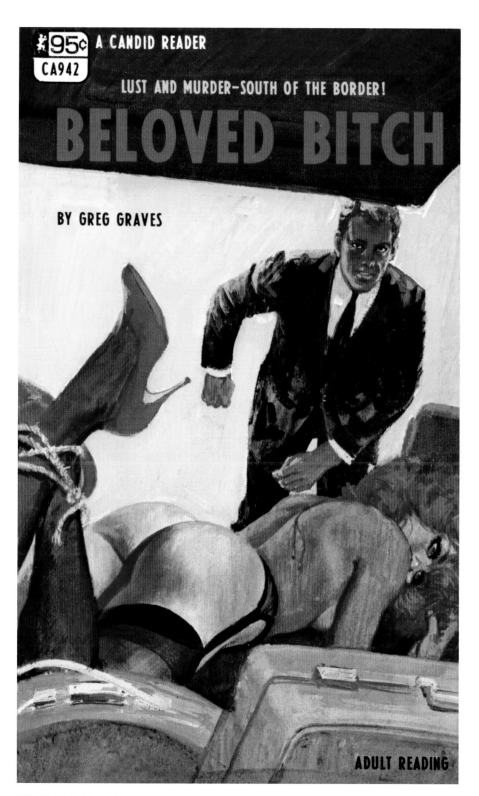

BELOVED BITCH (1968)
By Greg Graves
Candid Reader
Cover Artist: Robert Bonfils

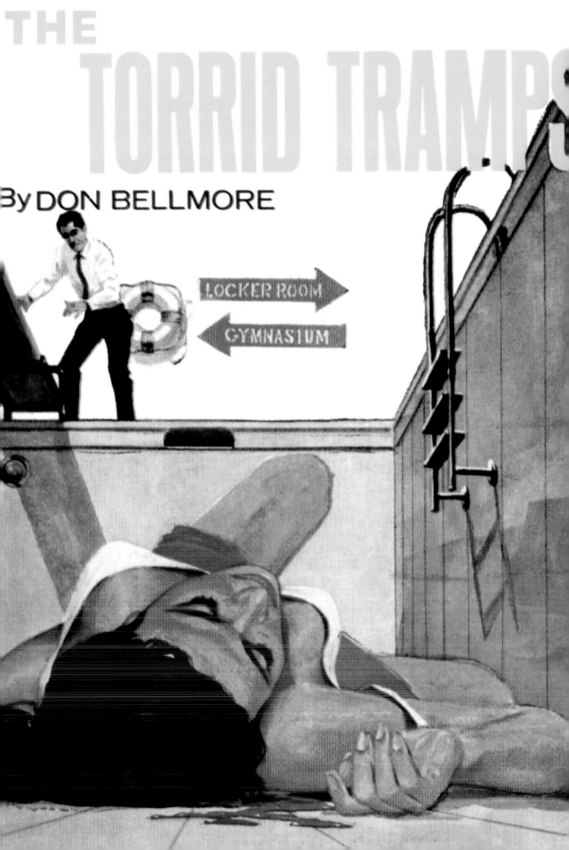

SHE WAS A LOSER IN THE SHAME-GAMES OF—

THE
TORRID TRAMPS

By DON BELLMORE

LOCKER ROOM

GYMNASIUM

SEX FURY (1962)
By Don Elliott (Robert Silverberg)
Nightstand Books
Cover Artist: Harold W. McCauley

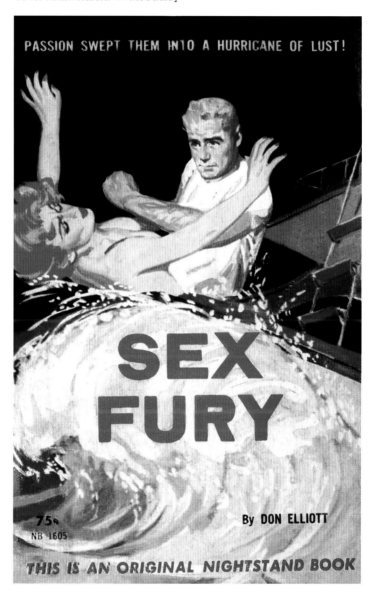

PASSION SWEPT THEM INTO A HURRICANE OF LUST!

SEX
FURY

75¢
NB 1605

By DON ELLIOTT

THIS IS AN ORIGINAL NIGHTSTAND BOOK

THE TORRID TRAMPS (1966)
By Don Bellmore
Nightstand Books
Cover Artist: Darrel Millsap

"The picture with Chief Eldridge holding the dead girl. It's a great shot. The greatest I've ever taken. There's just enough of the girl's body exposed, and with the Chief looking toward heaven, you get two elements. One of a sexual rapture and the other of a pious rapture."

"Did you fade the negative to hide the girl's figure?" I asked.

"Didn't need to, Chuck. Her breasts and thighs were so burned and blackened that nothing but shape really shows. Wouldn't be a bit surprised that picture wins a national award."

I swallowed the second drink Al set beside me.

"Haven't you got any sense of decency?" I asked. "That girl was all but nude. The naked flesh was torn from her leg almost to the bone."

There was a gleam in Higgins's eye that frightened me.

"I know, Chuck. That's what makes the picture great. If she was covered with a bathrobe it would be just another picture of a dead girl. The caption will read: RAPED BY FIRE. Great, huh?"

Jerry M. Goff, Jr., *Abnormal Assault* (Merit Books, 1962)

WARPED DESIRES (1961)
By Les Hinshaw
Merit Books

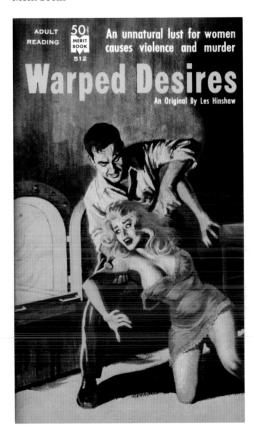

THE PERVERT! (1961)
By Myles Neville
Merit Books

EXCLUSIVE—Autobiography of

THE PERVERT!

ADULT READING

0¢

ERIT
OOK

602

"I spent many, many hours admiring and fondling my beauties. They were an obsession to me. I wanted to possess the finest in womanhood. But no one will ever believe my story. No one will believe that sex and murder were as necessary to my plan as bread and water are to survival."

Myles Neville

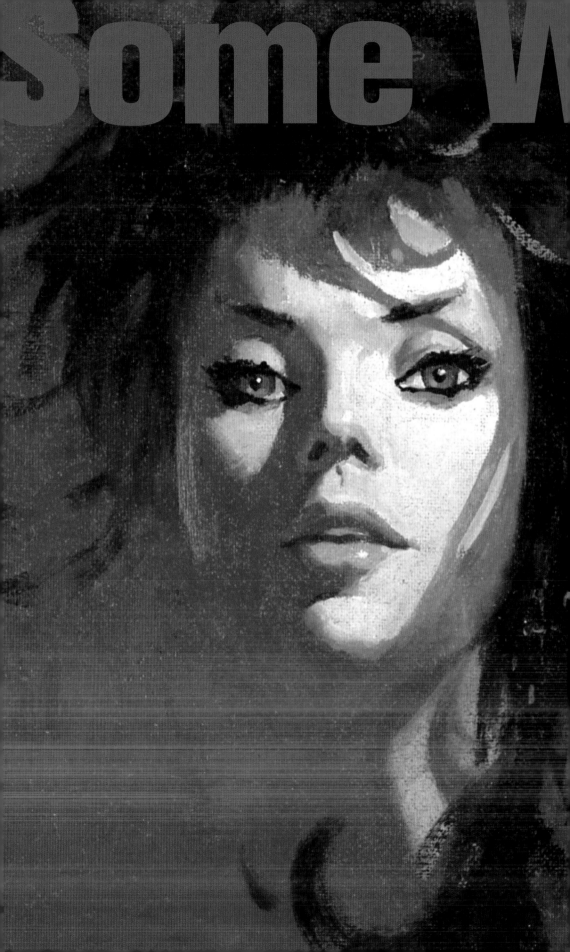

The best working incantations are those that must be whispered in the presence of she (or he) of whom the results are desired, like this one used by a man with a woman:

> Prince of Darkness, fiend of fiends
> Apply thy ghastly fearful means
> Conjure up thy awesome might
> And fire this broad up hot tonight?

A woman might whisper the following in the presence of a man:

> Prince of Monsters, Lord of Flies
> Grant thy power within me lies
> To help me in the tighter clinches—
> And make him feel like two more inches

Bill Breedlove, *Devil Sex* (P.E.C., 1967)

Original Art from SEXY SIREN (1968)
Cover Artist: Robert A. Maguire
From the Collection of Jeff Rich

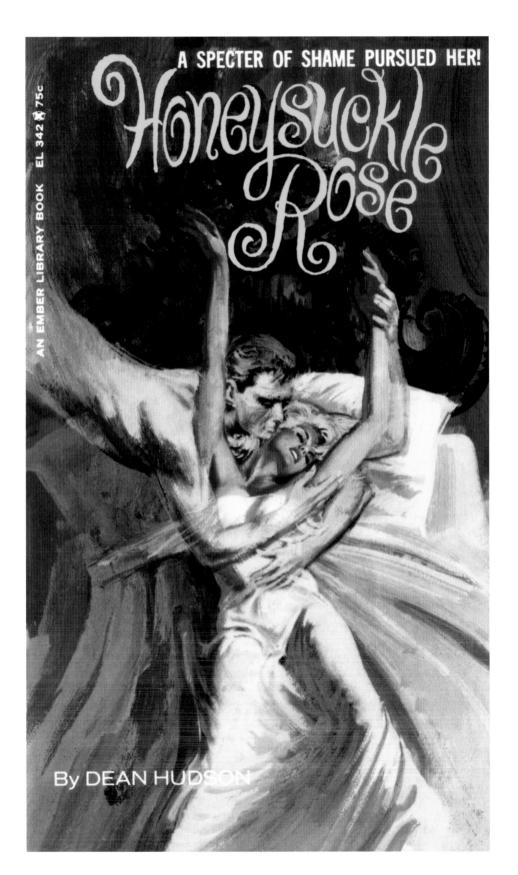

A SPECTER OF SHAME PURSUED HER!

Honeysuckle Rose

By DEAN HUDSON

AN EMBER LIBRARY BOOK EL 342 75¢

LUST DREAM (1962)
By Dean Hudson
Nightstand Books
Cover Artist: Robert Bonfils

HE HAD TO RAVISH HER — HE HAD TO KILL HER!

LUST DREAM

75¢
NB 1630

THIS IS AN ORIGINAL NIGHTSTAND BOOK

HONEYSUCKLE ROSE (1966)
By Dean Hudson
Ember Library
Cover Artist: Robert Bonfils

TOO GOOD TO BE TRUE (1967)
By Russ Trainer
Chevron
Cover Artist: Gene Bilbrew

THE MAN IN THE BOX (1968)
By Corley Dale
Nightstand Books
Cover Artist: Robert Bonfils

FLESH EPITAPH (1964)
By Don Holliday
Leisure Books

VAMPIRISM: A SEXUAL STUDY (1969)
By Dr. Phillip Carden, with Ken Mann
Late Hour Library
Cover Artist: Robert Bonfils

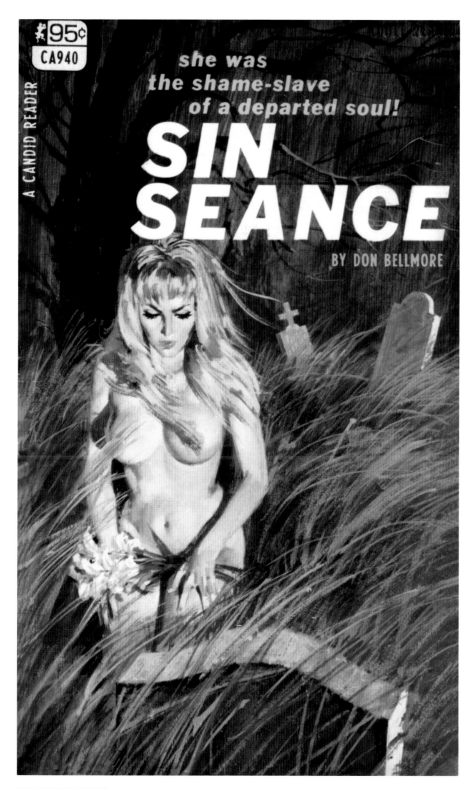

SIN SEANCE (1968)
By Don Bellmore
Candid Reader
Cover Artist: Robert Bonfils

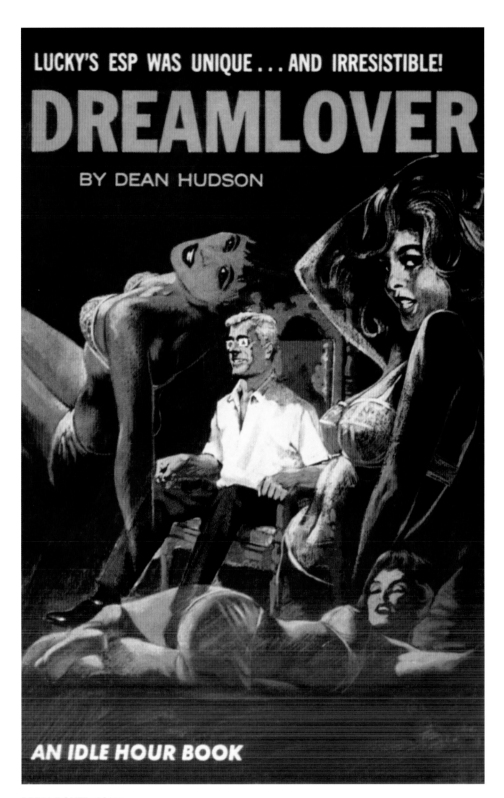

DREAMLOVER (1966)
By Dean Hudson
Idle Hour
Cover Artist: Darrel Millsap

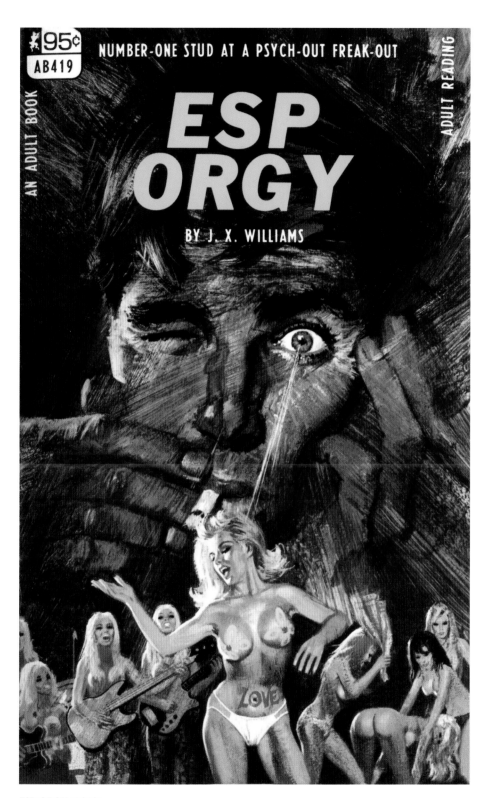

ESP ORGY (1968)
By J.X. Williams
Greenleaf Classics
Cover Artist: Robert Bonfils

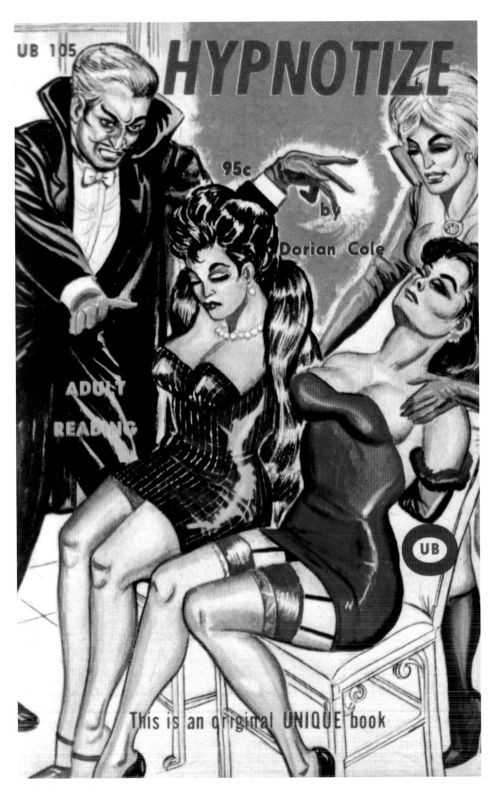

HYPNOTIZE (1966)
By Dorian Cole
Unique Books
Cover Artist: Gene Bilbrew

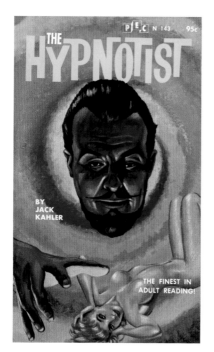

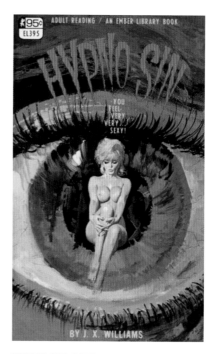

THE HYPNOTIST (1966)
By Jack Kahler
P.E.C.
Cover Artist: Doug Weaver

HYPNO-SIN (1967)
By J.X. Williams
Ember Library
Cover Artist: Robert Bonfils

"One-two-three-four-five. Your sleep state has now become the state of deep hypnosis. Five you are in deep hypnosis."

A pause.

"I want you to listen to what I say. Listen carefully to what I say. You will believe me. You will believe me, Angelina. You will obey my commands. You—"

Kay Johnson, *The Corrupted* (Softcover Library, 1966)

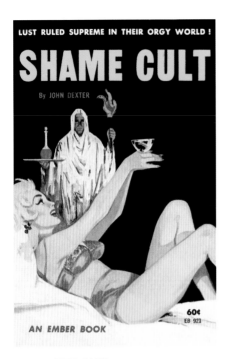

SHAME CULT (1963)
By John Dexter
Ember Books

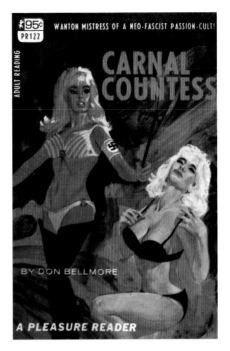

CARNAL COUNTESS (1967)
By Don Bellmore
Pleasure Readers
Cover Artist: Darrel Millsap

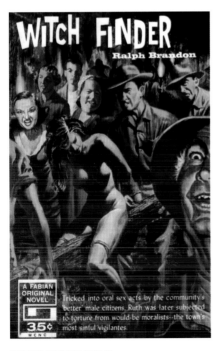

WITCH FINDER (1960)
By Ralph Brandon
Fabian Books

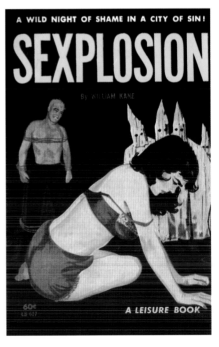

SEXPLOSION (1963)
By William Kane
Leisure Books

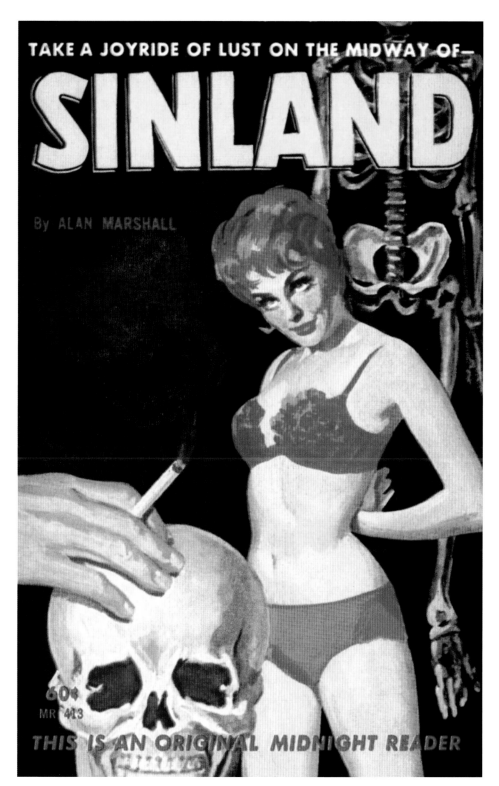

SINLAND (1962)
By Alan Marshall
Midnight Readers
Cover Artist: Harold W. McCauley

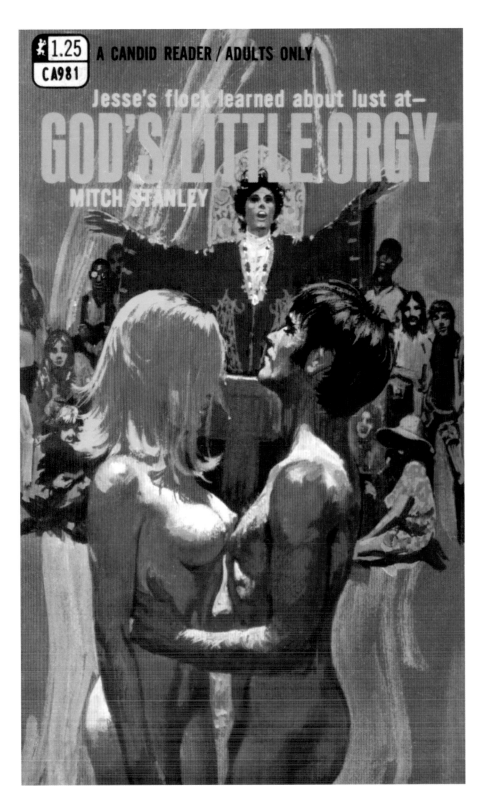

GOD'S LITTLE ORGY (1969)
By Mitch Stanley
Candid Reader
Cover Artist: Robert Bonfils

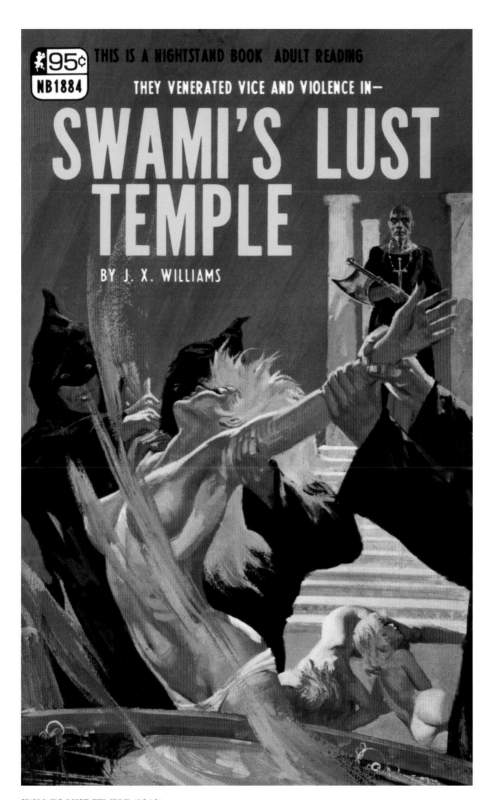

SWAMI'S LUST TEMPLE (1968)
By J.X. Williams
Nightstand Books
Cover Artist: Robert Bonfils

Anton Szandor La Vey, founder of the first Satanic church of the United States, is a hell of a lot better showman than Darren. La Vey is tall, suave, handsome and magnificently attired in a red and black satin costume, complete with cape, hood, and horns above his ears. He is a dramatic and compelling speaker, charming, erudite and cultivated. Apparently he uses no greasy kid's stuff on his Van Dyke. The most attractive thing about La Vey, however, is his assistant, Santana—waist-long black hair, with a lush full figure from the tips of her toes to the mole on the cheek of her lovely face. One glance at Santana and Saint Paul would have been a willing convert.

Bill Breedlove, *Devil Sex* (P.E.C., 1967)

THE SEXY SAINTS (1967)
By Stephany Gregory
Rapture Books

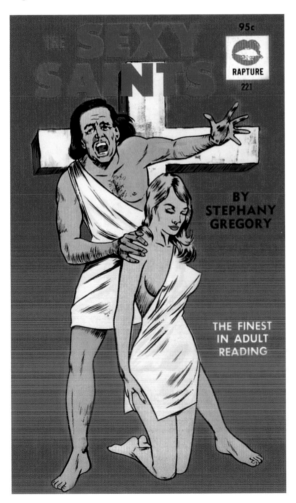

HOLLYWOOD SEX GOD (1962)
By Bob Howard
Parliament Books

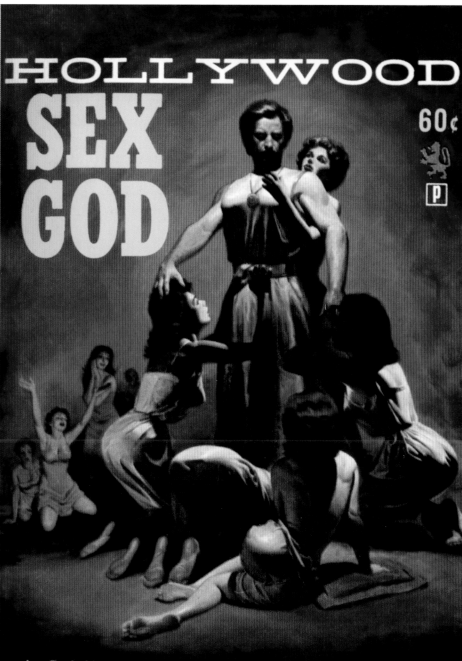

HOLLYWOOD
SEX
GOD

60¢

[P]

by Bob Howard

He founded a religious cult and declared himself
the living reincarnation of the god of procreation,
god of pleasure — and god of sex. And he and his
worshippers paid homage at the shrine of the orgy.

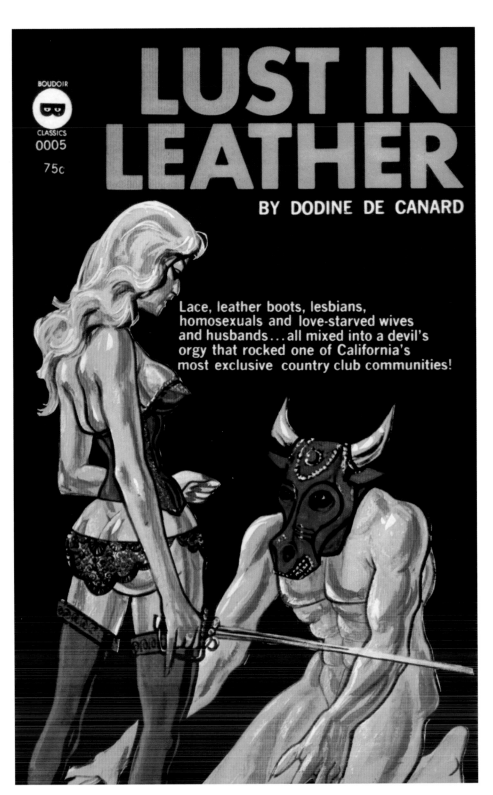

LUST IN LEATHER (1964)
By Dodine De Canard
Boudoir Books

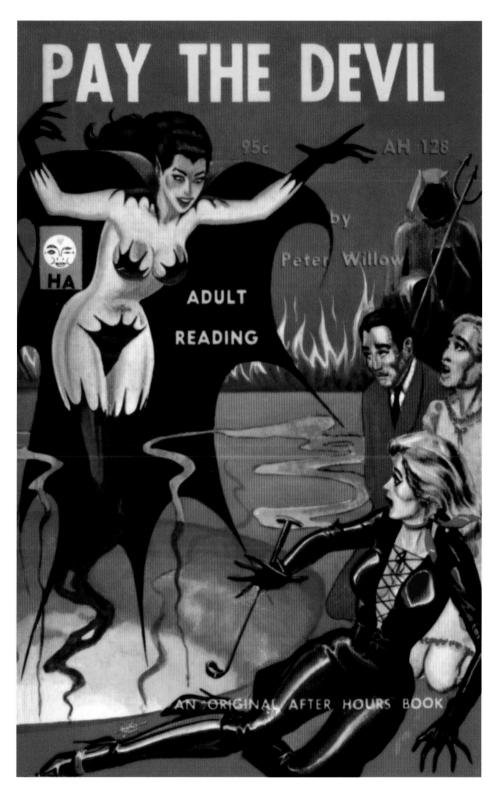

PAY THE DEVIL (1966)
By Peter Willow
After Hours
Cover Artist: Eric Stanton

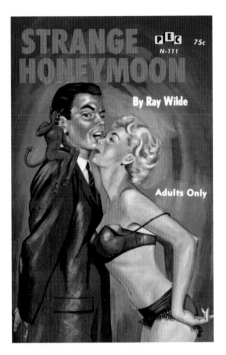

STRANGE HONEYMOON (1965)
By Ray Wilde
P.E.C.
Cover Artist: Doug Weaver

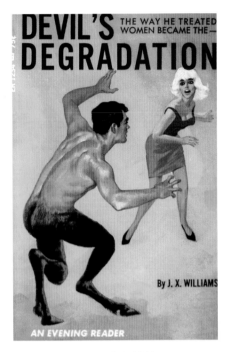

DEVIL'S DEGRADATION (1966)
By J.X. Williams
Evening Readers

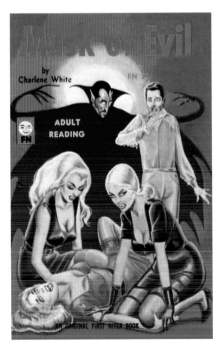

MASK OF EVIL (1966)
By Charlene White
First Niter
Cover Artist: Eric Stanton

GOD OF LUST (1964)
By Vin Saxon
Rapture Books

DEVIL'S HARVEST (1969)
By Rob E. Smith
Saber Books
Cover Artist: Bill Edwards

BRITTANY A. DALEY

SLEAZE PUBLISHERS: A CATALOGUE

SADIST ON THE LOOSE (1960)
By George H. Smith
Novel Books

JETMAN MEETS THE MAD MADAM (1966)
By Hardley Savage
Bee-Line Books

No catalogue or bibliographic references that I know of have inventoried sleaze publishers and/or their published titles. In addition, a number of individuals who were involved in the industry avoid speaking about their softcore careers, and are unwilling to share relevant information.

The catalogue below is partly a result of studying my collection and making connections between the various publisher names, addresses, and publishing styles. Most the information comes from other collectors, and from individuals who were unashamed about their involvement in the industry.

Many of the publishers listed below were evading the law, and thus changed their names and addresses quite frequently, when they weren't listing mail drops or no address at all. When more than one company name is listed, this indicates the use of multiple names by a publisher. If information on certain publishers in this catalogue seems incomplete, this is because many publishers printed little or no information about themselves on their copyright pages, and the experts I contacted were not able to fill in the blanks. Many of these publishers only issued a few titles, and I may have missed a number of these "fly-by-nights."

Please note that I have included only a few of the publishers' authors or titles, choosing to highlight the notables.

This catalogue is a work in progress that will benefit from the input of others. Please email any corrections or additions to: cobusa@intergate.com or Brittany Daley, 225 5th Street, Alvarado MN, 56710, or contact Feral House so future editions of this book can reflect corrections.

Special thanks are due the following people for their assistance: L. Truman Douglas, Steve Gertz, Jay Gertzman, Carole Jean, Earl Kemp, Miriam Linna, Lynn Munroe, Mike Resnick, and Ryan Richardson.

ADULT BOOKS (See Greenleaf Publications)

AFTER HOURS (See Satellite Publications)

ALL STAR BOOKS (Art Enterprises) (I)
Location: Hollywood, CA; later Los Angeles, CA,
and North Hollywood, CA
Years: 1961–1963
Artist: John Healey
Sample Titles: *The Girls On Main Street*;
Love Kitten; *Swamp Lust*

ALL STAR BOOKS
(Frimac Publications, Nite Lite Books) (II)
Location: North Hollywood, CA; later Canoga Park, CA
Years: 1963–1968
Artists: John Healey, Robert Maguire, Harvey Tow,
Doug Weaver
Other: These later All Star Books appear to have
a different publisher than the earlier ones.
Sample Titles: *Hot Pants Homo*; *Hush Hush Sweet
Harlot*; *Swing Low Sweet Lesbian*; *Watusi Nymph*

ANCHOR EDITIONS (See Pioneer Publishing Co.)

ANCHOR PUBLICATIONS
Location: Gardena, CA
Year: 1965
Sample Titles: *Boozers, Babes & Big Wheels*;
The Gay Bunch; *Sex on Fire*

ARROW READERS (See Pioneer Publishing Co.)

ATHENA BOOKS
Location: Hollywood, CA
Year: 1961
Sample Title: *Deadly Dolly*; *The Thrill Club*

AVANTI ART EDITIONS (Knight Publications)
First Editions in English of classic French erotica
Publishers: Bentley Morris & Ralph Weinstock
Editor: Jared Rutter
Distributor: AADC — All American Distribution Co.,
owned by Morris & Weinstock

BACHELOR BOOKS
(See Neva Paperbacks/ N.P. Inc.)

BANNER VOLUMES (See Pioneer Publishing Co.)

BEACON BOOKS/SOFTCOVER LIBRARY
(Universal Publishing)
Location: New York, NY
Publisher: Arnold E. Abramson
Years: 1954 to at least the early '70s
Artists: Darcy, Victor Olson, Robert Stanley,
George Gross, Walter Popp, Robert Maguire,
Micarelli, Al Rossi, Milo, Harry Barton,
Santopadre, Faragasso, Jack Thurston, Owen
Kampen, Jerome Podwill, Robert E. Schulz

Authors: Philip José Farmer, Harry Whittington,
C.M. Kornbluth, Charles Willeford, John Jakes,
Orrie Hitt, Richard E. Geis, Michael Avallone
Sample Titles: *Adam and Two Eves*; *Call-Girl
Wives*; *Cry Rape*; *Dial "M" for Man*; *The Eager
Beavers*; *Girl in a Go-Go Cage*; *Hitch-Hike Hussy*;
Loves of a Girl Wrestler; *Lust in Orbit*; *Marijuana
Girl*; *Shopping Center Sex*; *Station Wagon Wives*;
Sorority Sin; *Whose Wife Tonight?*

BEDSIDE BOOKS/BEDTIME BOOKS
(Pert Publications, Valiant Publications, E.K.S.
Corp., later Greenleaf)
Location: New York, NY
Publisher: William Hamling acquired Bedside in
1961 (beginning with the 1200 series)
Years: 1959–1963
Artists: John Duillo, Robert Maguire
Authors: William Knoles, Joe Weiss, Harry
Whittington, Robert Silverberg
Sample Titles: *Army Tramp*; *Campus Love Club*;
Gutter Lust; *Hellhole of Sin*; *Hotrod Sinners*;
Jailbait; *Office Casanova*; *Suburban Sin Club*

BEE-HIVE READERS
Year: 1964
Sample Titles: *The Mating Deal*; *The Sex Samplers*

BEE-LINE BOOKS
Location: New York, NY
Publisher: David Zentner
Years: Began in 1965 and still going into the '90s
Artist: Paul Rader
Sample Titles: *Alley of the Dolls*; *Big Stud Inc.*;
For Whom the Belles Toil; *From Here to Maternity*;
The Girl in the Grey Flannel Suit; *Have Body Will
Travel*; *In Hot Blood*; *Pussycat Named Desire*;
The Oversexed Astronauts

BELL BOOKS
Year: 1964
Sample Title: *Lust Games*; *Naked Tales*

BELL HOUSE CLASSICS
(See Neva Paperbacks/N.P. Inc)

BELL-RINGER BOOKS (L.S. Publications)
Location: New York, NY
Years: 1964–1965
Sample Titles: *B-Girl Bride*; *Passion Behind Bars*;
Two-Way Woman

BONANZA BOOKS
Year: 1963
Sample Title: *Lesbian Wives*

BOUDOIR BOOKS (Art Enterprises; later K.S.,
Tempo, & Imperial Publishing)
Location: Los Angeles, CA
Publisher: David Zentner

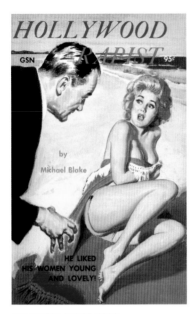

HOLLYWOOD RAPIST (1964)
By Michael Blake
Carousel Books

Years: 1962–1964
Author: George H. Smith, Jim Harmon
Sample Titles: *Abortion Mill*; *The Bordello Queen*;
Burn, Blonde, Burn; *Commie Sex Trap*; *Lady Stud*;
Sexodus; *Summer Stock Sex Theater*

BOW BOOKS
Other: Publisher pirated Boudoir Books' titles
Sample Title: *Male Mistress* (pirates *Kept Man*)

BRANDON HOUSE/PARLIAMENT BOOKS
(American Art Agency; later American Art
Enterprises 1968–69)
Location: North Hollywood, CA
Publisher: Milton Luros
Editors: Robert Reitman was Executive Editor for
American Art Agency, Harold Straubing for
Brandon House, Brian Kirby for Brandon House
Library Editions
Other: A few Brandon House titles were printed
under the Parliament Books imprint.
Years: 1962–1977
Artists: Larry Byrd, Fred Fixler, Wil Hulsey,
Jerry Pecoraro
Authors: Richard E. Geis, George H. Smith,
Robert Silverberg
Sample Titles: *Beat Nymph*; *Bedroom a Go-Go*;
The Bride Turned Gay; *Carnival Mistress*; *Flying
Lesbian*; *The Free Love Virgin*; *I Am a Hollywood
Call Boy*; *A Man Called Sex*; *Two Reel Gay Girls*;
Saddle Shoe Sex Kitten

BRENTWOOD PUBLISHING CO.
Location: Hollywood, CA
Year: 1964

Author: Lynton Wright Brent
Sample Titles: *Flaming Lust*; *The Passion Tree*;
The Sex Demon of Jangal

CANDID READER (See Greenleaf Publications)

CANDLELIGHT BOOKS
Year: 1964
Sample Title: *Craving Temptress*; *Naked Prize*;
Midway Mistress

CAMERARTS PUBLISHING
Imprints: Merit Books, Novel Books, Specialty
Books
Location: Chicago, IL
Publisher: Joe Sorren (real name: Sorrentino)
Editor: Paul Neimark
Years: 1959–1965 (different imprints ran in
different year ranges)
Artists: Robert Bonfils, Sloan, Arnie Kohn,
K. Freeman, Bill Ward
Authors: Con Sellers, Orrie Hitt, George H. Smith,
Bob Tralins, Herschel Gordon Lewis, Mamie Van
Doren, Mandy Rice-Davies, Lili St. Cyr
Sample Titles: *$1,000 Nymph*; *Color Me Blood
Red*; *Female Psycho Ward*; *I Was Male!*; *Lucky
Rape*; *Overdeveloped Dolls*; *Sadist on the Loose!*;
Shocking She-Animal; *Two Thousand Maniacs*;
Violent Orgy; *Wench!*

CAROUSEL BOOKS (Frimac Publications)
Location: North Hollywood, CA
Years: 1962–1964
Artist: John Healey
Sample Titles: *Fury in Black Lace*; *Lesbian Gang*;
Nude on Route 66; *Sex Doctor*; *Virgin for Sale*

CENTAUR NOVELS
Year: 1965
Sample Title: *Wanton is a Sex Letter Word*

CENTURY BOOKS (K.D.S.)
Location: Cleveland, OH
Publisher: David Zentner
Year: 1967
Sample Title: *I Was A Teenage Wife Swapper*;
Lesbianism and the Single Girl

CHARIOT BOOKS
Location: New York, NY
Years: 1959–1963
Artists: Wagner, Victor Olson, Jerome Podwill
Authors: Carlson Wade, John B. Thompson,
Orrie Hitt
Sample Titles: *Bitch on Wheels*; *Cold Wife*;
Creole Desire; *Dungaree Sin*; *Lesbo on the Make*;
Sin Gym; *Texas Tramp*; *Video Virgin*

CHEVRON (See Foremost Publishers/
Connoisseur Publications)

CHICAGO PAPERBACK HOUSE
Location: Chicago, IL
Years: 1962
Artists: Robert Bonfils, Cloutier, Kugach, Nystrom
Author: Charles Willeford
Sample Titles: *The Big Squeeze*; *Cockfighter*

CLOVER READERS
Year: 1964
Sample Title: *Nymph Hide-A-Way*; *Slash of Lust*

CLUB NOVELS
Sample Title: *Lust Racket* (pirate of the Tuxedo Book *Vice, Inc.*)

COACH VOLUMES (*See* Pioneer Publishing Co.)

COLLECTOR'S PUBLICATIONS
Location: West Covina, CA
Publisher: Marvin Miller
Authors: Chester Himes, Lawrence Durrell, Denis Diderot, Marcus Van Heller, James Joyce, Pauline Reage
Sample Titles: *Amish Love*; *Cave Man Sex*; *The Horny Headmaster*; *Meat the Girls*; *Peter Pecker*; *Pimp*; *Private Dick*; *The Talking Pussy*

COMPANION BOOKS (*See* Greenleaf Publications)

COMPASS LINE (*See* Pioneer Publishing Co.)

CONTINENTAL CLASSICS
Location: Long Island City, NY
Year: 1968
Sample Title: *Come Again*

CORINTH REGENCY (*See* Greenleaf Publications)

CORINTH SUSPENSE LIBRARY
(*See* Greenleaf Publications)

CORSAIR (*See* Foremost Publishers/
Connoisseur Publications)

CRESCENT (*See* Foremost Publishers/
Connoisseur Publications)

DANIEL PUBLISHING COMPANY
Location: Riverside, CA
Year: 1965

DOCUMENTARY CLASSICS
(Consolidated Publishing)
Location: New York, NY
Sample Title: *You ... Fetishist*

DOLLAR DOUBLE
Location: Chicago, IL
Year: 1962
Artist: Robert Bonfils
Sample Titles: *The Beatniks*; *Lash of Desire*; *Pillow Tramp*; *Strumpets' Jungle*

DOMINION BOOKS
Location: North Hollywood, CA
Year: 1969
Sample Titles: *Maid's Night Out*; *Trailer Camp Sex Ring*

DOMINO BOOKS (Lancer Books)
Location: New York, NY
Sample Titles: *200 Miles to Sin*; *The Golden Nymph*; *The Sweet Smell of Sin*; *Trouble in Skirts*

DRAGON EDITIONS (*See* Pioneer Publishing Co.)

EMBER BOOKS (*See* Greenleaf Publications)

EMBER LIBRARY (*See* Greenleaf Publications)

EMERALD READER
Year: 1964
Sample Titles: *Flesh Riddle*; *Lecher's Holiday*

EPIC BOOKS (Art Enterprises)
Location: North Hollywood, CA
Publisher: David Zentner
Editor: Ed Sullivan
Years: 1961–1962
Artists: Albert Nuetzel (as Gus Albet), Doug Weaver
Authors: Charles Nuetzel, George H. Smith, Jim Harmon, Ron Haydock
Sample Titles: *Bodies for Sale*; *The Lust Hillbilly*; *The Man Who Made Maniacs*; *Operation: Lust*; *Sorority Sluts*; *Two-Timing Tart*

ESSEX HOUSE
Location: North Hollywood, CA
Publisher: Milton Luros
Editor: Brian Kirby
Years: 1968–1969
Authors: Charles Bukowski, Philip José Farmer, David Meltzer, Michael Perkins
Sample Titles: *The Agency*; *Blown*; *The Image of the Beast*; *Notes of a Dirty Old Man*; *Tender Buns*; *Whacking Off*

EUROPA BOOKS (Comet Publications) (I)
Publisher specialized in fold-out covers
Location: Los Angeles, CA
Year: 1963
Artist: Bill Edwards (signed "B.E.")
Sample Titles: *Berlin Bed*; *Sin on the Continent*; *Sin Safari*

EUROPA BOOKS (L.S. Publications) (II)
Location: New York, NY
Sample Title: *The Homosexual Generation*

EVENING READERS (*See* Greenleaf Publications)

EXOTIK (*See* Foremost Publishers/Connoisseur Publications)

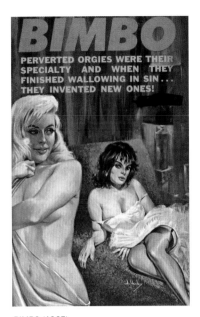

BIMBO (1965)
By Lester Lake
Nite Lite Books
Cover artist: John Healey

FABIAN BOOKS (See West Coast News Co.)

FALCON BOOKS (Publisher's Export Company)
Location: Los Angeles, CA
Year: 1964
Sample Titles: *Beach Stud*; *Black Silk Harem*;
Hot, Wild, and Wanton

FIRST NITER (See Satellite Publications)

FITZ PUBLICATIONS
Location: Cypress, CA
Years: 1964–1965
Authors: Ron Haydock
Sample Titles: *Hot Young Lust*; *I Want to Sin*

FLEUR DE LIS
Location: New York, NY
Sample Titles: *I, Homosexual*; *I, Prostitute*;
I, Virgin

**FOREMOST PUBLISHERS/CONNOISSEUR
PUBLICATIONS**
Imprints: Chevron, Corsair, Crescent, Exotik,
Mercury, Phantom, Satan Press, Vanguard, Wizard
Locations: Cleveland, OH (publishing was proba-
bly headquartered here); Detroit, MI, and San
Diego, CA, addresses are also listed on some
copyright pages though
Years: 1965–1968 (different imprints ran in dif-
ferent year ranges)
Publisher: Joe Sturman
Distributor: World Wide News Co. (WWNC)
owned by Reuben Sturman

Artists: Gene Bilbrew, Elaine Duillo (only for
Crescent)
Sample Titles: *Black Water Nympho*; *Blood Orgy*;
Celluloid Sex Bomb; *Fetish Farm*; *Motel 69*;
Queer Daddy; *Rubber Goddess*; *Swastika Sex Cult*;
Surf Broad; *Vice U.*

FRANCE (International Publications)
Publisher specialized in cheesecake photo covers
and fold-out covers that revealed a bit of nudity
Location: Hollywood, CA
Publisher: Lou Kimzey
Years: 1962–1963
Artist: Princeotta
Authors: John Gilmore, Ed Wood, Jim Harmon,
Ron Haydock, Adam Coulter
Sample Titles: *Bowling Bum*; *Cleopatra's Blonde
Sex Rival*; *Ding-A-Ling Broad*; *Door to Door Rape*;
Hollywood Homo; *My Foul Lady*

GALAXY BOOKS (See Neva Paperbacks)

GASLIGHT BOOKS (L.S. Publications Corp)
Location: New York, NY
Years: 1964
Authors: Bob Tralins, Orrie Hitt
Sample Titles: *Beaten By Passion*; *Jazzman in
Nudetown*; *Mexican Man-Trap*

GLOBE VOLUMES
Year: 1964
Sample Titles: *Around the Clock Sinners*;
Split Level Sin

GOLD STAR (New International Library)
Location: Derby, CT
Publisher: David Zentner
Years: 1963–1965
Artists: Harry Barton, Robert Maguire, Paul
Rader, Harry Schaare
Sample Titles: *Adultery in Suburbia*; *Demented*;
Expectant Nymph

GOOD BOOKS (Good Publications)
Location: Hollywood, CA
Sample Titles: *Sweet Taste of Sin*

GREENLEAF CLASSICS
(See Greenleaf Publications)

GREENLEAF PUBLICATIONS
Imprints: Adult Books, Candid Reader,
Companion Books, Corinth Regency, Corinth
Suspense Library, Ember Books, Ember Library,
Evening Reader, Greenleaf Classics, Idle Hour,
Late Hour Library, Leisure Books, Midnight
Reader, Nitime Swapbook, Pillar
Books, Pleasure Reader, Reed Nightstand,
Sundown Reader
Locations: Evanston, IL, then San Diego, CA
Publisher: William Hamling

Editor: Harlan Ellison, Algis Budrys, Earl Kemp. In the porn era: Patrick A. "Petey" Dixon
Years: Began 1959 & went until at least the '80s (different imprints ran in different year ranges)
Artists: Robert Bonfils, Ed Smith, Tomas Cannizarro, Darrel Millsap, Harold McCauley
Authors: Robert Silverberg, William Knoles, Lawrence Block, Marion Zimmer Bradley, Harlan Ellison, Evan Hunter, Victor Banis, Donald Westlake, Earl Kemp, George H. Smith, Charles Nuetzel, Ed Wood, Con Sellers, Richard Armory, Terry Southern
Sample Titles: *69 Swap Lane*; *Butcher Shop Swap*; *Call Girl School*; *Computer Swap*; *The Demon Dyke*; *Dial O-R-G-Y*; *Dr. Dildo's Delightful Machine*; *The Greedy Gynecologist*; *Hog Girl*; *Lust for a Green Beret*; *Narco Nympho*; *Orgy of the Dead*; *Psychic Sexpot*; *Sin and Tonic*; *Skid Row Sweetie*; *Song of the Loon*; *Swappers Don't Cheat*

GROVE PRESS—ZEBRA
Location: New York, NY
Publisher: Barney Rosset
Authors: William S. Burroughs, Henry Miller, Jack Kerouac, D.H. Lawrence, Samuel Beckett
Sample Titles: *The Devil in Miss Jones*; *Doctor Sax*; *Naked Lunch*

HEADLINE BOOKS (World News Incorporated)
Location: Los Angeles, CA
Years: 1960
Author: Con Sellers
Sample Titles: *Devil's Cult*; *Lust Farm*; *Red Rape*

HEART VOLUMES
Year: 1964
Sample Titles: *Jungle Lust*; *Sin-Sob Sister*

HERALD READER
Year: 1964
Sample Title: *Sin Bus*

HI-HAT (Tuxedo Books)
Year: 1963–1964
Sample Titles: *Beat Me Lover*; *Passion Prowler*; *Sex Clutch*

HOLLOWAY HOUSE (Knight Publications)
Publishers: Bentley Morris & Ralph Weinstock
Distributor: AADC (All American Distribution Co. —owned by Morris and Weinstock)
Editors: Milton Van Sickle, Jared Rutter, Ray Locke
Author: Iceberg Slim
Artist: Bill Edwards, Monte Rogers, Harry Wysocki
Sample Titles: *Honeyman: True Life Story of a B-Girl Hustler*; *Pimp: Story of My Life*

IDLE HOUR (See Greenleaf Publications)

IMPERIAL BOOKS
(Star News Co., L.S. Publications)

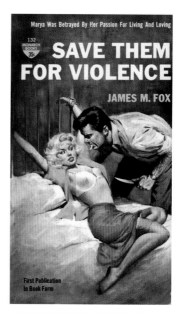

Marya Was Betrayed By Her Passion For Living And Loving

132 MONARCH BOOKS 35¢

SAVE THEM FOR VIOLENCE

JAMES M. FOX

First Publication In Book Form

SAVE THEM FOR VIOLENCE (1959)
By James M. Fox
Monarch Books

Locations: Union City, NJ, and Agoura, CA
Years: 1964–1966
Author: Ed Wood, Carlson Wade
Sample Titles: *Gay Gay a Go-Go*; *Homosexuality: The International Disease*; *Killer in Drag*

IN BOOKS (See Neva Paperbacks)

INTIMATE EDITION (Art Enterprises)
Location: Hollywood, CA
Publisher: David Zentner
Years: 1962–1963
Artist: Robert Caples
Author: George H. Smith
Sample Titles: *Madison Avenue Nympho*; *Strip Wench...Or Die*; *Sunset Strip Sex Agent*

JADE BOOKS (Onsco Publications)
Location: Hollywood, CA
Years: 1963
Artist: Robert Caples
Sample Titles: *Martian Sexpot*; *Nude Ranch Nymphs*; *Profile of a Pervert*

JADE EDITIONS
Year: 1965
Sample Title: *Fetish Beach*; *Play-For-Pay Studs*

JET READERS
Pirate titles distributed by Tuxedo Books, NYC
Sample Titles: *The Big Sin Siesta* (pirate of *Sexpot Señoritas*); *Flesh for Satan* (pirate of *Hell's Wenches*); *The Sin Kid* (pirate of *Child of Evil*)

JEWEL BOOKS (Classic Mail Service)
Location: Compton, CA
Year: 1967
Sample Titles: *Sex Every Witch Way*; *Swapping is for Suckers*; *Voodoo Orgy Cult*

KNIGHT VOLUMES
Year: 1964
Sample Titles: *Sex Cheaters*; *Shackles of Lust*

KOZY BOOKS
Location: Manhasset, NY
Years: 1960–1963
Authors: Orrie Hitt, "Adam Snavely"
Sample Titles: *The Abortionist*; *Blondes Don't Give a Damn*; *The Girl with the Golden G-String*; *Love is a Three Letter Word*; *Ski Gigolo*

LANCER BOOKS
Location: New York, NY
Artists: Robert Stanley, Lou Marchetti
Sample Titles: *The Man From O.R.G.Y.*; *Passionate Tigress*

LANTERN BOOKS (See Pioneer Publishing Co.)

LATE HOUR LIBRARY (See Greenleaf Publications)

LATE LATE BOOKS (Casanova Publishing)
Locations: Long Island City, NY, and Glen Burnie, MD
Years: 1966–1967
Sample Titles: *Diary of a Nympho*; *Desert Lust*; *Model's Ball*

LAY AWAKE BOOKS (Edka Books)
Location: Los Angeles, CA
Artists: Paul Rader, Robert Maguire
Sample Titles: *Call Girl Love*; *Cannibal Perversions*; *The Cuckoo Lovers*; *I, Rapist*

LEISURE BOOKS (See Greenleaf Publications)

LEISURE LIFE BOOKS
Location: Van Nuys, CA
Distributor: Golden State News (Bernie Bloom)
Year: 1966
Sample Title: *Killer From Queer Street*; *The Sex Racket*

LIVERPOOL LIBRARY PRESS
Locations: Mallorca, Monte Carlo, Geneva, Paris, Berlin (used Tiburon/Sausalito addresses)
Publisher: Jim Stevens
Editor: Jim Cardwell
Years: Began in 1967 and became a major porn era player at least into the 1980s (from 1973 onward reprinted original LLP titles)
Author: Bill Pronzini
Sample Titles: *Mama's Men*; *A Swap Around the Clock*; *A Wanton Receptionist*

MAGENTA BOOKS (Newsstand Publishing Co.)
Location: Delray Beach, FL
Year: 1966
Artist: Ellison
Sample Title: *The Avenue of Pimps*; *Gin Mill Gigolo*; *No Prudes Wanted*

MAGNET BOOKS (Nagam Corp.)
Location: New York, NY
Years: 1959–1960
Sample Titles: *The Country Tramp*; *The Hot Beat*; *Violent Desires*

MASK READERS (See Pioneer Publishing Co.)

MAYFAIR HOUSE (See Neva Paperbacks/N.P. Inc.)

MERCURY (See Foremost Publishers/ Connoisseur Publications)

MERIT BOOKS (See Camerarts Publishing)

MIDNIGHT READERS (See Greenleaf Publications)

MIDWOOD (Tower Publications)
Location: New York, NY
Publisher: Harry Shorten
Editors: Elaine Williams, Marshall Dugger
Years: Began in 1957 and lasted into the 1980s
Artists: Paul Rader, Robert Maguire, Victor Olson, Ruddy Nappi, George Alvara, Bruce Minney, Ron Lesser, Harry Barton, Charles Frace, Frank Frazetta, Jerome Podwill, Robert E. Schulz, RES, Hatfield, Wagner
Authors: Donald Westlake, Robert Silverberg, Richard E. Geis, Lawrence Block, Gil Fox, Joan Ellis, Orrie Hitt, Hal Dresner, William Knoles, Elaine Williams, Sally Singer, Ron Singer
Sample Titles: *Campus Sex Club*; *The Doctor and the Dike*; *Drive-In Girl*; *Horizontal Secretary*; *Mail Order Sex*; *Office Tramp*; *Sin on Wheels*; *Stag Stripper*; *Teen Butch*; *Wild Waitress*

MONARCH (Monarch Publishing)
Location: New York, NY
Years: 1958–1965
Publishers: Charles N. Hecklemann, Frederick Fell
Artists: Tom Miller, Robert Maguire, Rafael DeSoto, Harry Schaare, Harry Barton, Ray Johnson, Stanley Borack, Ralph Brillhart, John Schoenherr, Jack Thurston, Robert Stanley
Authors: Marion Zimmer Bradley, Robert Silverberg, Gardner Fox, John Jakes, Phillip Ketchum
Sample Titles: *Jailbait Street*; *The Lolita Lovers*; *The Luscious Puritan*; *The Trailer Park Girls*

MOONGLOW READERS (Art Enterprises/Epic)
Probable pirates of Imperial's titles, but Zentner may have owned Imperial at one time
Publisher: Probably David Zentner
Sample Titles: *Big Tease* ('pirate of *I Deal in Desire*); *I.O.U. Sex*; *Wild Lips*

MOONLIGHT READERS (Art Enterprises/Epic)
Location: North Hollywood, CA
Publisher: Probably David Zentner
Year: 1961
Author: George H. Smith
Sample Titles: *Love Cult*; *Naked Diver*; *Sin Spree*; *Teaser*

NARCISSUS SERIES (See P.E.C.)

NATIONAL LIBRARY BOOKS
(See West Coast News Co.)

NEVA PAPERBACKS (later known as N.P. Inc.)
Imprints: Bachelor Books, Bell House Classics, Criterion Classics, Galaxy Books, In Books, Jewel House, Mayfair House, New Library, Noble Library, Playtime, Royal House, Spotlight Books, Topaz Series (Magenta Books and Newsstand Library may be part of this empire as well)
Location: Probably Delray Beach, FL, although the books list a Las Vegas, NV, address
Publisher: Stanley Schrag
Distributor: United Graphics (owned by Schrag)
Years: 1962 and into the 1970s (different imprints ran in different year ranges)
Artist: Robert Bonfils
Authors: Richard E. Geis, George H. Smith, Fletcher Bennett
Sample Titles: *Acid Party*; *Dark Dreams*; *Female Peeping Tom*; *Hangout for Queers*; *Hot Little Hustlers*; *In the Hands of the Gestapo*; *Lesbian Hell*; *The Mating Machine*; *My Husband was a Woman*; *Route Sixty-Sex*; *Satan Was My Pimp*

NEW CHARIOT LIBRARY
Location: Hollywood, CA
Year: 1963
Sample Titles: *Lesbians in Black Lace*; *Lesbo Nurse*; *Lesbo Nympho*

NEW LIBRARY (I) (See Neva Paperbacks/N.P. Inc.)

NEW LIBRARY (Zil, Ltd.) (II)
Location: Woodside, NY
Year: 1967
Sample Title: *The Young Cats*

NEWSSTAND LIBRARY
Location: Chicago, IL
Years: 1958–1962
Artists: Robert Bonfils, Stake, Edgar
Authors: Charles Willeford, Richard E. Geis
Sample Titles: *Chained Sex; Fear of Incest; Love is a Gentle Whip*; *Sexy Psycho*; *Sinful Cowboy*; *Understudy for Love*; *The Woman Chaser*

NIGHT SHADOW (Casanova Publishing)
Location: Long Island City, NY; later Glen Burnie, MD
Years: 1966–1967

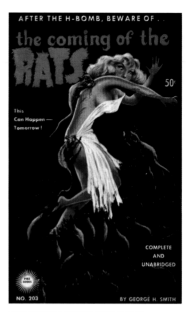

THE COMING OF THE RATS (1961)
By George H. Smith
Pike Books
Cover artist: Albert Nuetzel

Sample Titles: *Double Date*; *Hollywood Stripper*; *Love Slave*; *Rented Wives*

NIGHTSTAND BOOKS (See Greenleaf Publications)

NITELIGHT READERS (Art Enterprises/Epic)
Publisher: Probably David Zentner
Year: 1963
Sample Title: *Passion Place*; *Torrid Zone Tease*

NITE LITE BOOKS (Frimac Publications)
Location: North Hollywood, CA
Artist: John Healey
Sample Titles: *Bimbo*; *Dikesville*; *Hot Stud*; *Passionate Lesbian*

NITE TIME BOOKS (Publisher's Export Company, Frimac Publications)
Locations: El Cajon, CA; later North Hollywood, CA, and San Diego, CA
Distributor: Golden State News (Bernie Bloom)
Artists: Doug Weaver, E.M.
Authors: Ron Haydock
Sample Titles: *Erotic Executives*; *Gay Boy*; *House of Wild Women*; *Sex Burns Like Fire*

NITEY-NITE (See Satellite Publications)

NITIME SWAPBOOKS
(See Greenleaf Publications)

NOBLE LIBRARY (See Neva Paperbacks/N.P. Inc.)

NOVEL BOOKS (See Camerarts Publishing)

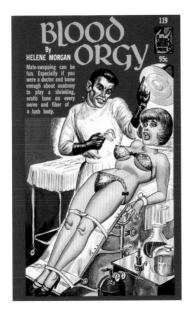

BLOOD ORGY (1966)
By Helene Morgan
Satan Press
Cover artist: Gene Bilbrew

OLYMPIA PRESS
Locations: Paris, France; New York, NY
Publisher: Maurice Girodias
Years: 1953–1973
Authors: William S. Burroughs, Vladimir Nabokov, Henry Miller, J.P. Donleavy, Pauline Reage, Terry Southern, Jean Genet, Gregory Corso, Diane Di Prima
Sample Titles: *Lolita*; *Memoirs of a Beatnik*; *Naked Lunch*; *The Story of O*; *Tropic of Cancer*

OLYMPIC FOTO READERS (B.B. Sales Co.)
Location: New York, NY
Years: 1967–1968
Sample Titles: *The Acid Eaters*; *Color Me Deep Red*; *She-Master*; *Two Thousand Maniacs*

PAD LIBRARY (Europa)
Locations: Los Angeles, CA; later Agoura, CA
Years: 1965–1967
Authors: Ed Wood, Lynton Wright Brent
Sample Titles: *Death of a Transvestite*; *Dyke is a Dirty Word*; *Gay Boy Returns*; *Swap Me Daddy*; *Watts...The Difference*

PAGAN BOOKS (Art Enterprises)
Location: Los Angeles, CA
Year: 1962
Author: Jim Harmon
Sample Title: *... And Sudden Lust!*

PALETTE EDITIONS (See Pioneer Publishing Co.)

PALM BOOKS (See Pioneer Publishing Co.)

PARAGON BOOKS (*See* West Coast News Co.)

PARAISO BOOKS
Location: Sherman Oaks, CA
Year: 1963
Sample Title: *They Call Me Lez*

PARLIAMENT BOOKS (*See* Brandon House)

P.E.C. (Publisher's Export Company)
Imprints: Narcissus Series, P.E.C., P.E.C. French Line, Rapture Books (Rapture was likely bought by Donald Partrick and became a part of P.E.C. in the imprint's later years)
Locations: San Diego, CA, and El Cajon, CA
Publisher: Donald Partrick
Years: Began in 1965 and went until 1971 (different imprints ran in different year ranges)
Artist: Doug Weaver
Author: Ron Haydock
Sample Titles: *Animal Lust*; *Ape Rape*; *Blackmail Bitch*; *Chili Pepper Swap*; *Devil Sex*; *Girls in Bondage*; *Merry-Go-Round Sex*; *Mistress of Satan's Roost*; *Satan was a Lesbian*, *Sex-A-Reenos*

P.E.C. FRENCH LINE (*See* P.E.C.)

PENDULUM BOOKS
Location: Atlanta, GA ('67–'69); Los Angeles, CA ('69–'72)
Publisher: Michael Thevis
Editors: Dale Koby ('67–'69); Charlie "Norman Bates" Anderson & Dennis Rodriguez ('69–'72)
Years: 1967–1973 (ended when Thevis was convicted of murder)
Authors: Ed Wood, Del Britt, Dale Koby
Sample Titles: *Bye Bye Broadie*; *Cauliflower Dick*; *Lust Quake*; *Virgins Die Horny*

PERIOD BOOKS (Period Publications)
Location: Los Angeles, CA
Years: 1961
Author: John Jakes
Sample Titles: *The Defiled Sister*; *Filth for Sale!*; *Sinners Don't Cry!*

PHANTOM (See Foremost Publishers/ ConnoisseurPublications)

PIKE BOOKS
Location: Van Nuys, CA
Publisher: Bob Pike
Distributor: Paragon News
Years: 1961–1962
Artist: Albert Nuetzel
Authors: Charles Nuetzel, Ron Haydock, George H. Smith, Bob Pike
Sample Titles: *The Flesh Peddler*; *Nymphos Be Damned*; *Scarlet Virgin*

PILLAR BOOKS (See Greenleaf Publications)

PILLOW BOOKS (Art Enterprises)
Location: Hollywood, CA
Publisher: David Zentner
Years: 1962–1963
Author: Ed Wood
Sample Titles: *Flesh Seller*; *Hollywood Playgirls*; *Ringside Tarts*

PIONEER PUBLISHING CO.
Imprints: Anchor Editions, Arrow Readers, Banner Volumes, Coach Volumes, Compass Line, Dragon Editions, Lantern Books, Mask Readers, Palette Editions, Palm Books, Prize Volumes, Regal Line, Royal Line, Shield Books, Spade Volumes, Spartan Line, Spur Editions, Stardust Readers, Sun Volumes, Swan Readers, Target Books, Tiger Books, Torch Readers, Trophy Volumes, Wing Books
Location: Las Vegas, NV
Years: 1964–1967 (different imprints ran in different year ranges)
Other: Arrow Readers pirated Boudoir
Sample Titles: *Art Colony Perverts*; *Explosion of Lust*; *Kindle My Passion*; *Lez on Wheels*; *The Lust Leeches*; *Merchant Sinman*; *Orgy Rut*; *The Sex Pigeon*; *The Sex Séance*; *Sintime Beatniks*; *Super Dyke*; *Tycoon of Lust* (pirate of *The Boss' Boudoir*); *Wanton Addicts*

PLAYTIME BOOKS (See Neva Paperbacks/N.P. Inc.)

PLEASURE READERS (*See* Greenleaf Publications)

PRIVATE EDITION
Locations: Hollywood, CA, and Canoga Park, CA
Publishers: Dick Sherwin (bought by Milton Luros in the late '60s)
Distributor: Columbia News, co-owned by Sherwin and Bill Trotter
Years: 1962–1969
Artists: John Healey, Paul Rader
Author: Ed Wood
Sample Titles: *AC-DC Lover*; *Babes Behind Bars*; *The Body Box*; *Butch Fever*; *Homo Sap*; *So Sweet So Soft So Queer*

PRIZE (See Pioneer Publishing Co.)

PUSSYCAT PRESS (Star)
Location: New York, NY
Year: 1967
Sample Title: *Nympho House*

RAM BOOKS (Imperial)
Pirate editions of Boudoir and Tuxedo
Location: Hollywood, CA
Years: 1961–1962
Sample Titles: *Executive Broad*; *Lust Bandits*

RAPTURE BOOKS (I)
Location: Culver City, CA; San Diego, CA
Distributor: World Wide News Company (WWNC)
Years: 1963–1964

Author: Ron Haydock
Sample Titles: *God Of Lust*; *Lust For Lace*; *Pagan Urge*; *Perverted Lust*

RAPTURE BOOKS (II) (*See* P.E.C.)

RAVEN BOOKS (Frimac Publications, Private Edition)
Location: North Hollywood, CA
Years: 1962–1964
Artist: John Healey, Doug Weaver
Author: Ed Wood
Sample Titles: *A Bed is Not For Sleeping*; *Blacklace Drag*; *Sex Haven*; *Sin Valley*

REED NIGHTSTAND (See Greenleaf Publications)

REGAL LINE (*See* Pioneer Publishing Co.)

RENDEZVOUS READER (Tuxedo Books)
Location: New York, NY
Years: 1962–1963
Authors: Bob Tralins, Colin Ross
Sample Titles: *Passion Trap*; *Pleasure Girl*; *Twisted Sinner*; *Wanton Sinner*

REX BOOKS (Falcon Books)
Location: Los Angeles, CA
Artist: Ric
Sample Titles: *Prisoner of Passion*; *Wild Woman*

RNS BOOKS
Publisher: Dick Sherwin

ROOM MATE BOOKS (Casanova Publishing Company)
Locations: Glen Burnie, MD, and Long Island City, NY
Years: 1966
Sample Titles: *Her Mother's Man*; *Naked Witch*

ROYAL LINE NOVELS (See Pioneer Publishing Co.)

SABER BOOKS (*See* West Coast News Co.)

SABER TROPIC (*See* West Coast News Co.)

SATAN PRESS (*See* Foremost Publishers/ Connoisseur Publications)

SATELLITE PUBLICATIONS
Imprints: After Hours, First Niter, Nitey Nite, Unique Books, Wee Hours
Locations: New York, NY, was real location but listed addresses in: Buffalo, NY; Culver City, CA; Cleveland, OH
Publishers: Stanley Malkin, Eddy Mishkin
Years: 1963–1969 (different imprints ran in different year ranges)
Artists: Eric Stanton, Gene Bilbrew, Bill Ward, Bill Alexander
Authors: Bill Ward, Gil Fox

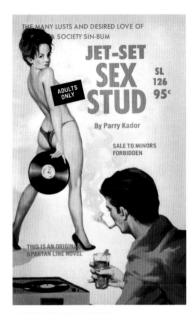

JET-SET SEX STUD (1966)
By Parry Kador
Spartan Line Novels

Sample Titles: *Bathhouse Peeper*; *Discipline Hour*; *Female Tyrant*; *Rooftop Peeper*; *Rubdown*; *Sex Carnival*; *Sin Strippers*; *Slave Girl*; *Swapping in Suburbia*

SATURN NOVELS
Year: 1967
Sample Titles: *Sex Specialist*; *Shameless Schemers*; *Their Friendly Desires*

SCARLET READER (Frimac Publications)
Location: North Hollywood, CA
Years: 1964
Artist: John Healey
Sample Titles: *Queer Bedfellows*; *Sex on the House*

SCORPION BOOKS (N.A.C. Publications)
Location: Los Angeles, CA
Publisher: Charles Nuetzel
Distributor: Golden State News (Bernie Bloom)
Years: 1964
Artist: All covers by Albert Nuetzel (as Gus Albet)
Author: All written by Charles Nuetzel
Sample Titles: *Jungle Nymph*; *Nobody Loves a Tramp*; *Wantons of Betrayal*

SELBEE PUBLICATIONS
Mostly printed digest-sized paperbacks
Location: New York, NY
Artists: Gene Bilbrew, Eric Stanton
Sample Titles: *The Gay Jungle*; *Male Madame*; *Mr. Muscle Boy*

SHIELD BOOKS (*See* Pioneer Publishing Co.)

SOFTCOVER LIBRARY (*See* Beacon Books)

SPADE VOLUMES (*See* Pioneer Publishing Co.)

SPARTAN LINE NOVELS (*See* Pioneer Publishing Co.)

SPECIALTY BOOKS (See Camerarts Publishing)

SPOTLIGHT BOOKS
(See Neva Paperbacks/ N.P. Inc.)

SPUR EDITIONS (*See* Pioneer Publishing Co.)

STANLEY LIBRARY
Location: New York
Year: 1958–1959
Author: Harry Whittington
Sample Titles: *The Oldest Profession*; *So Nice, So Wild*

STAR DISTRIBUTORS
Location: New York, NY
Year: 1969
Sample Title: *Orgy a Go-Go!!*

STARDUST READERS (*See* Pioneer Publishing Co.)

SUNDOWN READERS (*See* Greenleaf Publications)

SUN VOLUMES (*See* Pioneer Publishing Co.)

SWAN READERS (*See* Pioneer Publishing Co.)

TARGET BOOKS (*See* Pioneer Publishing Co.)

TIGER BOOKS (Powell Publications) (I)
Location: Reseda, CA
Publisher: Bill Trotter
Years: 1968–1969
Authors: Charles Nuetzel, Ed Wood, Stuart Byrne
Sample Titles: *Baby Faced Harlot*; *The Body Merchants*; *Sex Bash*

TIGER BOOKS (II) (*See* Pioneer Publishing Co.)

TOPAZ BOOKS (Centaur)
Year: 1965
Sample Title: *Casting Couch to Excess*

TOPAZ SERIES (*See* Neva Paperbacks/N.P. Inc.)

TOPPER EDITIONS
Year: 1965
Sample Titles: *Naked in the Grass*; *Over the Edge of Lust*

TORCH READER (*See* Pioneer Publishing Co.)

TRIUMPH FACT BOOK (Triumph News)
Location: Van Nuys, CA
Publisher: Ray Goldin

Editor: Frank O'Neill
Author: Ed Wood
Sample Titles: *Drag Trade*; *Suburbia Confidential*

TRIUMPH NOVEL (Triumph News)
Location: Van Nuys, CA
Artist: Ertag
Sample Title: *Enslaved in Ebony*

TROPHY VOLUMES (See Pioneer Publishing Co.)

TUXEDO BOOKS
Locations: New York, NY; later Los Angeles, CA
Years: 1961–1962
Artists: Elaine Duillo, Frace, Bruce Minney, Schultz, Paul Rader
Sample Titles: *Dance of Lust*; *Petting Place*; *Sin Caravan*; *Sin Lens*

TWILIGHT READERS (Tuxedo Books)
Location: New York, NY
Years: 1963–1965
Sample Titles: *Bed Bait*; *Flesh Harlot*; *Orgy Mob*; *Red-Hot and Ready*

UNIQUE BOOKS (See Satellite Publications)

UPTOWN BOOKS (Uptown Publishing Co.)
Location: Los Angeles, CA
Publisher: David Zentner
Years: 1962
Artist: Albert Nuetzel
Author: Charles Nuetzel
Sample Titles: *He Kissed Her There*; *The Sex Life of the Gods*; *Woman Trap*

VALENTINE BOOKS
Year: 1964
Sample Titles: *Flesh Witch*; *Jaded Virgin*; *Lust Roots*; *Sex Glutton*; *Shack Studs*

VANGUARD (See Foremost Publishers/ Connoisseur Publications)

VEGA BOOKS (See West Coast News Co.)

VENICE BOOKS (Venice Publishing Corp.)
Location: Van Nuys, CA
Publisher: Dick Sherwin
Sample Titles: *Call Me Pervert!*; *Gays and Dolls*; *Rx for Sex*; *The Sex Trippers*; *Sick Sex*

VENUS LIBRARY–VENUS BOOKS
Publisher: Grove Press (1969–1971). Sold to distributor Kable News, 1971. Kable News sells to Maurice Girodias, 1973.
Sample Titles: *A Lustful Female*; *A Pilgrim of Passion*; *Sadist in Satin*

VENUS VOLUMES
Year: 1964
Sample Title: *The Mask on a Wanton's Torso*

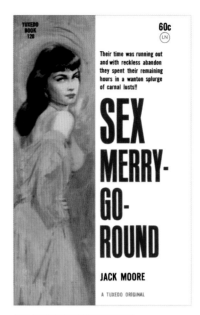

SEX MERRY-GO-ROUND (1962)
By Jack Moore
Tuxedo Books

VICEROY (Genell Corp.)
Location: Los Angeles, CA; later Canoga Park, CA
Years: 1964–1968
Author: Ed Wood
Sample Titles: *Gay Underworld*; *Love of the Dead*; *The Married Lesbian*; *Runaway Wantons*

WEE HOURS (See Satellite Publications)

WEST COAST NEWS CO.
Imprints: Fabian, National Library Books, Paragon Books (Aday and Ortega Maxey played some part in this imprint but whether it was printer, distributor, and/or publisher is uncertain), Saber, Saber Tropic, Vega
Locations: Fresno, CA; Clovis, CA; Los Angeles, CA (Paragon only)
Publishers: Sanford Aday and Wallace de Ortega Maxey
Years: 1956–1973 (different imprints ran in different year ranges)
Artist: Bill Edwards (signed "B.E.")
Authors: Sanford Aday, Wallace de Ortega Maxey, Richard E. Geis
Sample Titles: *Abnormals Anonymous*; *Bought Wife*; *From Sex to Eternity*; *His Sisters Were Call Girls*; *Love Your Neighbor's Wife*; *Orgies By Appointment*; *Parasites of Sex*; *Rape Was Their Bag*; *Sex Life of a Cop*; *Wanted: Broad Minded Couples*; *The Wives Were Call Girls*

WING BOOK (See Pioneer Publishing Co.)

WIZARD (See Foremost Publishers/ Connoisseur Publications)

PSEUDONYMS: AUTHORS

Kay Addams: pseudonym of Orrie Hitt
Curt Aldrich: pseudonym of Richard Curtis, William Knoles
Clyde Allison: pseudonym of William Knoles
Kym Allyson: pseudonym of Thom Racina
Terry Andrews: pseudonym of Thom Racina
Pierre Angelique: pseudonym of Georges Bataille
Rick Arana: pseudonym of Con Sellers
Ricardo Armory: pseudonym of George Davies
Richard Ashby: pseudonym of Sybah Darrich
Jeremy August: pseudonym of George H. Smith
Jerry August: pseudonym of George H. Smith
Sonny Barker: pseudonym of Jerome Murray
Willie Baron: pseudonym of Baird Bryant
Ralph Basura: pseudonym of Jerome Murray
Don Bellmore: pseudonym of George H. Smith
Vivien Blaine: pseudonym of Vivien Kern
Alex Blake: pseudonym of Charles Nuetzel
Stephanie Blake: pseudonym of Jack Pearl
Dr. Jill Boyle: pseudonym of Jerome Murray
Dr. Lance Boyle: pseudonym of Jerome Murray
Sloane Britain: pseudonym of Elaine Williams
Tony Calvano: pseudonym of Thomas P. Ramirez
Gage Carlin: pseudonym of Thomas P. Ramirez
David Challon: pseudonym of Robert Silverberg
Lee Chapman: pseudonym of Marion Zimmer Bradley
John Cleve: pseudonym of Andrew J. Offut
Frederick Colson: pseudonym of Richard E. Geis
James Colton: pseudonym of Joseph Hansen
Erik Dahl: pseudonym of Earl Kemp
Harriet Daimler: pseudonym of Iris Owen
Christian Davidson: pseudonym of Christian Davies
John Davidson: pseudonym of Charles Nuetzel
Jay Davis: pseudonym of Charles Nuetzel
John Dexter: all-purpose Nightstand pseudonym
Sam Diego: pseudonym of Jerome Murray
Winifred Drake: pseudonym of Denny Bryant
Carl Driver: pseudonym of Phillip Lee
Milo DuPree: pseudonym of Milo Perichitch
G.C. Edmondson: pseudonym of José Edmondson y Cotton
Neil Egri: pseudonym of John Gilmore

Neil Elliot: pseudonym of Neil Elliot Blum
Don Elliott: pseudonym of Robert Silverberg
Joan Ellis: pseudonym of Julie Ellis
Jill Emerson: pseudonym of Lawrence Block
Charles English: pseudonym of Charles Nuetzel
Gene Evans: pseudonym of Harold Harding
Kathleen Everett: pseudonym of Edward D. Wood, Jr.
Felix Lance Falkon: pseudonym of George Scithers
Lisa Fanchon: pseudonym of Lee Florin
Lee Gardner: pseudonym of Leslie Gladson
Miriam Gardner: pseudonym of Marion Zimmer Bradley
Greg Hamilton: pseudonym of Ron Singer
Jon Hanlon: pseudonym of Earl Kemp
Matt Harding: pseudonym of Lee Florin
March Hastings: pseudonym of Sally Singer
Marcus van Heller: pseudonym of John Stevenson
Christine Hernandez: pseudonym of Earl Kemp
Don Holliday: pseudonym used by Hal Dresner, Victor J. Banis, Lawrence Block, David Case, William Coons, Sam Dodson, John Jakes, Arthur Plotnik
Jay Horn: pseudonym of Ron Haydock
Dean Hudson: pseudonym of Evan Hunter (legal name change for Salvador Lombino)
Jan Hudson: pseudonym of George H. Smith
Morgan Ives: pseudonym of Marion Zimmer Bradley
Albina Jackson: pseudonym of Richard E. Geis
Jerry Jason: pseudonym of George H. Smith
N.V. Jason: pseudonym of Edward D. Wood, Jr.
William Jeffries: pseudonym of Arthur Plotnik
David Johnson: pseudonym of Charles Nuetzel
Wash Johnson: pseudonym of Jerome Murray and Gary Sohler
Henry Jones: pseudonym of John Coleman
Kimberly Kemp: pseudonym of Gilbert Fox
Jeff King: pseudonym of Ron Haydock
Shane Lansing: pseudonym of Thomas P. Ramirez
Frances Legel: pseudonym of Alexander Trocchi
Lance Lester: pseudonym of George Davies
D. Barry Linder: pseudonym of Linda DuBreuil

Marlene Longman: pseudonym of Marion Zimmer Bradley

Violet Loring: pseudonym of Gilbert Fox

Fred MacDonald: pseudonym of Charles Nuetzel

Jim Macher: pseudonym of James Schumacher

Steve Maier: pseudonym of Earl Kemp

Ray Majors: pseudonym of Jerome Murray

Jack Manning: pseudonym of Jack Moskovitz

Alan Marshal: pseudonym of Donald E. Westlake

Bill Marshall: pseudonym of Bill Ward

Dallas Mayo: pseudonym of Gilbert Fox

Paul Merchant: pseudonym of Harlan Ellison

Linda Michaels: pseudonym of Julie Ellis

Marcus Miller: pseudonym of Milo Perichitch and Samuel Dodson

Wu Wu Ming: pseudonym of Sinclair Beiles

Murray Montague: pseudonym of Jerome Murray

Jill Monte: pseudonym of Julie Ellis

Emil Moreau: pseudonym of Edward D. Wood, Jr.

Brian Morley: pseudonym of Marion Zimmer Bradley

Joyce Morrissey: pseudonym of Jerome Murray

Thurlow Mortensen: pseudonym of Jerome Murray

Muffy: pseudonym of Austryn Wainhouse

Jason Nichols: pseudonym of Edward D. Wood, Jr.

Erika Norman: pseudonym of Norma Erickson

Dee O'Brien: pseudonym of Marion Zimmer Bradley

Robert Owen: pseudonym of Richard E. Geis

Faustino Perez: pseudonym of Mason Hoffenberg

Hardy Peters: pseudonym of George Laws

Akbar del Piombo: pseudonym of Norman Rubington

John Quinn: pseudonym of Edward D. Wood, Jr.

Ann Radway: pseudonym of Richard E. Geis

Lou Rand: pseudonym of Lou Hogan

Susan Richard: pseudonym of Julie Ellis

Pat Richards: pseudonym of James Schumacher

Stu Rivers: pseudonym of Charles Nuetzel

Alec Riviere: pseudonym of Charles Nuetzel

Alan Robinson: pseudonym of George H. Smith

Mick Rogers: pseudonym of Donald F. Glut

Paul V. Russo: pseudonym of Gilbert Fox

Mark Ryan: pseudonym of Robert Silverberg

Genevieve St. John: pseudonym of Leslie Gladson

Randy Salem: pseudonym of Pat Perdue

Steve Savage: pseudonym of Thomas P. Ramirez

Vin Saxon: pseudonym of Ron Haydock

Andrew Shaw: pseudonym of Lawrence Block, William Coons, Hal Dresner, Donald E. Westlake

Shep Shepard: pseudonym of Harry Whittington

Don Sheppard: pseudonym of Ron Haydock

Leda Starr: pseudonym of Gilbert Fox

Trisha Stevens: pseudonym of Jack Pearl

Chad Stuart: pseudonym of William J. Lambert, III

Peggy Swan: pseudonym of Richard E. Geis

Peggy Swanson: pseudonym of Richard E. Geis

Peggy Swenson: pseudonym of Richard E. Geis

Dick Trent: pseudonym of Edward D. Wood, Jr.

Les Tucker: pseudonym of Jack Moskovitz

Miles Underwood: pseudonym of John Glassco

Count Palmiro Vicarion: pseudonym of Christopher Logue

Jay Vickery: pseudonym of Victor J. Banis

Jay Warren: pseudonym of Ron Singer

Nicky Weaver: pseudonym of Orrie Hitt

David L. Westermier: pseudonym of Edward D. Wood, Jr.

Rita Wilde: pseudonym of Ron Haydock

Lambert Wilhelm: pseudonym of William J. Lambert, III

J.X. Williams: pseudonym of John Jakes, George H. Smith, Victor J. Banis, Earl Kemp, Arthur Plotnik, Edward D. Wood, Jr.

Rose Willing: pseudonym of Rosemary Whiteside

Peter Willow: pseudonym of Gilbert Fox

L.T. Woodward: pseudonym of Robert Silverberg

Rob Wynters: pseudonym of Thom Racina

XXX: pseudonym of Diane Bataille

AUTHORS: PSEUDONYMS

Keith Ayling: "Hilary Hilton," "Arthur Adlon"

Victor J. Banis: "Don Holliday," "Jay Vickery," "J.X. Williams"

Diane Bataille: "XXX"

Georges Bataille: "Pierre Angelique"

Sinclair Beiles: "Wu Wu Ming"

Lawrence Block: "Andrew Shaw," "Don Holliday," "Jill Emerson"

Neil Elliot Blum: "Neil Elliot"

Jack Bozzi: "Adam"

Marion Zimmer Bradley: "Lee Chapman," "Brian Morley," "Dee O'Brien," "Marlene Longman," "Morgan Ives," "John Dexter," "Miriam Gardner"

Baird Bryant: "Willie Baron"

Denny Bryant: "Winifred Drake"

Robert H. Carney: "Herb Roberts"

David Case: "Don Holliday"

John Coleman: "Henry Jones"

William Coons: "Don Holliday," "Andrew Shaw"

Tony Crechales: "Tony Trelos"

Richard Curtis: "Bert Alden," "Curt Aldrich"

Sybah Darrich: "Richard Ashby"

Christian Davies: "Christian Davidson"

George Davies: "Ricardo Armory," "Lance Lester"

Sam Dodson: "Marcus Miller"

Hal Dresner: "Don Holliday," "Andrew Shaw"

Linda DuBreuil: "D. Barry Linder"

Julie Ellis: "Joan Ellis," "Linda Michaels," "Jill Monte," "Susan Richard"

Harlan Ellison: "Paul Merchant," cover blurbs for Nightstand Books

Norma Erickson: "Erika Norman"

Lee Florin: "Lisa Fanchon," "Matt Harding"

Gilbert Fox: "Kimberly Kemp," "Dallas Mayo," "Paul V. Russo," "Violet Loring," "Peter Willow," "Leda Starr"

Richard E. Geis: "Peggy Swenson," "Peggy Swanson," "Peggy Swan," "Robert Owen," "Frederick Colson," "Albina Jackson," "Ann Radway"

John Gilmore: "Neil Egri"

Leslie Gladson: "Lee Gardner," "Sebastian Gray," "Kyle Roxbury," "Genevieve St. John"

John Glassco: "Miles Underwood"

Ted Gottfried: "Ted Mark," "Leslie Behan"

Donald F. Glut: "Mick Rogers"

Joseph Hansen: "James Colton"

Harold Harding: "Gene Evans"

Jim Harmon: "Judson Grey," "Jim Harvey"

Ron Haydock: "Vin Saxon," "Don Sheppard," "Jeff King," "Rita Wilde," "Jay Horn"

Morris Hershman: "Arnold English," "Jack Whiffen"

Orrie Hitt: "Kay Addams," "Nicky Weaver"

Mason Hoffenberg: "Faustino Perez"

Lou Hogan: "Lou Rand"

John Jakes: "J.X. Williams," "Don Holliday"

Laurence Mark Janifer: "Barbara Wilson"

Earl Kemp: "Erik Dahl," "John Dexter," "Jon Hanlon," "Christine Hernandez," "Steve Maier," "J.X. Williams"

Vivien Kern: "Vivien Blaine"

John Kimbro: "Kym Allyson"

William Knoles: "Clyde Allison," "Curt Aldrich"

William J. Lambert, III: "Chad Stuart," "Lambert Wilhelm"

George Laws: "Hardy Peters"

Philip Lee: "Carl Driver"

Paul Hugo Little: "Myron Kosloff," "Sylvia Sharon"

Christopher Logue: "Count Palmiro Vicarion"

Richard Love: "Richard Armory"

Anna Selma Morpurgo and Billie Taulman: "Artemis Smith"

Jack Moskovitz: "Tony Calvano," "John Dexter," "Jack Manning," "Les Tucker"

Jerome Murray: "Ralph Basura," "Thurlow Mortensen," "Joyce Morrissey," "Murray Montague," "Ray Majors," "Sonny Barker," "Sam Diego," "Wash Johnson,""Dr. Lance Boyle," "Dr. Jill Boyle"

Charles Nuetzel: "John Davidson," "Alec
 Riviere," "Jay Davis," "Stu Rivers," "Charles
 English," "David Johnson," "Fred MacDonald,"
 "Alex Blake"
Andrew J. Offut: "John Cleve"
Gil Orlovitz: "Stacey Clubb"
Iris Owen: "Harriet Daimler"
Jacque Bain "Jack" Pearl: "Stephanie Blake,"
 "Trisha Stevens"
Pat Perdue: "Randy Salem"
Milo Perichitch: "Marcus Miller," "Milo DuPree"
Art Plotnik: "Don Holliday," "William Jeffries,"
 "J.X. Williams"
Gil Porter: "Rick Raymond"
Thom Racina: "Rob Wynters," "Teryl Andrews,"
 "Kym Allyson"
Thomas P. Ramirez: "Tony Calvano," "Gage
 Carlin, "Shane Lansing," "Steve Savage"
Norman Rubington: "Akbar del Piombo"
James Schumacher: "Jim Macher," "Pat
 Richards"
George Scithers: "Felix Lance Falkon"
Con Sellers: "Rick Arana"
Robert Silverberg: "Loren Beauchamp,"
 "David Challon," "V.S. Clark," "Don Elliott,"
 "Marlene Longman," "Mark Ryan,"
 "L.T. Woodward"
Ron Singer: "Jay Warren," "Greg Hamilton"
Sally Singer: "March Hastings"
George H. Smith: "Don Bellmore," "Jan
 Hudson," "Alan Robinson," "J.X. Williams,"
 "Jerry Jason," "Jeremy August,"
 "Jerry August"
Gary Sohler: "Wash Johnson"
John Stevenson: "Marcus van Heller"
Whitney Ward Stine: "Jonathan Ward"
John Trimble: "Roger Blake"
Alexander Trocchi: "Frances Legel"
Bela Von Block: "Adolfo Lucchesi"
Austryn Wainhouse: "Muffy"
Bill Ward: "Bill Marshall"

Donald E. Westlake: "Alan Marshal,"
 "Andrew Shaw"
Rosemary Whiteside: "Rose Willing"
Harry Whittington: "Shep Shepard"
Elaine Williams: "Sloane Britain"
Edward D. Wood, Jr.: "David L. Westermier,"
 "Emil Moreau," "Jason Nichols," "N.V. Jason,"
 "Kathleen Everett," "Dick Trent," "John Quinn,"
 "J.X. Williams"

IT'S A MAN'S WORLD
Men's Adventure Magazines, the Postwar Pulps
Edited by Adam Parfrey and Hedi El Kholti

"The buttoned-down image of 1950s America comes undressed ... in the pages of *It's a Man's World* ... a red-blooded celebration of unbridled virility... A panorama of vintage covers and magazine layouts as well as acerbic insightful narratives from Parfrey and his contributors ... a sprawling, well-endowed retrospective of a lost mid-20th century culture." —*Spin*

"A truly remarkable and very highly recommended showcase of 20th century American popular culture." —*Midwest Book Review*

8 1/2 x 11 • 288 pages • hardcover • ISBN: 0-922915-81-4 • $29.95

WHEN SEX WAS DIRTY
By Josh Alan Friedman

Josh Alan Friedman, author of *Tales of Times Square*, recounts his glory days as editor of *Screw* magazine and profiles a hysterical array of the city's most infamous pimp laureates, porn starlets, smut publishers, sexual con men, and dubious beauty queens.

5 1/2 x 8 1/2 • 240 pages • ISBN: 1-932595-07-4 • $12.95

SUICIDEGIRLS
Edited by Missy Suicide

The book is here! 156 pages of full-color photos of pre-eminent *SuicideGirls* in a finely-printed, strikingly designed hardcover. The book contains Missy Suicide's great pin-up photography as well as SuicideGirls' self-portraits with major diary excerpts. SuicideGirls.com started it all, a place where punk/emo/goth girls can be themselves and where their creativity and uniqueness define their beauty. SuicideGirls is a fast-growing new alternative community that appeals equally to women and men.

"A throwback to the glamorous Pin-Up days, the models are beautifully imperfect, artistically bent emo, goth and punk rockers." —*Nerve*

11 x 8 • 156 pages • hardcover • color photos • ISBN: 1-932595-03-1 • $19.95

TO ORDER FROM FERAL HOUSE:
Individuals: Send check or money order to Feral House, P.O. Box 39910, Los Angeles CA 90039, USA. For credit card orders: call (800) 967-7885 or fax your info to (323) 666-3330. CA residents please add 8.25% sales tax. U.S. shipping: add $4.50 for first item, $2 each additional item. Shipping to Canada and Mexico: add $9 for first item, $6 each additional item. Other countries: add $11 for first item, $9 each additional item. Non-U.S. originated orders must include international money order or check for U.S. funds drawn on a U.S. bank. We are sorry, but we cannot process non-U.S. credit cards.